Venetian Art from Bellini to Titian

Johannes Wilde

Venetian Art from Bellini to Titian

CLARENDON PRESS · OXFORD

Oxford University Press, Walton Street, Oxford OX2 6DP

Oxford New York Toronto
Delhi Bombay Calcutta Madras Karachi
Petaling Jaya Singapore Hong Kong Tokyo
Nairobi Dar Es Salaam Cape Town
Melbourne Auckland
and associated companies in
Beirut Berlin Ibadan Nicosia

OXFORD *is a trade mark of Oxford University Press*

Published in the United States by
Oxford University Press, New York

ISBN 0 19 817331 8

© *Oxford University Press 1981*

First published 1974
Reprinted 1981, 1982, 1985

Printed in Hong Kong

Preface

WHEN Johannes Wilde died in 1970 he bequeathed all his papers to the Courtauld Institute where he had taught, first as a Reader and later as Professor, from 1947 to 1958.

Although he was one of the great scholars and great teachers of his generation, Wilde was a perfectionist who published little during his life-time. His few printed articles and lectures are proof both of his intimate knowledge of the art of the Italian Renaissance and of his penetrating insight into the nature of works of art, but his wisdom was mainly dispensed in lectures, supervisions and private conversation. The results of these are stored in the memories of those fortunate enough to be his pupils, but owing to a lucky chance—the fact that he had to lecture in a foreign language—a large number of his lectures survive written out in full, and it is from a group of these that the present volume is composed.

The problem of editing the lectures for publication was in certain ways simple. The text was complete, the handwriting beautifully clear and the illustrations were indicated by the slide lists accompanying each manuscript. After some thought it was decided that the notes should be kept to a minimum; the texts were to be presented as lectures, not as a monograph, and to give full references to documents and to the works of other scholars would have interrupted the argument and added nothing essential to Wilde's intention. The relevant documents are accessible in any text-book, and it was a fundamental characteristic of Wilde's lectures that, although he was fully conversant with the writings of other scholars on the subject about which he was speaking, he rarely quoted them. He preferred to concentrate on the known facts and the works of art themselves.

The most delicate question was how far to edit the text. Wilde never spoke or wrote English with complete ease (he could not speak the language at all when he came to England in 1939) and a certain number of the phrases were definitely wrong and had to be corrected. But there were many others which, though not strictly in accordance with English usage, were so characteristic of Wilde's spoken style that to those who had heard him lecture they had a peculiarly personal flavour. However after much hesitation it was decided that in cold print and in a book

which would mainly be used by people who never heard Wilde lecture it would be an affectation to preserve these phrases when they were actually contrary to correct usage. Great care was, of course, taken not to falsify the meaning of Wilde's text when any alteration was made.

The original text was of eight lectures, but their form was necessarily dictated by the time available for their delivery, and in book form it seemed logical to divide the text into seven chapters, Chapter 1 comprising the first lecture and the first half of the second, and Chapter 2 the second half of the second lecture and the third lecture.

The basic text of the lectures was established by Professor Giles Robertson of Edinburgh University, who had to decide which of the various versions was the latest, what footnotes were necessary and where the plate references should come. Mr. Maurice Howard of the Courtauld Institute brought the notes and the list of plates to their final form. Much gratitude is due to those friends and pupils of Wilde who gave advice over points in the text where the meaning was not at first sight clear or where there was some doubt about the way in which the phrasing should be altered. The final text was completely retyped and rechecked by Miss Elsa Scheerer.

Any lectures suffer from being read in printed form, because when they are heard in the lecture-room the ear takes in the argument while the eye is looking at the work of art in the slides, whereas in print the two processes are bound to take place in succession. This disadvantage is particularly marked in the case of Wilde's lectures, because in them the argument was tied in at every stage with the visual evidence.

Wilde was not a speculative art-historian; he did not invent ingenious theories and then find arguments to support them. He studied the documentary and historical evidence but above all the work of art. In this context he paid particular attention to such points as the place for which the work had been painted, the light in which it would have been seen, its present state, considering particularly whether it was complete in itself or was part of a larger whole, whether it had been enlarged or cut down, whether it had been altered by later repainting. By asking such apparently simple questions he often arrived at results of great originality; but the reader must not be deceived: it was only through the wisdom born of great experience that Wilde was able to know what were the questions which would lead to revealing results.[1]

The lectures cannot, unhappily, give any idea of the method of enquiry which he imparted in his supervision, gently correcting some wild hypothesis put forward by a student, suggesting an alternative, pointing out some obvious but overlooked fact which clarified the whole problem. From this experience the student did not exactly learn a method— Wilde never inculcated anything so mechanical—but he would find himself able to look at works of art with a new penetration, one could

almost say a new intimacy. The wisdom which Wilde conveyed person-
ally in his teaching shines out from the text of the lectures, and it is for
this reason that his friends wished to have them printed. These friends
have helped in a very practical way to make this possible by contributing
to a fund which has enabled us—we hope—to publish them at a price
within the reach of students. For it was primarily to students that Wilde
spoke; but there are many ideas and observations in the lectures on
which the more mature scholar can brood with profit.

Wilde was born in Budapest in 1891. He studied at the Universities
of Budapest, Freiburg-im-Breisgau and Vienna, where he was awarded
his doctorate in 1918 for a thesis on the origins of the art of etching in
Italy. He was an assistant in the Museum of Fine Arts, Budapest, from
1914 to 1922, and at the Kunsthistorisches Museum, Vienna, from 1923
till 1938, when he resigned as a result of the Anschluss and came to
England. After the outbreak of war he went to Aberystwyth to work
on the catalogue of the Michelangelo drawings in the British Museum
which had been transferred there for safety. At the time of the general
internment in 1940 he was taken to the Isle of Man and later to Canada.
On his release in 1941 he took up work again on the British Museum
drawings and later on those by Michelangelo in the Royal Library at
Windsor Castle. In 1948 he was appointed Reader in the History of
Art in London University and Deputy Director of the Courtauld
Institute. In 1950 the title of Professor was conferred upon him and he
continued to lecture and teach at the Courtauld Institute till his
retirement in 1958.

During his years at the Kunsthistorisches Museum his interests settled
on the two subjects which were to be his main preoccupations for the
rest of his life: Venetian painting of the 16th century and the art of
Michelangelo. For the former study the museum offered unparalleled
opportunities of which Wilde took full advantage, and which led to a
series of articles incorporating revolutionary discoveries about paintings
in the gallery by Antonello da Messina, Giorgione, Titian and others.
In these studies Wilde made great use of examination of paintings by
X-ray, a technique which had hardly been applied before this time.
His work on Michelangelo led to a series of articles, most of which deal
with individual sculptures or groups of drawings, but which all in-
corporate discoveries or ideas with implications for the whole work
of the artist. A few of his lectures on Michelangelo were published, but
he left at his death a large body of manuscript material on the artist
which, it is hoped, will in due course be published.

A full bibliography of his published articles was printed with his
obituary in the *Burlington Magazine* for March, 1971 (MCXIII).

February 1973 ANTHONY BLUNT

Contents

List of Plates

gracious permission of H.M. The Queen).

Giovanni Bellini

THE mission of the Venetian School in the secularization of painting sprang from a programme that had been formulated by Giovanni Bellini in the second half of the fifteenth century. Born probably in the middle of the 1430s, Bellini was among the first artists in northern Italy who understood the meaning of the Florentine 'rebirth' (*rinascita*); and he was the last of his generation to leave the field of action. In the middle of his life he became the leading artist, the *pictor laureatus*, of the Republic, and he was the teacher of most of the younger painters.

One cannot study the history of Renaissance painting in Venice—the story which is headed by the names of Giorgione and Titian—without taking account of these facts. I propose, therefore, to begin with a short survey of the works through which Bellini established his position.

In the fifteenth century Venice was one of the largest cities in Europe and the capital of one of the five principal states of the peninsula. What matters most in our context is that Venice also possessed an important school of painting of her own by the first half of the Quattrocento. Although the decoration of the Great Hall in the Ducal Palace with monumental histories was done with the help of foreign artists—Gentile da Fabriano and Pisanello, both of them representatives of the last phase of Gothic painting—these artists left behind able followers to carry on their work, such as Jacobello del Fiore, Giambono and, most important of all, Jacopo Bellini, Giovanni's father. The fact that the first appearance of Florentine artists in Venice—Uccello and Castagno—had little effect there, was partly due to this well-organized production on traditional lines. As in her politics, Venice on the whole was cautiously progressive in her art.

This does not apply to Giovanni Bellini. Indeed, his earliest works known to us must have appeared to his contemporaries as something revolutionary—as a complete break with the firm traditions of his father's workshop. In his *Virgin and Child* in the Metropolitan Museum (Plate 1) the content is still hieratic and is in conformity with the late-mediaeval Venetian tradition, but the means adopted to express it are different. If one compares the picture stylistically with one of the late Madonnas of Jacopo Bellini (Plate 2), with which it is about con-

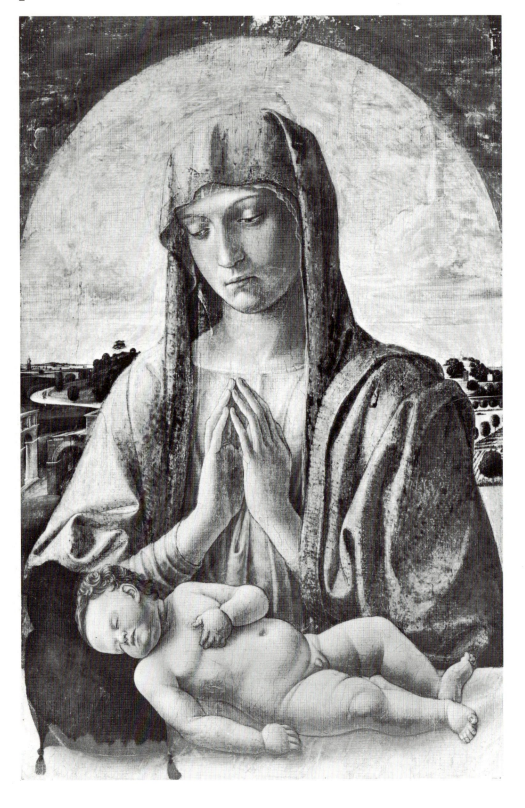

1. (*left*) Giovanni Bellini. *Madonna and Child*. New York, Metropolitan Museum.

2. Jacopo Bellini. *Madonna and Child*. Florence, Uffizi.

temporary, one is struck by the way in which the compact mass of the earlier figure has been split up, and how the almost uninterrupted, gently flowing outline has been replaced by sharp curves and straight lines. The naked Child, iconographically a novelty in Venice, the cushion, the hands of the Virgin, her head, are so many corporeal entities; so are the piled-up folds of the drapery. From such clearly defined, independent parts a three-dimensional volume has been constructed.

It appears that two factors contributed to this new orientation of the young artist: the works of Andrea Mantegna and those of Florentine artists, especially Donatello. Mantegna was Bellini's senior by only a few years; but he was a precocious artist, and he worked at Padua, where there were many more works by Tuscan artists to be seen than in Venice and where the innovations which they announced were enthusiastically received by the young generation. This ancient seat of humanistic learning, although it had been politically a province of the Republic of Venice since the beginning of the century, proved its own cultural independence by patronizing young artists who honestly tried to speak the new idiom of the Florentines and to create, as they did, 'ad analogiam naturae et ad analogiam antiquitatis'. This Madonna (Plate 3) is an early work by Mantegna, almost grotesque in its honesty of rendering cubic forms. In Bellini's picture the plastic effect is enhanced by the distant vista. The horizon is level with the Virgin's shoulders and the Child is seen from above.

But from derivations such as this Bellini proceeded to a study of the prototypes, particularly to that of Donatello's sculpture at Padua. In his *Pietà* in the Museo Correr at Venice (Plate 4) the compositional scheme and the figure of Christ were taken from Donatello's bronze relief of the same subject, which was part of the high altar in the Santo, while the angels were modelled on the music-making putti which in all probability once covered the plinths of the columns of the same altar.

A third example of this earliest group of the paintings by Bellini—a masterpiece—is his *Agony in the Garden* in the National Gallery (Plate 5). It shows a high degree of independence, although in its general disposition and in some of its main motives it is close to the two pictures which Mantegna executed while he was still at Padua, one as a part of his altarpiece for the church of S. Zeno at Verona (Plate 6)—probably the earlier of the two—the other as a picture for private devotion (Plate 7). Mantegna's paintings, as well as Bellini's, seem to depend, though to different degrees, on a silverpoint drawing by Jacopo Bellini (Plate 8), but the different education and the different personality of the younger artist made his work a translation so free that it can be considered as an independent expression of his own ideas. This certainly applies to his interpretation of the subject. He keeps strictly to the Gospel text and draws his inspiration from its poetry. In this scene, showing the hour of day-break, the first rays of the sun light up the far-away horizon, and the houses on the hillside are white flashes in the nocturnal air. Behind the rock there is a deep, sombre valley, and above it, against the dark sky, the angel with the chalice appears in lunar colour—a vision of the anxious watch. Mantegna, in both his pictures, shows everything in bright daylight, when the forms are at their sharpest. He does not know the unifying effect of light, because he does not try

3. Mantegna. *Madonna and Child*. Berlin, Dahlem Museum.

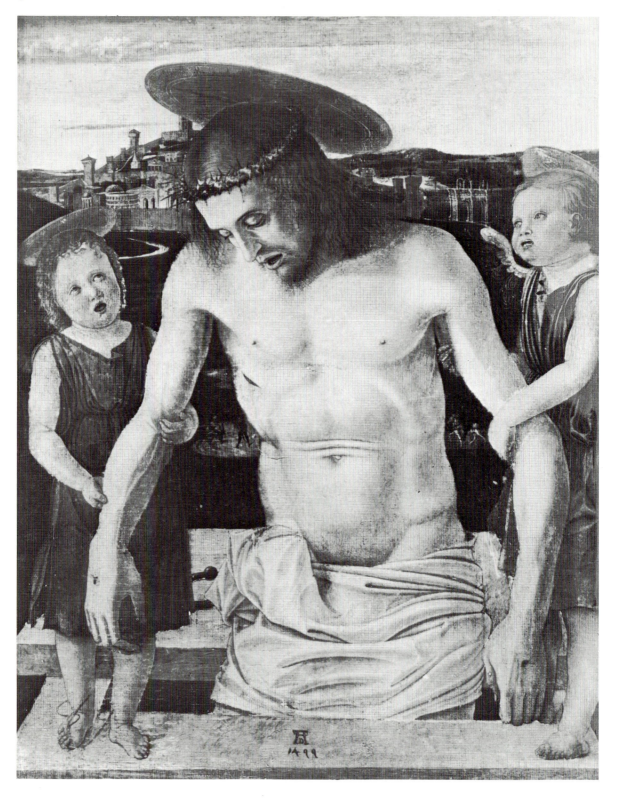

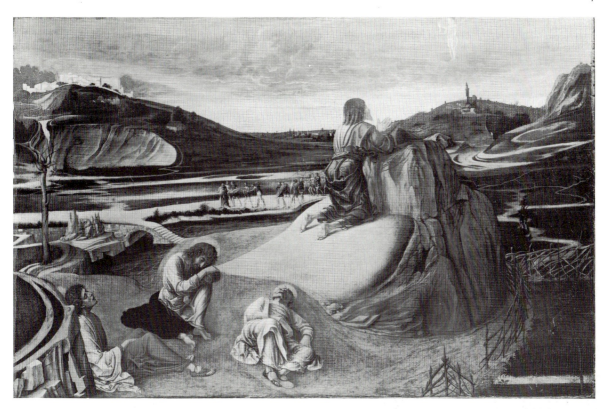

5. Giovanni Bellini. *Agony in the Garden*. London, National Gallery.

6. Mantegna. *Agony in the Garden*. (From the predella of the altarpiece in San Zeno, Verona) Tours Museum.

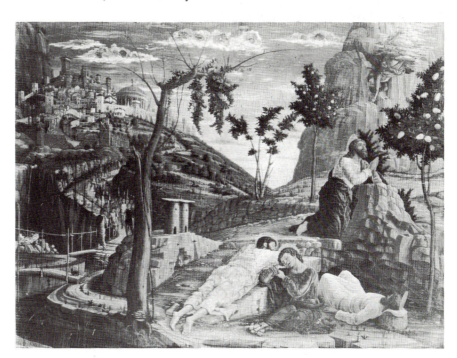

4 (*left*). Giovanni Bellini. *Pietà with two Angels*. Venice, Correr Museum.

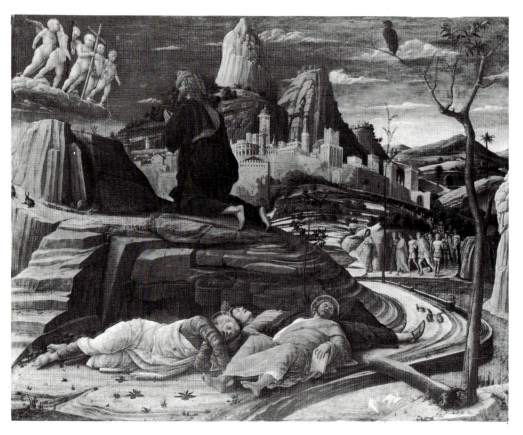

7 (*left*). Mantegna. *Agony in the Garden*. London, National Gallery.

to see the whole. Compared with Bellini's, one cannot properly call his setting a landscape; it is a reconstruction of reality from its parts, chosen and arranged for the sake of this particular composition. The continuous 'natural' landscape of Bellini seems to have originated in the content and is built up by means of lighting; it is a novelty, and not only in Venetian art. The colour-schemes, too, are widely different; that of Bellini is in harmony with his conception of the landscape as a whole, and is the most striking proof of his independence. The figures fit easily into this landscape. They do not have the violent plasticity of Mantegna's which are closely knit together in a compact group and placed in a kind of niche. Of course Bellini's figures are less correctly drawn, but in spite of the bold foreshortenings their outline remains closed, and they can also be read as ornaments on the surface. The tendency to combine the continuity of the plane with the continuity of space prevails even in the distant landscape, where the sunk road which leads up to the town easily associates itself with the upright articulation of the rocks. This is one of the qualities which distinguishes the art of the young Bellini from that of his more experienced brother-in-law. Another is his poetic feeling, which contrasts strongly with Mantegna's intellectual passion, with his, one may say, scholarly exploitation of visible forms. Bellini admired the new art of Padua and found it necessary to learn from it; but he soon revised its programme to make it compatible with Venetian ideals. This was a task in which none of his fellow artists succeeded.

There followed pictures in which the newly acquired forms were applied with greater ease. In them the emphasis is laid, partly with the help of reflected lights, on the graceful modulations of the contour; but a truly pictorial sense protected Bellini from the danger of ever becoming mannered. This stage, however, passed as quickly as the vigorous plasticity of the previous phase. Roberto Longhi probably had this group of works in mind when he spoke of the 'dolorous elegance' of the young Bellini.[1]

The *Redeemer* in the National Gallery (Plate 9) is, as far as I can see, iconographically an invention of Bellini. It is a synthesis of two conceptions: the Saviour with the instruments of His passion—one of the types of the Man of Sorrow—and the angel receiving the blood in a chalice, a motif which was sometimes used in representations of Golgotha. The result is an image of deep theological significance, but one which is also designed to awake compassion in accordance with the teaching of St. Francis. The artist was doubtless inspired by the mystical literature of Franciscan origin on the Sacred Blood, and this literature and the passionate discussion it provoked, which soon led to a papal prohibition, suggest a date between 1462 and 1464 for the picture—I think the first fairly certain date connected with a work of

8 (*left*). Jacopo Bellini. *Agony in the Garden*. London, British Museum Sketchbook.

Giovanni Bellini. It is a subtle composition. The two figures are as far as possible turned into the picture-plane. Their background is divided into horizontal sections, and these are given different ornaments. The treatment of both floor and landscape serves the same double purpose as in the *Mount of Olives*.

The little picture in the Johnson Collection at Philadelphia (Plate 10) is the first of Bellini's lyrically conceived representations of the Mother and Child. It would hardly be possible to describe the countless variations which he elaborated on this theme in the course of some fifty

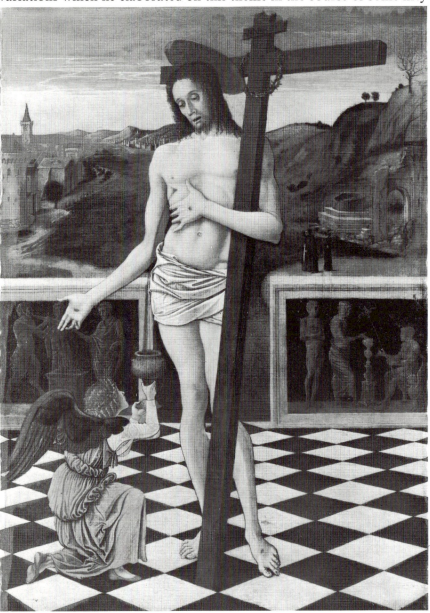

9. Giovanni Bellini. *The Blood of the Redeemer*. London, National Gallery.

years. This production satisfied a popular demand. As in the orthodox East, there was no home in Venice without its picture of the Virgin, and documents tell us that a number of specialists, mostly humble painters called *Madonnieri* (Madonna-makers), exclusively supplied commodities of this sort. Bellini's paintings represent only the highest class in this type of production.

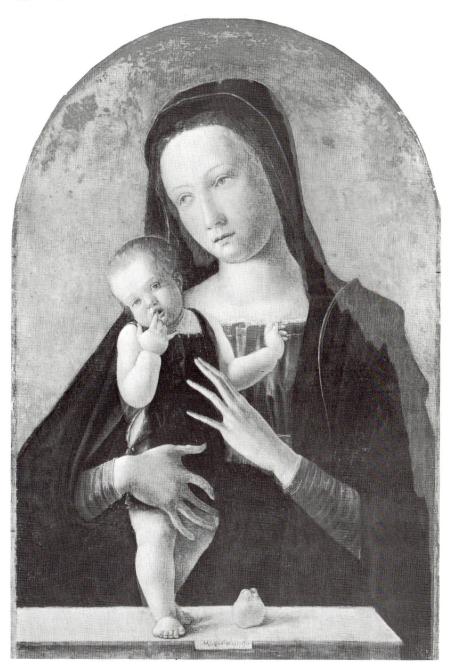

10. Giovanni Bellini. *Madonna and Child*. Philadelphia, Johnson Collection.

The *Pietà* in the Brera at Milan (Plate 11) is generally regarded as the supreme achievement of Giovanni's early period. Indeed, it is a summary of all that had been achieved in previous works, displaying their qualities in a most harmonious ensemble. First, notice the four hands arranged in the centre: are they not rendered as individuals each with its distinct character and with the ability to express it? Each is a reflection of the sentiment embodied in the corresponding figure: the generically human and specifically Christian feelings of blameless suffering, ardent love, and self-effacing commiseration, seen here in their clearest and most moving formulations. It was again Bellini's own invention to represent the Man of Sorrows with the Virgin and St. John alone, the two persons who were next to the Cross. All three stand in the sarcophagus: they tell the drama without words and actions, with a symbol-like finality. The forms, too, are the sum of what the artist had learnt by studying nature under the guidance of the works of Mantegna and Donatello.

11. Giovanni Bellini. *Pietà with the Virgin and St. John.* Milan, Brera.

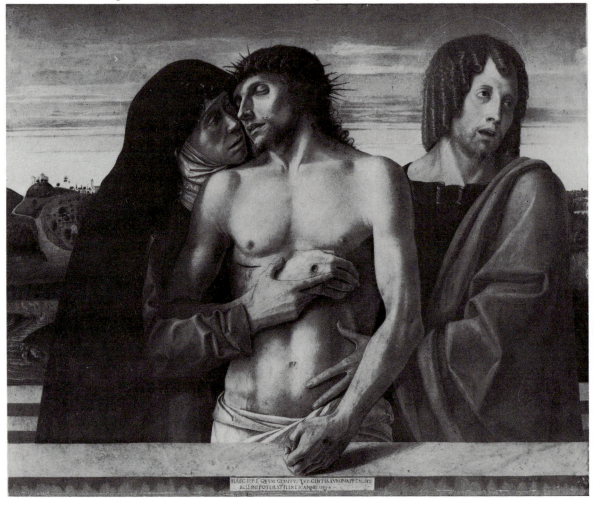

There are no violent foreshortenings, no crowded details here: the simplified forms, rhythmically arranged in the plane, reflect the silent grandeur of the subject.

Not much later Bellini, for some unknown reason, executed a copy from a work by Mantegna, the *Presentation* in the Querini-Stampalia Gallery in Venice (Plate 12). The changes he has introduced, slight though they may appear at first glance, are so many symptoms of his striving after a Venetian paraphrase of the Paduan idiom. Mantegna's picture, now in Berlin (Plate 13), has an air of studied archaism about it. It is painted on canvas in size-colour and is almost monochrome. Doubtless the artist had seen late-Roman marble or stone slabs with high reliefs within projecting frames, which were common in the former Roman provinces. His composition is cut by the frame, and some of the forms encroach on it, devices much favoured by Mantegna in his youth. Within the narrow limits of space there is a multitude of detail, engraved rather than painted and forming hard and sharp angles. In all these points Bellini's replica shows almost the opposite. Painted on a panel in bright colours, the composition has been extended on all sides and has, through the addition of two heads, received not only an inner framing but also a rhythmic articulation. The forms do not suggest hard material; details have been simplified, and linear effects and sharp angles softened. Bellini's copy was never quite finished and, moreover, it seems to have suffered in places through too radical cleaning. Therefore I show it with a contemporary picture which is in perfect condition. This little *Virgin and Child*, now in the Castello Sforzesco, Milan (Plate 14), is a composition in creamy white and pale rose on a gold ground.

If I am not mistaken, we have reached with these works the end of the seventh decade of the fifteenth century. The first twelve or fifteen years of Giovanni's activity seem to have been rather prolific. What I have shown is only a small selection of what is still preserved, and one must also reckon with lost works. Indeed, we are now compelled to consider a lost painting because of its great historical significance.

It appears that about 1470 Bellini received the commission to paint an altarpiece for the church of SS. Giovanni e Paolo; it was to decorate the second altar in the right aisle of the church, and it received its light through the main entrance. The picture, highly praised from the time of Vasari till that of Crowe and Cavalcaselle, was completely destroyed in a fire in 1867. Apart from descriptions we only know it from a feeble watercolour by a dilettante (Plate 15), but the altar-frame exists and it shows that the panel was very large, with figures at least life-size. The subject was a *Sacra Conversazione* with St. Thomas and St. Catherine of Siena, each accompanied by four other figures.

This lost work was, as far as we can see, the earliest example of the unified *pala* painted in Venice, and it marked a turning-point in the

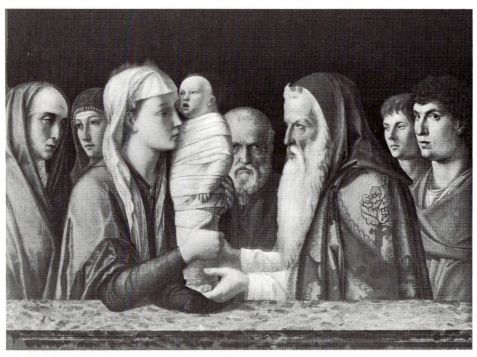

12. Giovanni Bellini. *Presentation of Christ*. Venice, Querini-Stampalia Gallery.
13. Mantegna. *Presentation of Christ*. Berlin, Dahlem Museum.

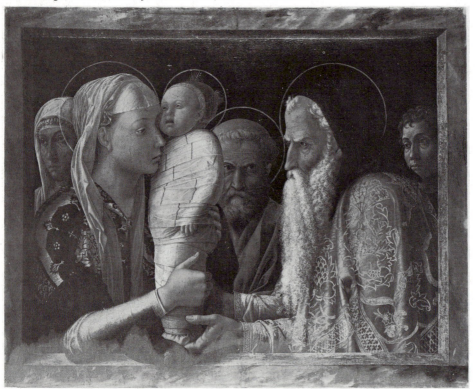

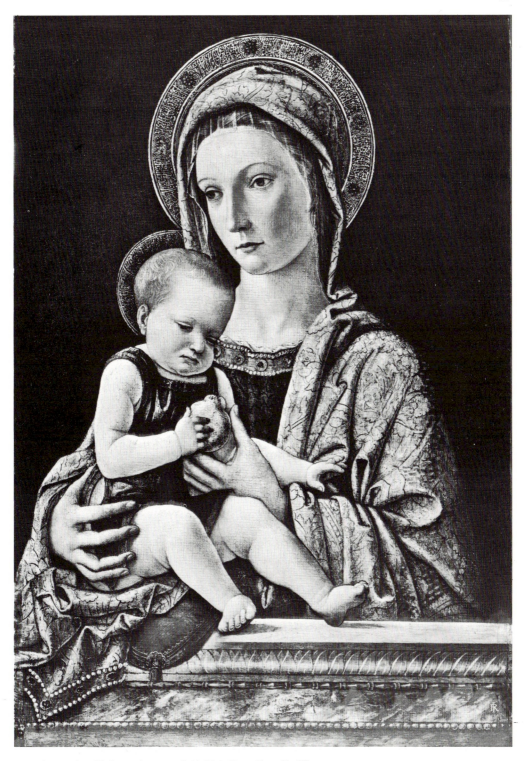

14. Giovanni Bellini. *Madonna and Child*. Milan, Castello Sforzesco.

history of the *Sacra Conversazione*. Elements of the previous form of this composition, the Gothic polyptych, still survived to some extent in Mantegna's San Zeno altar, a work to which I have already referred, and which Mantegna finished in 1459, before leaving Padua. In this work the last remnant of the traditional scheme is the tripartite frame, though its Gothic forms have been replaced by Renaissance ones. Behind this frame there is a continuous composition of space and figures, and as

15. Nineteenth-century watercolour copy of Giovanni Bellini's lost altarpiece in the Basilica of SS. Giovanni e Paolo, Venice.

the frame is also part of the architecture represented in the paintings, we have here, in fact, a near approach to the unified *pala* or *quadro* of the Florentines. Bellini's lost work represented a logical sequel to this altarpiece and established a compositional type which remained valid for half a century. Piero della Francesca took the same step in his altar-piece, now in the Brera, about the same time, but the type as created by Bellini was more successful because it was more consistent. In it he raised the throne, whilst keeping Mantegna's low view-point, and this allowed him to unify the figure composition in a pyramid. The groups are compact; in this and in the elongated proportions, the forms of the drapery, and the group of singing angels, one can perhaps still trace some Paduan influence. I think you can get a fairly good idea of what the style of the lost picture was like with the help of a very nearly con-temporary work; it can do an even better service to us than the little *Madonna* in the Castello Sforzesco did in the case of the unfinished *Presentation*. The picture (Plate 16) represents St. Justina, whom the Borromeo family claimed as their ancestor, as the inscription says. Now, this is not a sculpture in the round, as most of Mantegna's figures are; it is softly embedded in its surroundings, and the clouds look like wings, or at any rate act as ornaments to the figure. The folds and the precious jewels form flashes of light which are contrasted with shadows and which give life and brilliance to the surface.

The lost *pala* of SS. Giovanni e Paolo was, in all probability, a work of the early 1470s. The style is represented by yet another picture of great beauty, the *Pietà* in the gallery at Rimini (Plate 17). This work seems to be free from all reminiscences of the artist's previous develop-ment. Perhaps the first thing to notice is how harmoniously the figures fill the whole picture-space, and how natural their poses and movements are. Their heads all reach the same level, as in a Greek frieze or metope of the fifth century. The body, the head, and the arms of the dead Saviour are so disposed as to be seen almost frontally; the figures of the angels are turned as much as possible into the plane. And yet we have a sensation of depth, at least to some extent. The composition is built up in parallel zones, the figures being superimposed one on another; and these zones are distinguished by means of colour and light: the closer to the ground-plane, the deeper the colour. This effect is supplemented by a delicate chiaroscuro: it avoids sharp contrasts and it is used consistently over the whole surface. Contours are naturally produced where figures appear against the dark background, but are defined by lines of varying breadth where they appear against other figures. They have little in common with the sharply cut drawing of Mantegna, which is strained by the amount of objective information it has to convey. They are purified. They are simplified to soft curves which follow one another in a continuous flow. Their melody is at least

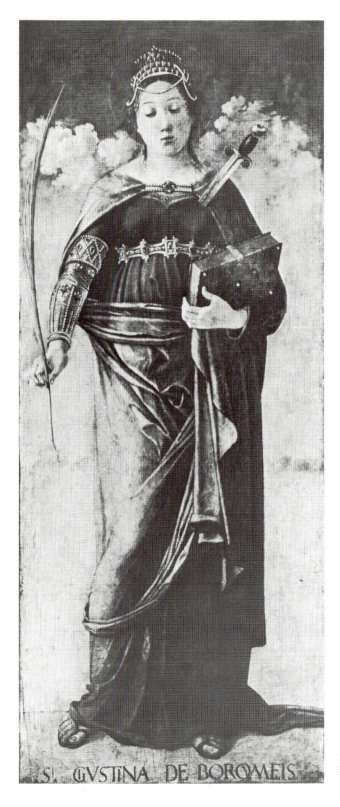

S. GVSTINA DE BOROMEIS.

16. Giovanni Bellini. *St. Justina*. Milan, Bagatti-Valsecchi Collection.

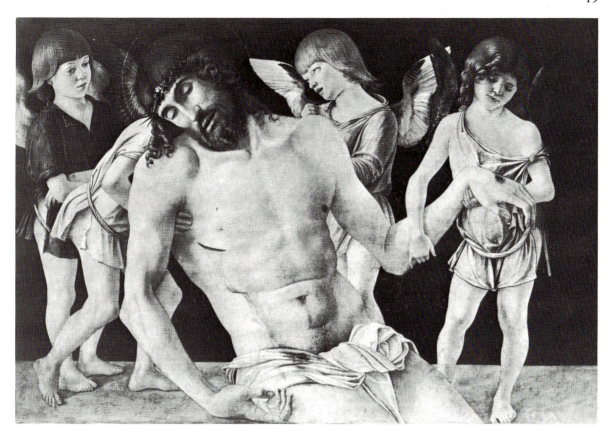

17. Giovanni Bellini. *Pietà with four Angels*. Rimini, Pinacoteca.

as important as what they say about the inner structure and the movement of form; and this melody is never-failing. The figures are natural types chosen for no reason but their beauty; the angel on the right looks like the Christ Child. The almost dolorous sadness of some of the early works has given way to serenity, to a mood of tender sympathetic contemplation. And so, form and content equally contribute to a harmony which is rich and full, for it embraces even the smallest details.

Soon afterwards one notes some further symptoms of a change in the artist's ideals. I will try to illustrate it with two pictures in Venice of the *Virgin and Child* of which the later, in the Madonna dell' Orto (Plate 19), is clearly a free replica or variation of the earlier (Plate 18), which is now in the Museo Correr. The motif of the Virgin is the same; the Child has been changed round and is larger. But, as often happens with great artists, the 'variation' has resulted in a new invention. Here it has changed the whole character of the work. There is a deliberate rounding of the forms which converts them into fuller volumes; the increase of scale in the Child also serves this purpose. The group is more compact. The drawing is less emphatic, line plays a less important

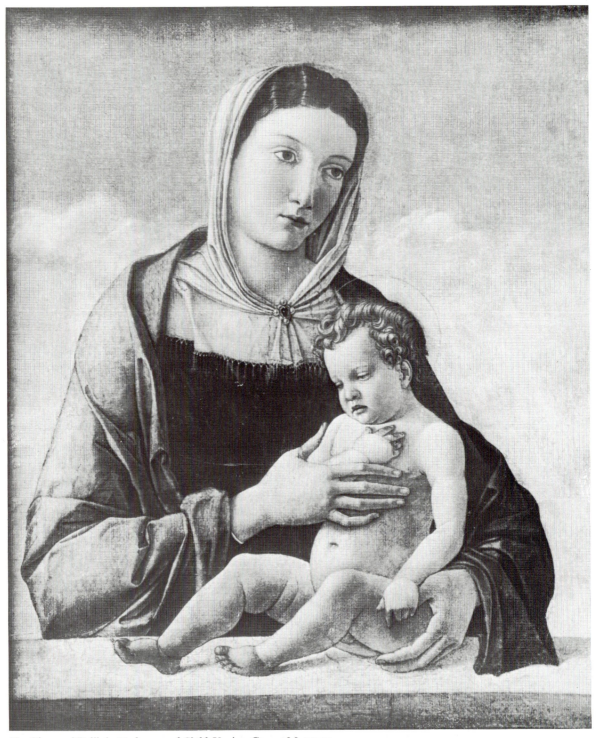

18. Giovanni Bellini. *Madonna and Child*. Venice, Correr Museum.
19 (*right*). Giovanni Bellini. *Madonna and Child*. Venice, Church of Santa Maria dell'Orto.

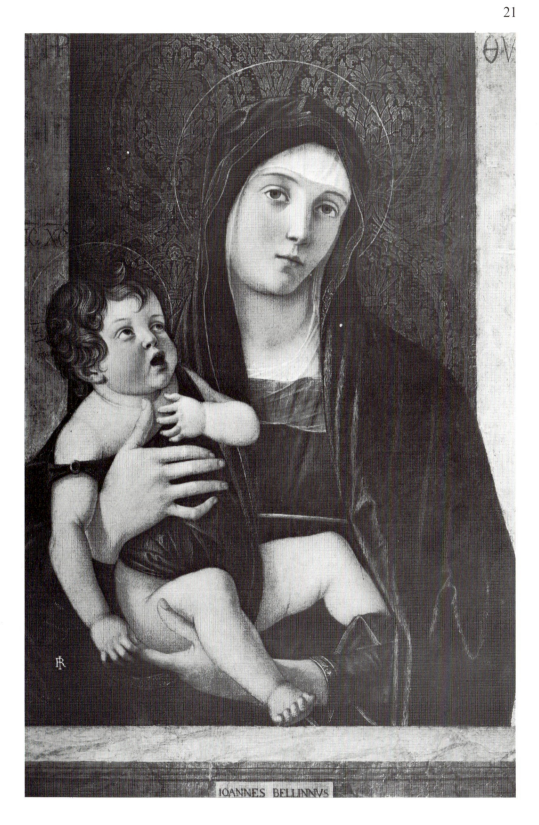

part in the structure of the whole. The more complete balance of these rounded forms is echoed in the pattern of the curtain. The change one observes in this work and in subsequent ones involved in the first place a great simplification of the forms; but it offered a new order for the eye and the mind: an order simpler and calmer, sharing the dignity of the laws of geometry.

About the middle of the 1470s Bellini began the execution of another large altarpiece, this time not for Venice but for Pesaro, a town on the coast of the Adriatic, for the high altar of the Gothic church of S. Francesco (Plate 20). Plate 21 shows the whole structure in the form in which it once stood in its place in the church; it has been deprived of its crowning section, which is now in the Vatican; the rest is in the museum at Pesaro. Bellini again chose the form of a unified *pala*, which, however, in this case is nearly square. The *pala* itself is enclosed in a carved frame; it is also the centre of a tabernacle, formed by a low base, used as a predella, two decorated pilasters, and a richly carved entablature. This structure is repeated at the top on a smaller scale, and the small tabernacle is connected with the large one by two volutes. It is worthwhile describing this frame because the whole composition of the *pala* is determined by it, or—to put it the other way round—the composition has been given the surroundings it demands, surroundings which both explain and enhance it. Painting and architecture together produce a more complete and monumental unit. We meet this emphasis on architectural forms in Bellini's work for the first time.

The subject of the central panel is the Coronation of the Virgin but it is treated as a *Sacra Conversazione* and, in accordance with the new conception of this theme, the scene is not Heaven but a terrace in, or behind, the church choir, a rather surprising iconographic innovation. Pietro Bembo, the painter's friend, once mentioned this independence of Bellini with regard to subject-matter when writing to a patron who wanted to give the artist over-exact instructions for a picture.[2] The actual conception is not without a poetic meaning: Christ's throne has become an altar of the church, and the Virgin receives a second crown in the beauty of the Earth to which she belonged. The patron saints of the church—St. Paul and St. Peter on the left, St. Francis and St. Jerome on the right—stand by as faithful paladins. Compositionally they form the link between the pillars of the tabernacle and its model, the throne. A solemn geometric order underlies the whole composition, even in its smallest details. Notice, for instance, how the scrolls of the picture-frame—an ornament in accordance with the Corinthian order of the architecture—have been replaced by an abstract, intertwined ornament on the frame of the opening in the back of the throne, that is to say, on the frame to the landscape, and how this inside ornament harmonizes with the round cherub-heads which adorn the sky. These heads are

23

20. Giovanni Bellini. *Coronation of the Virgin* (the *Pala di Pesaro*). Pesaro, Museum.

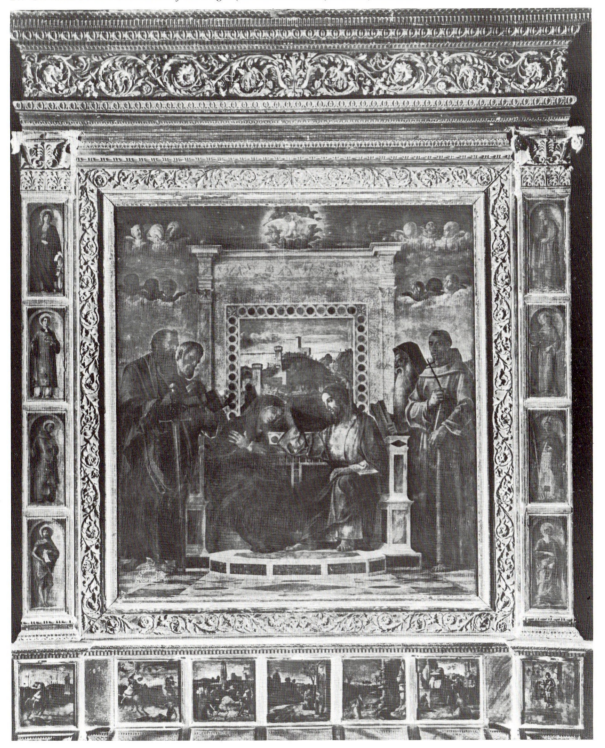

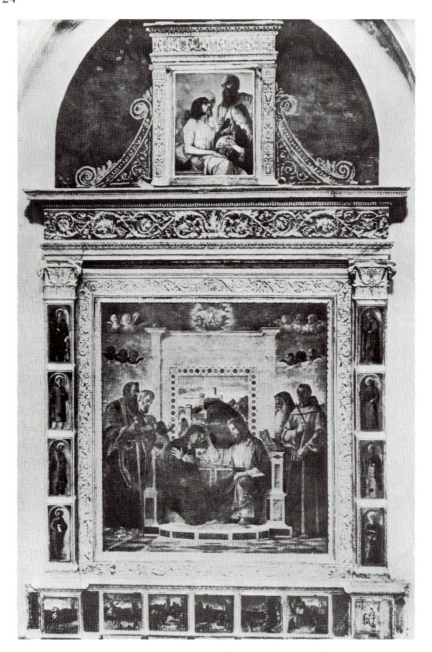

21. Reconstruction of the original state of the Pesaro altarpiece by Giovanni Bellini.

painted red and blue and are rather conspicuous. The broad volumes of the life-size figures fill the zone between the foreground of the terrace and the back of the throne, the depth of which can be measured. Then there follows a third zone, seen only in the centre through the opening in the back of the throne and constructed on identical lines.

You will see better how the figures are painted in the *Pietà* (Plate 22) which was once at the top of the altar. It shows the Redeemer attended

22 (*right*). Giovanni Bellini. *The Dead Christ with Saints.* Rome, Vatican Gallery.

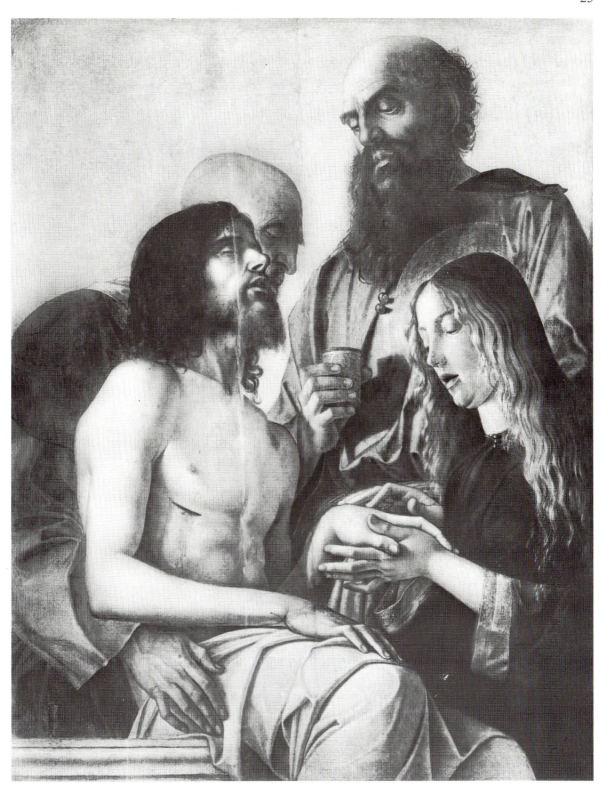

by Joseph of Arimathea, Nicodemus and Mary Magdalene; the Virgin is not present. Comparing it with the *Pietà* at Rimini (Plate 17), you will note a difference similar to that between the two Madonnas which we have just seen, but which is more distinctly shown by these two counterparts. Here the figures are not spread out; on the contrary, as deliberately as in the later Madonna, positions have been chosen which give the greatest suggestion of volume. All four figures are shown in three-quarter view, and the two in front are completely superimposed on the others. The chiaroscuro serves the same purpose: there are deep shadows and there are heavy contrasts all over the panel. In the *Pietà* at Rimini generally bright forms appeared against a dark ground; here you have the reverse; and you can note the different effect. An epitome of what the artist was striving after is the stereometric show-piece of four hands in the centre of the composition. We may recall the similar passage in the Brera *Pietà* (Plate 11).

Characteristically the altarpiece at Pesaro is the first among Bellini's larger works in which he used oil as his medium; all his previous pictures were executed in tempera. According to a seventeenth-century writer, he learnt the new technique from Antonello da Messina during the latter's stay in Venice in 1475–6.[3] We are used to taking stories of this kind told in later sources sceptically; but in this case it must be noted that there is no chronological argument against it. At any rate the state of the panels of the altarpiece proves that the painter had not yet acquired full command of the new method. Some of the colours have darkened considerably and have become almost opaque in the shadows. Instead of the previous luminosity the dominant note in this *Pietà* is a dull, rusty brown.

Here are two of the seven pictures of the predella (Plates 23 and 24); that in the centre, with the Nativity, and that next to it on the right, with St. Jerome in Penitence. We have not seen any painting by Bellini in which the landscape is predominant since his early *Agony in the Garden* (Plate 5). These modest compositions show his growing sense of a rational, that is to say visually controllable, order. He avoids fore-shortenings in the landscape as clearly as he does in the figures; and yet one receives a fuller impression of depth. The terrain is built up of distinct zones, and to penetrate to the horizon means passing through all these zones—passing through them in a zig-zag prescribed by a road, a river, or simply by the formations of the landscape which follow one behind another as in a stage-set, projecting one from the right, one from the left. This recession step by step into depth is something different from the fascinating directness, the 'fluid space' of the landscape in the *Agony in the Garden*. The unified vision of the early work has been replaced by a rational scheme. I cannot deny myself the pleasure of showing you a contemporary drawing (Plate 25). It turned up some

23. Giovanni Bellini. *Nativity* (from the predella of the Pesaro altarpiece). Pesaro, Museum.

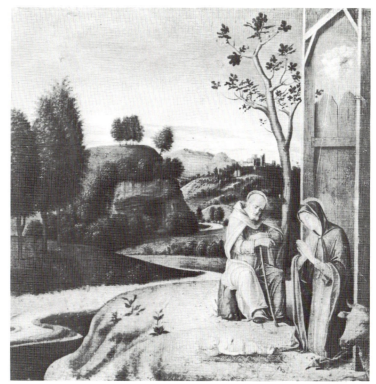

24. Giovanni Bellini. *St. Jerome in Penitence* (from the predella of the Pesaro altarpiece). Pesaro, Museum.

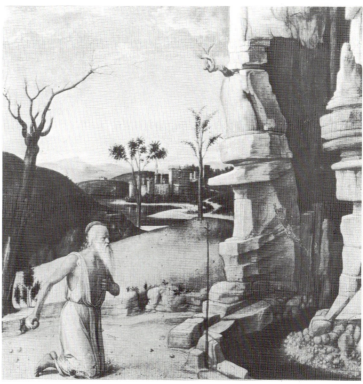

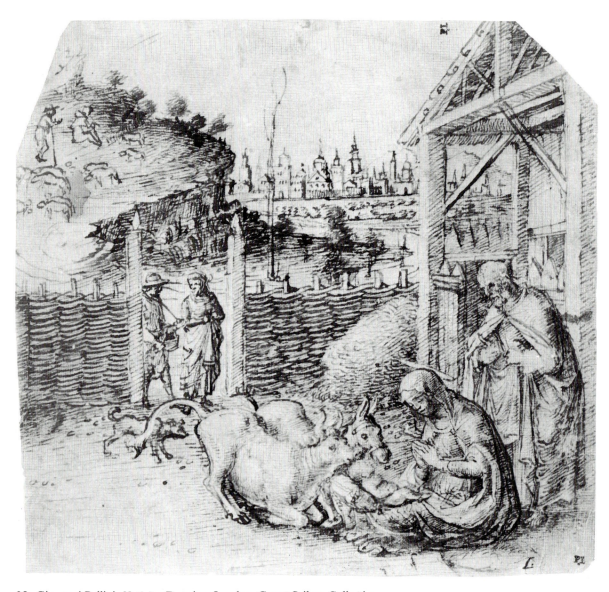

25. Giovanni Bellini. *Nativity*. Drawing. London, Count Seilern Collection.

years ago in the sale-room and is one of the very few surviving com-
position studies by Giovanni Bellini. It is simply a variant of the *Nativity*
at Pesaro and it may be the preparation for a picture of private devotion,
or a *modello* to be shown to a patron. The use of the constantly broken,
vibrating lines is Bellini's own invention; the colour and light effect
produced by this method are startling.

Once the scheme had been established, it proved easy to fill it again
with a variety of naturalistic details and to make it look 'natural' in
this way. Two of Bellini's outstanding compositions in elaborate

landscape settings belong to a period of intensive activity which followed the completion of the Pesaro altar: *St. Francis on La Verna*, in the Frick Collection at New York (Plate 26), and the *Transfiguration* in the Naples gallery (Plate 27). They are, of course, much larger than the predella panels, about four foot high each. Both are so rich and the impressions they convey are so 'natural', that it is easy to overlook the fact that underlying their compositions as a principle of order there is the scheme we have just seen in its geometrical nakedness. As for the figures, you find the same arrangement in zones as in the *Coronation of the Virgin*; and this layout as well as the preference given to the three-quarter view applies also to the landscape formations, including the clouds. This is Bellini's form of classicism that characterizes the works of the later phase of his maturity. Figures and space contribute to the solemn order of the whole; and this order is the visible expression of the nobility of sentiment vested in the content. The order is both articulate and static; it can be read easily. The painter catches the attention of the spectator's eye, as in other pictures, by placing some brightly coloured forms right in the background: they attract the eye and lead it into the picture, and our impression of depth is thus intensified. In the picture of St. Francis one has the feeling that the landscape was the main subject. This conforms with the poetic conception represented here for the first time: Nature, as God's creation, was also the subject of contemplation to the Saint who preached to the birds and composed the Song of Brother Sun. Bellini was doubtless thinking of those years which were spent by St. Francis on the rocks of La Verna in complete seclusion. His work is one of the most poetic representations in Quattrocento art.

To conclude this survey of a stylistic change—a change of both forms and ideals—let us look at the second large *pala* executed by Bellini for his native town, about twelve years after the first one, now lost. In this connection I must once more mention Antonello da Messina's visit to Venice. But first, here is Bellini's *pala* (Plate 28), now in the Academy at Venice, and the altar in the church of S. Giobbe which it once adorned (Plate 29). The church, one of the earliest Renaissance buildings in Venice, was erected in the 1470s. The altar, one of four set against the right wall of the nave, must have been designed by the architect himself, so completely does it fit into the structural and decorative system of the building. On the other hand, the architecture represented in the painting is a continuation of this system and, therefore, what is shown in the picture must have been meant to be taken as a real chapel of the church. (The shape of the *pala* was changed when it was removed from the altar.) To serve this illusion the view-point is that of the spectator, level with the bottom edge of the picture. The attendant saints are placed in the barrel-vaulted square room in front of the apse with the Virgin's

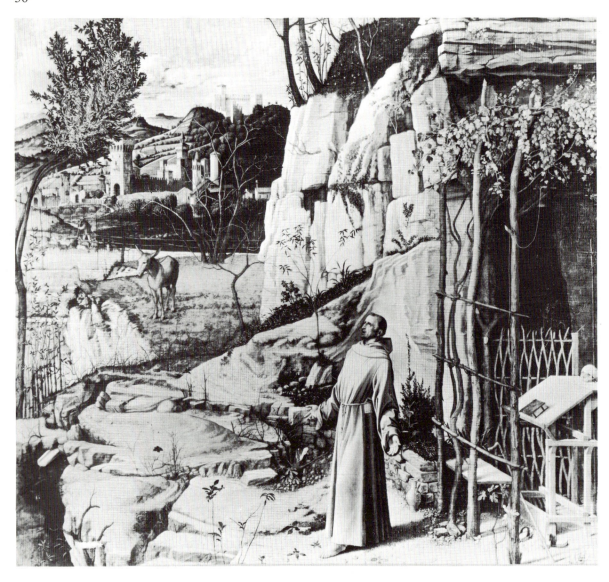

throne. Their correct spatial relations can be perceived at a glance.

This crystalline clarity of structure, this carrying through of one principle consistently, had been seen in Venice in a *Sacra Conversazione* of the same type before Bellini began his *Pala di S. Giobbe*. This was Antonello da Messina's *pala*, once in the church of S. Cassiano (Plate 30). It was cut up at the beginning of the seventeenth century and only three contiguous fragments from the central part have survived, which are now in Vienna. This reconstruction is based on these fragments and on copies of two further fragments which are lost. It is reliable as far as the figures go, except that we possess no evidence concerning the base of the throne and the little angels who in all probability were standing

26. Giovanni Bellini. *St. Francis*. New York, Frick Collection.

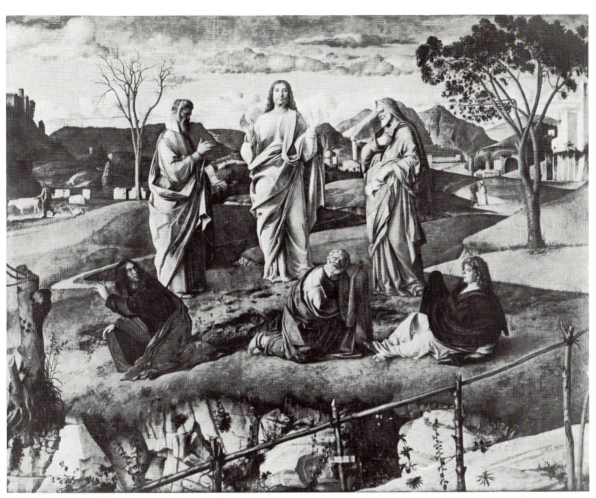

27. Giovanni Bellini.
Transfiguration. Naples,
Capodimonte Gallery.

or sitting in front of it. For the rest the reconstruction is conjectural and is based on later works which were demonstrably dependent on Antonello's altarpiece.[4] One of the earliest among these was Bellini's S. Giobbe *pala*. On the other hand I have little doubt that Antonello evolved his own scheme from Bellini's once famous *Sacra Conversazione* in SS. Giovanni e Paolo. He may also have known Piero della Francesca's Brera *pala*, which was then in Urbino, but all the constituent elements of his composition were to be found in Bellini's lost painting. What Antonello added to them of his own is precisely this extreme clarity of spatial relations, this new order based on volumes and geometrical regularity. In Antonello's work it embraces the figures as well. In his striving to make them appear round he arrived at almost spherical or hemispherical forms, at bodies shaped like a ball, an egg, a cylinder, and so on. And these additional qualities of Antonello's art are met again in Bellini's *Pala di S. Giobbe* (Plate 28), and in other works of his, datable about 1480 or later.

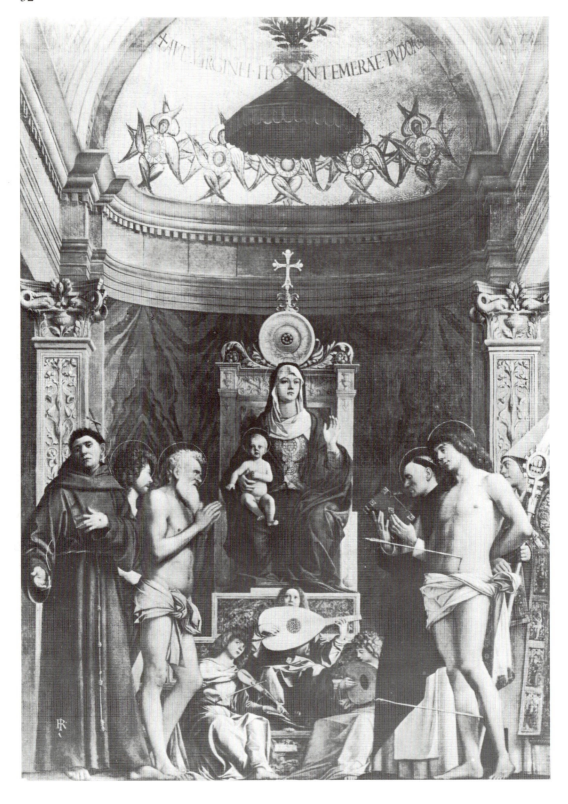

We know for certain that Antonello cannot have spent more time in Venice than the two years ending in the autumn of 1476, and that his *pala* was finished by the summer of that year. But this short period was particularly productive and it brought the ideals of the artist, as they are known to us from his earlier works, to their full realization. An impressive series of works from this period, both portraits and compositions, have been preserved. They show the same consistent figure style, and the same brilliance of colour, derived from the new technique, which was handled in a masterly way by Antonello. While he received manifold inspiration from Venetian painting—as in the case of his principal work where the composition type is derived from Bellini—he had also something to offer in exchange. One can observe a far-reaching influence of Antonello's works in Venice during the decade or two succeeding his visit to the town. The reaction of Giovanni Bellini, the greatest artist of the school and probably junior to his Sicilian colleague by only a few years, is typical of this influence. We recognize it in the altarpiece not only in the spaciousness and the lucidity of the general layout, but also in some of the figures; that of St. Dominic, for instance, is simply a replica of Antonello's corresponding figure. But more important than this: all the figures, the naked as well as the draped, have been still more simplified and reveal the same tendency towards cylindrical forms. Further, the colour has become transparent again, and a soft light falls on all the forms, figures and architecture alike.

And so the meeting between these two great artists was remarkably fruitful. In his efforts to reach a style based on volume instead of line Bellini was supported by the mature examples of Antonello's congenial art.

I have already discussed a selection of Giovanni Bellini's early works and some of those of the first period of his maturity, and I tried to point out the changes of forms and ideals revealed in the latter. To remind you of these two phases of Bellini's development, I add one more example of each. Both these pictures are in the Gallery at Bergamo and both are in almost perfect condition.

In the first period Bellini's style was, as far as form is concerned, determined by a characteristic style of drawing. He evolved this drawing from two roots: the decorative late-Gothic art of his father Jacopo Bellini, and the realistic and structural linearism of his brother-in-law Mantegna. By the end of the period to which the smaller picture belongs (Plate 31), about 1470, Giovanni's drawing had become a very flexible instrument: it allowed him to give a consistent texture to the whole picture-space, and to preserve the unity of the surface over which the forms are extended, without suppressing the three-dimensional character of the objects rendered in the picture. The Child moves diagonally across the panel; this movement is repeated in the folds of the Virgin's

28 (*left*). Giovanni Bellini. *Madonna Enthroned with six Saints* (the San Giobbe altarpiece). Venice, Accademia.

29. The original frame of the San Giobbe altarpiece. Venice, church of San Giobbe.

mantle and is answered by the pattern of the marbling—thus connecting two planes which are at right angles to one another. Bellini's colour, which was mainly expressive at the beginning, has become a vehicle of light and a means of modelling. The surface shines; here, for instance, the light-blue garment is enlivened by parallel strokes of pure gold—a Byzantine inheritance used by Bellini for a purely artistic effect.

In Bellini's second period a different visual order prevails: it is based on volume, not line. In the larger picture at Bergamo the group is placed between two vertical planes (Plate 32), the parapet and the curtain; and the clearly defined spatial zone between these two planes is filled with the volumes of the two figures. More distant planes follow: sections

30. Reconstruction by Wilde of the San Cassiano altarpiece by Antonello da Messina.

of the landscape, and the sky with driving clouds. The eye, caught by the nearest plane, the reddish-brown parapet with its white *trompe-l'oeil cartellino*, easily follows this recession. It is helped by modelling in shadow and by the shadows cast by the figures on the next plane. This enchanting play of light and dark stops nowhere. Its medium is a

range of simple and very beautiful colours: a rose and a dark-red, a light and a deep blue, warm green, and, on a few points of concentration, a brilliant white. This is the palette of Bellini's classic period; it is as harmonious as his selection of spherical and hemispherical forms.

The second Bergamo *Madonna* dates from the mid-1480s—Bellini was just about fifty when he painted it. There followed three of his best-known masterpieces, the first of his works which he not only signed but also dated. I leave out the *Madonna degli Alberetti* of 1487 in the Venetian Academy, because it is a ruin, and turn to the two larger works, both dated 1488: the altarpiece in the Frari and the votive picture of Doge Barbarigo at Murano.

The triptych still stands on the altar where it was erected, in the polygonal apse of the sacristy of the Frari (Plate 33), a small Gothic room of perfect proportions. The altar-frame, quite untouched, is the best remaining example of Renaissance wood-carving in Venice. It is perhaps not correct to speak of a frame in this case, for pictures and frame are inseparable; the altarpiece is one work, partly carved, partly painted, and its unity both in colour and design is complete. Like the tabernacle of the Pesaro altar, this tripartite whole corresponds to a classical form often used in Venetian architecture (for instance in monumental wall-tombs); and it is equally true to say either that the figure composition produced this form or that it is homogeneous with this form. The steep pyramid of the central group reaches the cornice of the entablature; the two principal saints, Nicolas and Benedict, stand like broader piers between the pillars which enclose them. Above them the crowning motif of the candelabra and above the arch a high vase form a whole attic of ornaments to echo the structure. The picture space does not appear to be detached from a façade of a different order of reality: the viewpoint is again that of the spectator—in the case of a small altar such as this, it is high enough for the floor to be seen—and it is taken at a considerable distance to avoid startling foreshortenings. Where a conspicuous perspective effect occurs, at the top centre, the gold of the carving is directly continued in the painted gold-mosaic of the barrel-vault and of the semi-cupola. The figure style is that of the second Bergamo *Madonna*. As characters, these calm, contemplative saints are all members of the same family: St. Benedict is turned to the worshipper only to listen to his prayer attentively and to recommend it to the Child. When Dürer, fascinated by Bellini's prototype, painted his *Four Apostles* nearly forty years later, he transformed these figures into representatives of the four temperaments.

The second work dated 1488 (Plate 34), is the picture in Murano which is fairly large, ten and a half feet wide, and is the first canvas we meet in Giovanni's work. This type of official votive picture—the Doge recommended by his patron saints to the Child and the Virgin—is well

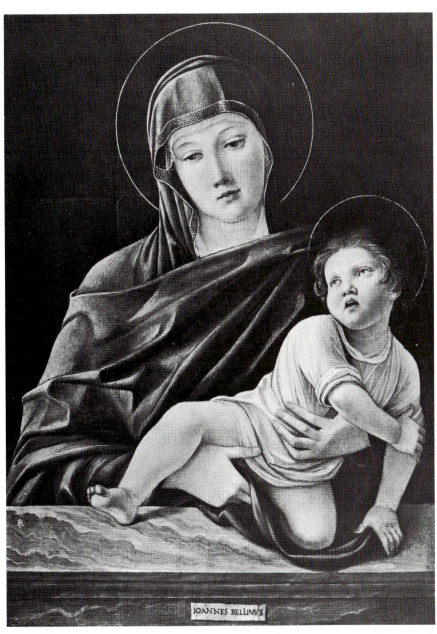

IOANNES BELLINVS

31. Giovanni Bellini.
Madonna and Child.
Bergamo, Accademia
Carrara.

known to us from later examples, but there must also have existed earlier ones. One that has survived (Plate 35) (it is in the National Gallery) was commissioned by Doge Giovanni Mocenigo, the last Doge but one before Barbarigo, elected in 1478, so that the painting is only a few years earlier than Bellini's canvas. Bellini's innovations need not be emphasized—indeed, the artless scheme of his predecessor has been transformed in his work into a structure no less impressive than that of the Frari triptych. You can find many other links with the

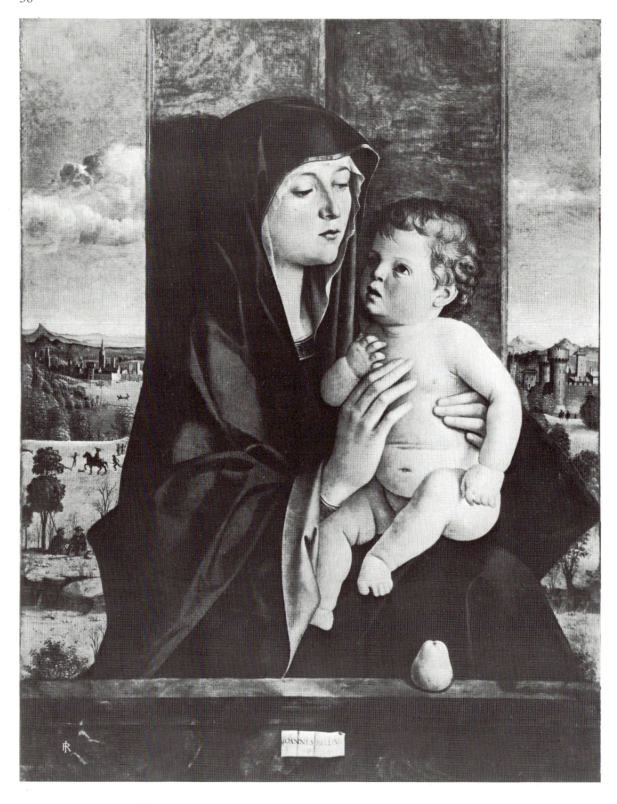

32 (*left*). Giovanni Bellini. *Madonna and Child.* Bergamo, Accademia Carrara.

33. Giovanni Bellini. *Triptych with Madonna and Saints.* Venice, Sacristy of the Basilica of Sta. Maria Gloriosa dei Frari.

masterpieces of the preceding twelve years, that is to say since the Pesaro altar: the central pyramid, so much broadened here that its base reaches the edge on one side and includes the figure of the kneeling Doge as an inside repetition of the larger form; the 'wings' in the form of broad single figures (the lively ornament of the pairs of cherubs indicates the articulation of a triptych); the curtain motif of the Madonna compositions is here repeated twice, and the function of modelling and shadows intensified; finally the terrace motif. In point of fact, the

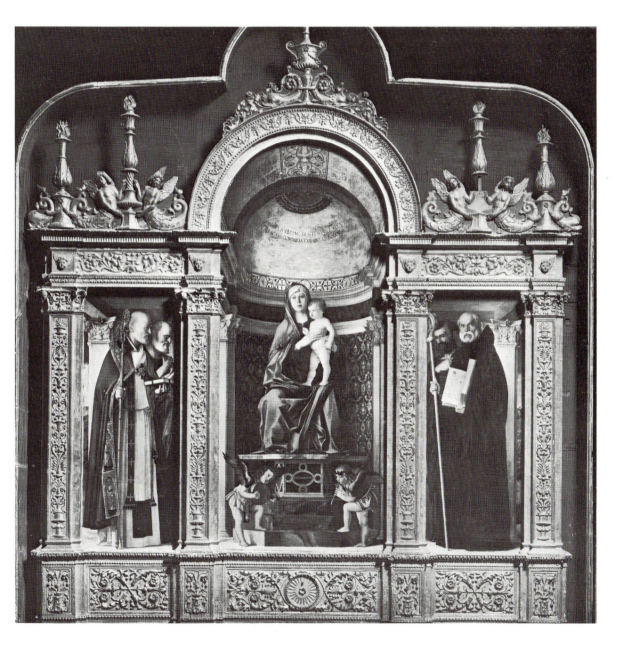

landscape of the *Pala di Pesaro* (Plate 20) has been repeated on the right, enriched with some pleasant details; like the dark mass of shrubbery on the left, it adds a further zone to the composition. At the same time these extensions lay greater emphasis on the surface, and so this second period of Bellini's development appears to end where the first ended: in a reconciliation of the new formal means, the rounded volume, to the plane, which is the prime agent of all pictorial thinking in Venice. This reveals itself also in the execution of some smaller units: the distribution of light and shade on the angel's head is no longer so continuous and the forms are noticeably flattened; the texture of the canvas increases this effect (Plate 36). The handling is freer; in passages such as the hair one perceives the strokes before seeing the modelling which they produce.

We know very little about the activity of Giovanni Bellini during the last decade of the century, the years which his best pupil, Giorgione, spent as an apprentice and perhaps as a young assistant in his studio. Bellini seems to have been mainly working on large histories for the Ducal Palace, which are lost. No dated pictures survive and only a few can be placed in this decade on the evidence of style. The most important among them is the *Sacred Allegory* (Plate 37) in the Uffizi. The panel is about four feet wide; it has been cut at the top (originally the peak of the mountain was to be seen and a small strip of sky above it). This religious allegory is doubtless based on a text, but the content is the artist's: it is a representation of the blissful calm and motionless silence of Eden, or to use a Renaissance term, of the Christian Elysium. Calm is also inherent in the forms: almost all the figures are seen either from the front or in clear profile, and almost all other forms have been arranged parallel to the picture plane. Very little remains of the stage-set, alternating in a zig-zag of forms which built up Bellini's earlier landscapes; nevertheless, through the parallel zones, distinguished one from another by slight modifications of tone, a slow recession is achieved, offering us homely sights that make this religious allegory a panorama of our world.

One can enjoy this bright *plein-air* effect more fully in a set of five small pictures, each about a foot high, which originally were parts of some piece of furniture, perhaps of a stand for toilet utensils (Plates 38, 39). Probably in this case, too, the allegories were based on texts. One of them seems to represent the antithesis of Virtue and Vice in some qualified form. It is very much like the picture in the Uffizi; but, here as well as in its counterpart, the landscape has been brought very near to the figures (Plate 39): it is hardly more than a coloured foil behind them. Nor can one speak in this case of volumes any longer—at least not in the sense of the measurable ones of the previous decade. However, these almost impressionist abbreviations of form could not have been

34 (*right*). Giovanni Bellini. *Doge Agostino Barbarigo before the Virgin*. Murano, Church of San Pietro Martire.

35 (*right*). Venetian School. *Doge Giovanni Mocenigo before the Virgin*. London, National Gallery.

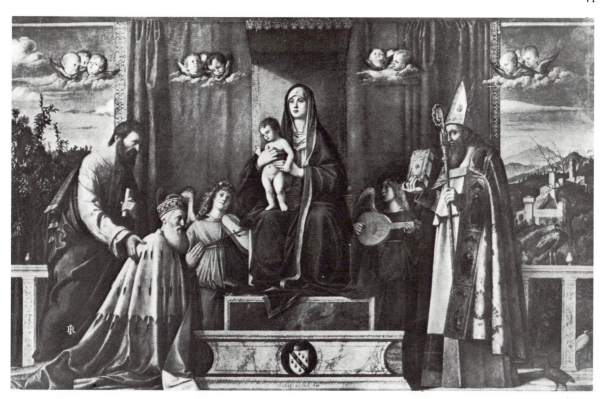

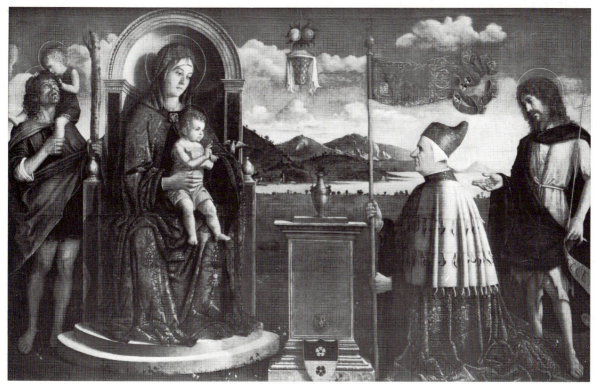

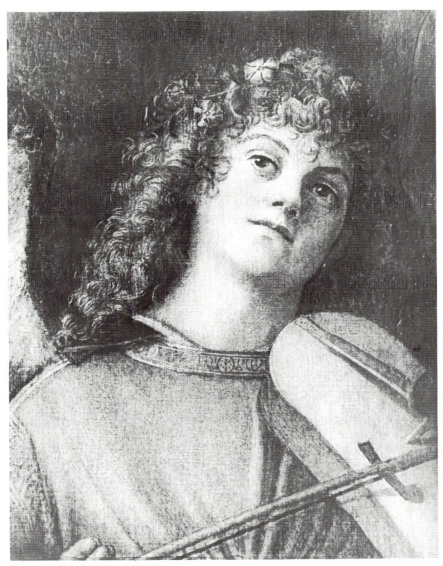

36. Detail of plate 34.

found without Bellini's prolonged studies in plastic effects, realized first in angular forms and firm drawing and later in round volumes and a consistent modelling in light and shade.

At the turn of the century, in the years when the young Titian was apprenticed to him, Bellini's position among artists was still unchanged. Dürer's judgement of 1506 on the septuagenarian—that 'though he is old he is still the best in painting'—was certainly shared by all his Venetian colleagues. For the most important fact concerning this last period of Bellini's career is that he evolved a real late style—a style which in a way was also up to date, that is to say was in step with the

general development of Italian painting. This applies to him alone of all the members of his generation. I shall try to illustrate this with a small selection of his late works.

The altarpiece of the *Baptism of Christ* in the Gothic church of S. Corona at Vicenza (Plate 40), was painted in the first years of the new century; it commemorates a pilgrimage to the Holy Land undertaken by one of the citizens of Vicenza. The central figure shows an attempt at classical *contrapposto*—it can be profitably compared with the somewhat timid nudes of Perugino, Bellini's contemporary in Central Italy, with their simple outlines. The action of St. John the Baptist has, like all representations of movement by Bellini, something of that unreal duration which is known to us from slow-motion pictures. But these two figures, as well as the angels in the rich folds of their garments and the forms of the landscape, contribute to the building up of a very rich surface pattern, which was to become one of the main qualities of the new Venetian painting. Its elements are different colours of equal intensity, with no vacuum left between them. One cannot properly speak of zones of depth in this case: the landscape is not a measurable space in which the figures are placed, nor are the mountains pyramids or cones. Their flat forms are piled up, right up to the line on which the semicircle of the sky rests, forming a background full of colour, and

37. Giovanni Bellini. *Sacred Allegory*. Florence, Uffizi.

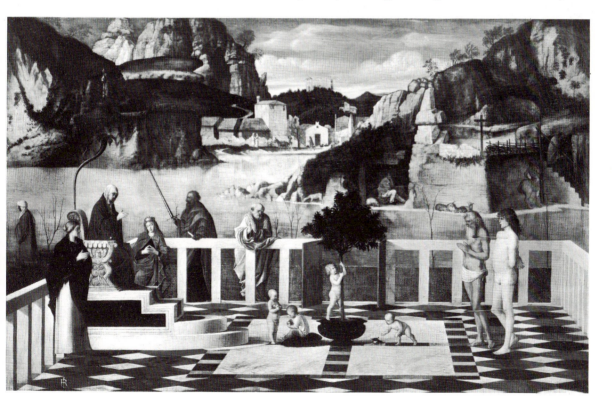

38. Giovanni Bellini. *Allegory*. Venice, Accademia.

yet in its function not entirely unlike the gold ground in Byzantine mosaics.

This virtual equation of figure and surroundings, of foreground and background, established by means of colour, was, as I have said, an innovation of far-reaching effect. The altarpiece in S. Zaccaria in Venice is dated 1505 (Plate 41). It contains seven nearly life-size figures; five are seen squarely from the front, two—and these are links between the

39. Giovanni Bellini.
Allegory. Venice,
Accademia.

sections of the tripartite composition—are seen in profile; that is to
say, even more clearly than in the *Baptism* all the figures have been
arranged parallel to the picture plane. They are considerably broadened
by their draperies, that is to say by forms which are merely optical or
visual supports, and which make for a unified surface; notice how the
garments of the two main saints merge into those of their neighbours.
The architecture, though still of the same system as in earlier composi-

tions of this type (that is to say, continuing the real architecture of the altar-frame), is seen in a perspective which makes the half-cylinder of the apse appear as a shallow niche owing to the great distance from which it is viewed. The viewpoint has also been raised well above the spectator's level, and thus the representation has lost its illusionistic effect: it has become something objective. Symmetry and a regular alternation of bright and dark colours prevail in the whole. All these qualities make this reunion of saints timeless. There are few pictures in Venice in which the classical ideal of a pure and calm existence is as fully realized as here. The detail (Plate 42) shows how far Bellini has moved towards replacing his 'material' chiaroscuro—the means by which he constituted the solids in his works in the 1480s—by tone-values of pure colour.

As an example of Bellini's late Madonnas, we may look at the one of 1510 in the Brera (Plate 43). The format of this picture is remarkable, an oblong instead of the upright rectangle of all Bellini's earlier Madonna compositions. As the painter is not keeping any longer to measurable volumes—to the forms which were the essence of those earlier compositions—the space has been shaped anew. The picture is a kind of triptych in small—it is, in the words of an Italian writer, a 'Sacra Conversazione from which the Saints have departed'. But the wings, that is to say the sections of landscape, are not ends in themselves: they give support to the central mass and enhance its significance. They contain horizontal forms where such forms are needed; the slopes of the mountain repeat the general outline of the centre; the trees emphasize the upright axis. In this way a well-knit texture of forms has been expanded over the tripartite whole: the parts are inseparable from one another and have an equal share in producing the general effect. The colour no longer really serves to differentiate the objects: you find the green of the landscape also on the curtain, the blue of the mantle also in the sky, and the rose of the faces is echoed in the tints of the Virgin's dress. Most of these are brilliant colours, and their selection is representative of the total spectrum.

Titian's early *Gipsy Madonna* (Plate 95) offers a comparison to this work—a comparison that would lead us right to the centre of the problem of classic art in Venice, as would an examination of the two altarpieces we have just seen. Indeed most of the works created by Bellini in the first decade of the sixteenth century were immediate and important factors in the further development of painting in Venice. This does not apply in the same sense to the products of his last years. These, although their intrinsic beauty is no less great, and although they do not reveal any decline in the creative powers of the octogenarian, are more individualistic and more subjective. Let us look at some of them.

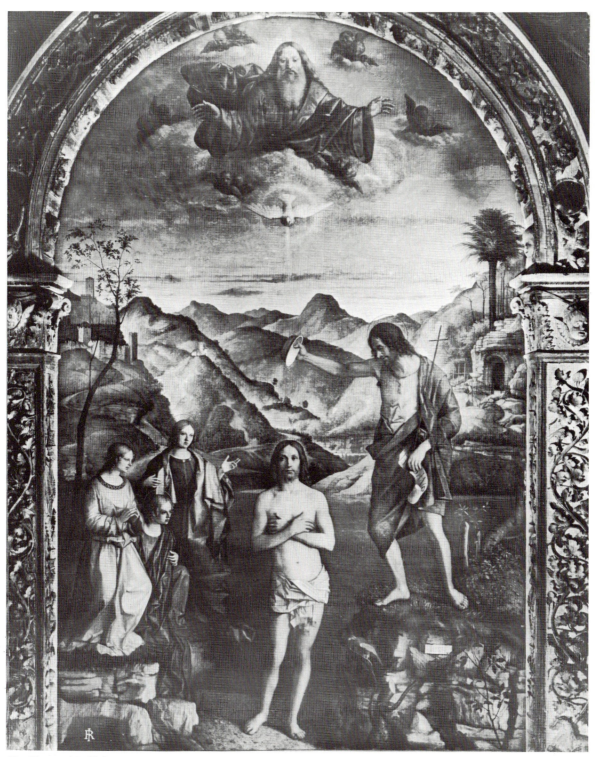

40. Giovanni Bellini. *Baptism of Christ*. Vicenza Cathedral.

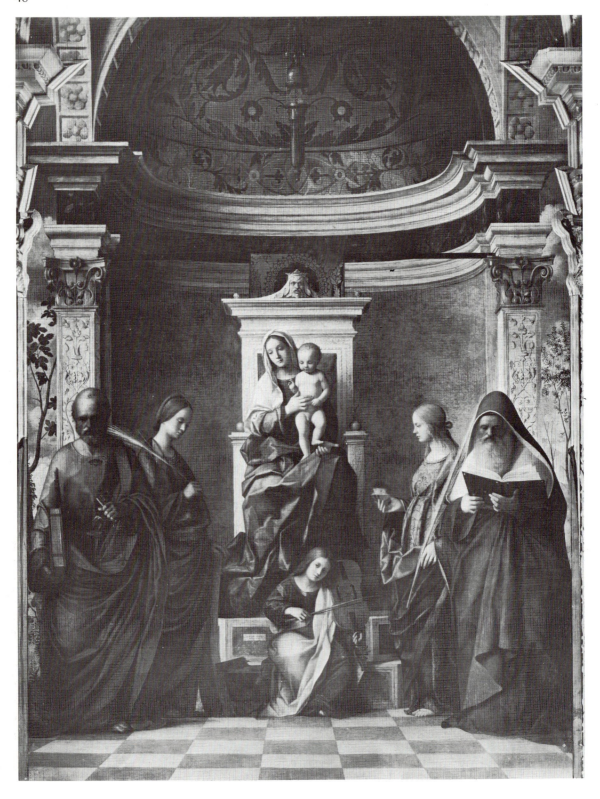

41 (*left*). Giovanni Bellini. *Madonna and Child with four Saints* (the *Pala di San Zaccaria*). Venice, Church of San Zaccaria.

42. Detail of plate 41.

The *pala* (Plate 44) which stands on one of the side-altars of the small Renaissance church of S. Giovanni Crisostomo in Venice is dated 1513. The chapel is narrow and just deep enough to leave room for a small side-window. The artist has repeated this form in the arch and has used the natural light as lighting in the picture. So much has remained of the traditional definition of the place of the *Sacra Conversazione*. The arch is closed by a low parapet, similar to that of the chapel entrance, and is open above the parapet. Behind it there is a high pedestal of rocks on which St. Jerome, who has taken the Virgin's place, is seated; and there is also a landscape similar to that in the *Baptism* (Plate 40).

The attendant saints, St. Christopher and St. Louis, stand under the arch and before the parapet. Thus the single construction has again become remarkably tectonic and is in complete harmony with the noble forms of the Renaissance church. Bellini seems to have turned back to the ideal of his maturity, giving to the attendant figures the same full volumes as in his *Pala di S. Giobbe* of the 1480s (Plate 28): they once more look like piers supporting an arch; even the forms within the semicircle are more plastic. However, on these convex surfaces the artist freely displays the mastery of his brush and the richness of his palette: faces, draperies, carved stone, rocks and tree—all are painted with the same delicacy which you find in the Loredan bust in the National Gallery, and have the same still-life quality; and this homogeneity of handling counterbalances the plastic effect of the forms. A black-and-white reproduction reveals very little of this harmony.

In 1514 Bellini finished a large canvas representing a *Bacchanal* for the so-called Alabaster Chamber in the castle of Ferrara (Plate 45). I say finished, for Vasari's story that, because of his age, Bellini left the picture unfinished and that the young Titian was called in to complete

43. Giovanni Bellini. *Madonna and Child*. Milan, Brera.

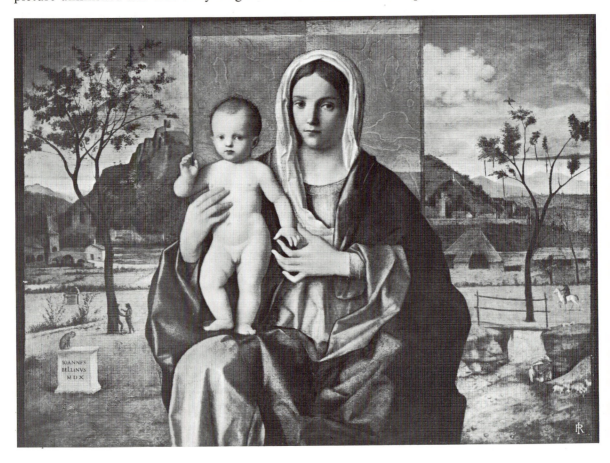

it, is obviously a wrong explanation of a peculiarity of the picture as it was known to Vasari and is known to us today. Clearly, in this painting, which is now in the National Gallery, Washington, only the figure group and the foreground are Bellini's work, while nearly the whole of the landscape, that is to say more than half the surface, is Titian's. However, we know that Bellini received the full payment for his work two years before his death, and this means that the picture was completed by that time. Accordingly, he set his signature on a *cartellino* with that date. What really happened is probably this: when the decoration of the room was finished, the patron, Alfonso d'Este, found that Bellini's contribution did not harmonize with the rest of the series, pictures of the same size and of similar subjects by Titian and the young Ferrarese artist Dosso Dossi; and he asked Titian to put this right. Titian solved the task by painting out Bellini's landscape (what the latter probably looked like can best be seen in his contemporary *St. Peter Martyr* in the National Gallery, London (Plate 46)) and by replacing it with a landscape of his own invention, a landscape full of life, vigour and movement, as fully in harmony with his own compositions in the room as it is in contrast to Bellini's. X-ray photographs of the Washington picture confirm this explanation.[5] The story throws a sharp light on the historical position of Bellini's latest works. Most of his figures are motionless, like objects in a still-life, and are surrounded by proper still-life motives (one is reminded of Vermeer). They are of non-classical proportions, and their draperies reminded Vasari of Dürer. Their frozen state was the condition of their all-important co-ordination in one plane. This restricted geometry was no longer acceptable, but, characteristically, Poussin liked this picture and made a copy of it, now in Edinburgh.

This painting in Vienna (Plate 47) dates from 1515, the year before Bellini's death. If Jacob Burckhardt's assumption is right, it is a portrait mentioned by Vasari as that of an *innamorata* of the humanist Pietro Bembo. But it is as little particularized as any likeness of a human being can be, and Bembo's poetic praise of the work of which Vasari speaks, the verse *O imagine mia celeste e pura*, would apply to it in any case. It is a panel two feet high and of a similar format to Bellini's late Madonnas (on the right a strip of two inches has been cut off). The background behind the figure is not a curtain: it is a green wall, or something of the sort, of the same green as the landscape but just a little darker. Similarly, the nude is almost as white as the clouds in the pale-blue sky. Further, the pattern of the hair-net is green on a blue ground. The drapery is pale rose. These four colours are shown in horizontal strips, one above the other on the left; they also recur in darker tones in the carpet on the right. Painters know the difficulty of combining green, blue and rose to a harmonious effect. Velasquez

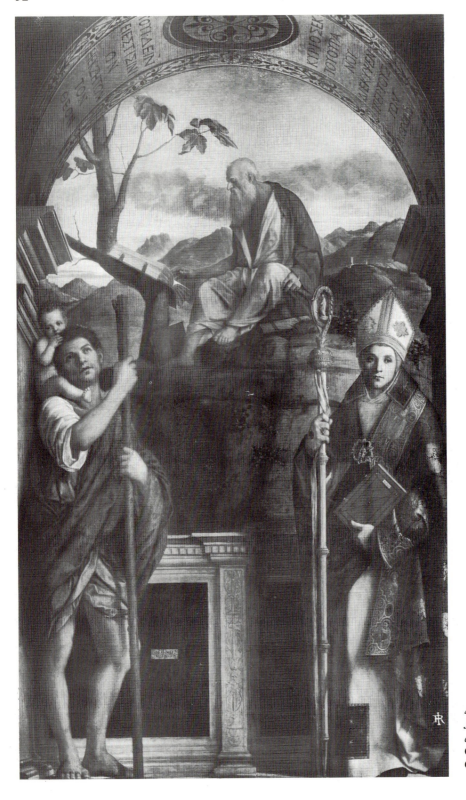

44. Giovanni Bellini. *St. Jerome with St. Christopher and St. Louis*. Venice, Church of San Giovanni Crisostomo.

ventured on it once or twice; then French painters of the eighteenth century; and, of course, the Impressionists, most of all Renoir. In Bellini's picture these colours indicate planes of more or less regular shapes; their relation to one another is much the same as in Poussin's *Self-portrait* in the Louvre, and is the main artistic content. But this abstraction has not harmed the beauty of the invention—an invention that was as new in its period as the form in which it was realized.

Of the same year is the moving *Portrait of a Dominican* in the National Gallery (Plate 48). It is a canvas. It shows another unusual and bold colour combination: yellow, green and vermilion, with the addition of

45. Giovanni Bellini. *Bacchanal*. Washington, National Gallery.

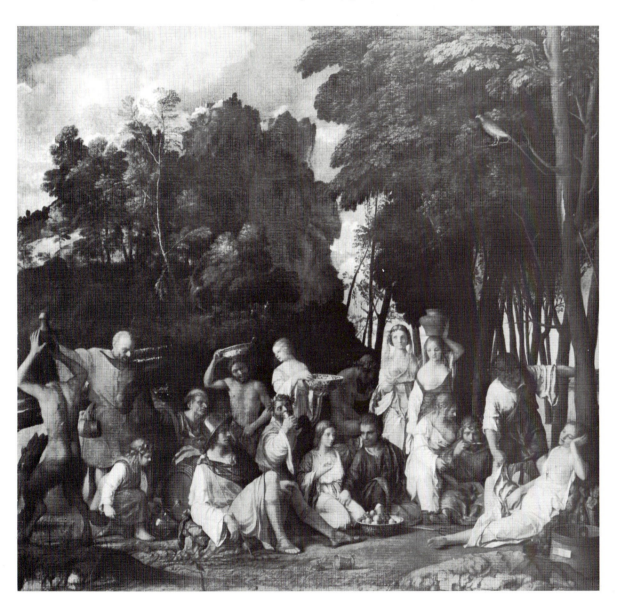

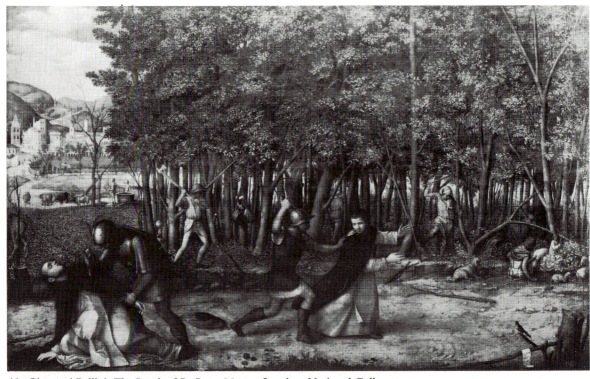

46. Giovanni Bellini. *The Death of St. Peter Martyr*. London, National Gallery.

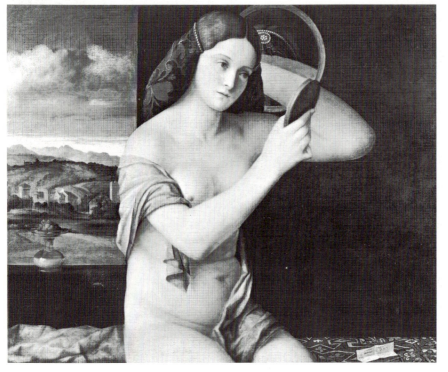

47. Giovanni Bellini. *Lady at her Toilet*. Vienna, Kunsthistorisches Museum.

48 (*right*). Giovanni Bellini. *Portrait of a Dominican*. London, National Gallery.

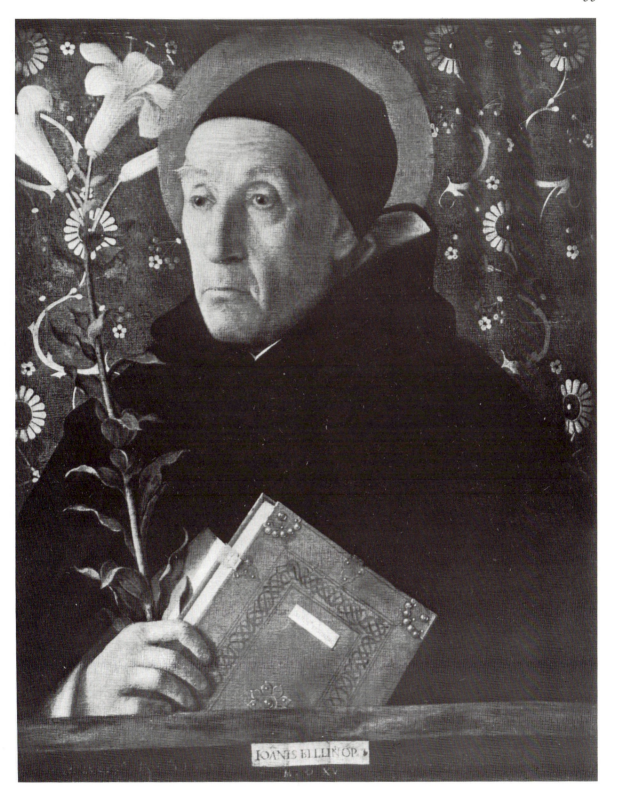

IOANIS BELLINÖP.

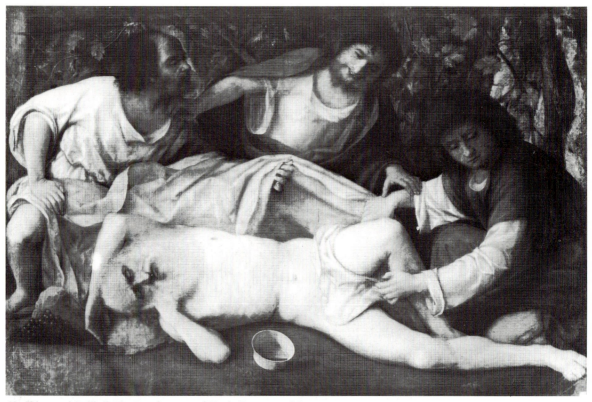

49. Giovanni Bellini. *The Drunkenness of Noah*. Besançon, Museum.

black and white used as positive colours—all five of equal intensity. Both the combination and the intensity are well known to us from Post-Impressionist art—more than one picture by Gauguin could be directly compared with it. But this portrait is also a last word of wisdom on how to render a character.

Another work, perhaps still later than these two, is, I think, even more surprising. In this *Drunkenness of Noah* in the Museum at Besançon (Plate 49) the balance has been tipped—tipped heavily—to the side of the subject, or content. For it is a work of an extraordinary expressive power, and its forms are determined by the intention of conveying this. The proportions are wilful, the types rather ugly, the drawing is of studied simplicity, or primitiveness; and there are only two colours: red and olive. The red, poured over nearly the whole width of the canvas, is the deep and yet transparent red of Italian wine; the olive tends softly towards green in one direction, towards warm brown in the other. The picture space appears densely filled by this movement of colour, but the composition is calm and is possessed by the intensity and symbolism of the sacred narrative.

There is no Madonna executed in this latest style. I conclude my short

survey of Bellini's activity by showing you his earliest and his latest representation of the *Man of Sorrows*, one in the Poldi-Pezzoli Collection at Milan (Plate 50), the other at Stockholm (Plate 51). Although they are separated in his *œuvre* by the distance of more than half a century, the identity of the artistic personality—of imagination and intellect, of taste and character—that stands behind them is, it would seem to me, unmistakably felt.

50. Giovanni Bellini. *Man of Sorrows*. Milan, Poldi-Pezzoli Museum.

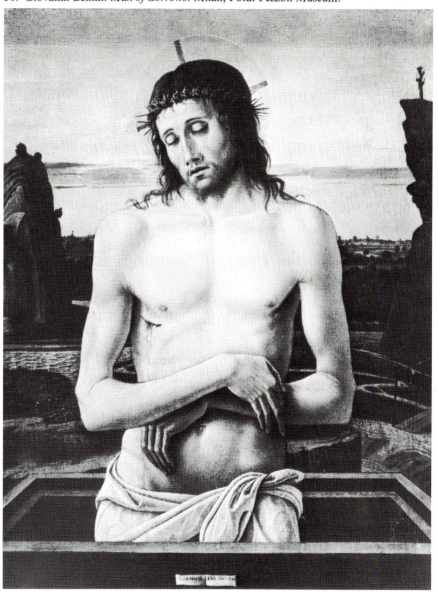

58

51. Giovanni Bellini. *Man of Sorrows*. Stockholm, National Gallery.

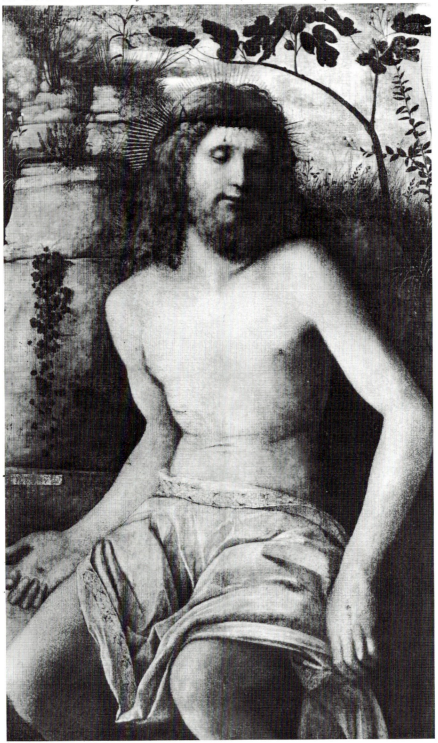

The early phase of Giorgione

EVEN a very summary survey of Giovanni Bellini's career must take note of his activity as a teacher. It began early and lasted to the end of his life. The significance of the two other important Venetian studios had expired by the turn of the century. One was the workshop of the Vivarini in Murano, then led by Antonio's son Alvise Vivarini; there the students learned Antonello da Messina's forms which, surprisingly, had become in Alvise's interpretation sharper and were therefore soon out of date. Gentile Bellini, too, had a large studio and many assistants. His studio specialized in those particularly Venetian narrative cycles which the lay confraternities wanted for their *Scuole*—paintings, of events in the histories of saints, told as if they had been episodes in the life of the Republic with an extensive and explicit representation of actual buildings, streets, lagoons and landscape, paintings full of charming details and of high colouristic quality, but, as is so often the case with provincial efforts, showing an inspiration of limited duration. We see this clearly in the later works of Gentile's pupil Carpaccio. In Giovanni's studio by contrast one generation of students followed another in an uninterrupted sequence, and all participated to some extent in his universalism. Many came from the newly won provinces of the *terra ferma* and later became heads of local schools.

One generation of Giovanni's pupils is of a special significance. Vincenzo Catena, Giorgione, Palma Vecchio, Lorenzo Lotto, all born in the late 1470s, belonged to it. Orthodox at the beginning, these artists widened their horizon by studying models outside Venice, and this paved the way for a new generation which was to follow soon and through which Venetian painting definitely left the status of a provincial school.

Considering the activity of Giorgione and studying the works ascribed to him, one sadly notices the lack of biographical sources in Venice. Vasari's *Vita* leaves the reader dissatisfied. He was well informed about the historical position of Giorgione and placed his biography next to Leonardo's; he reports a few facts of the artist's life (that he came to Venice from a humble family of the *terra ferma*; that he was a pupil of Giovanni Bellini; and that he had a reputation as a musician); and Vasari was deeply impressed by, and vividly recorded his impression

of, Giorgione's outstanding work in public, the façade decoration of the Fondaco de' Tedeschi. But otherwise his list of works is sparse and confusing. In the first edition it consists of five items. Two of these works are lost; the remaining three are demonstrably by other masters, indeed by three different masters. In his second edition Vasari listed eight more works, all but one portraits and all but one unidentifiable or lost. The conclusion is that Vasari's interest in the subject was not very great and, further, that already a few decades after Giorgione's death it was impossible to obtain an adequate picture of his activity without making special efforts.

As for primary sources, we possess only six documents concerning Giorgione. Three refer to a large canvas, painted by him between August 1507 and May 1508 for the presence chamber of the Council of Ten, the most powerful body of the Republic. Strangely enough, we never hear again of the work produced on such an important commission. Two documents record the payment for the façade frescoes of the Fondaco de' Tedeschi, which were finished by November 1508. The last document is an inscription of 1506 on the back of one of Giorgione's pictures. Besides these documents we also have two letters written immediately after Giorgione's death. They are rather informative, and I should like to quote from the second which also contains an extract from the first. The letter is addressed to the Marchioness Isabella d'Este by the Mantuan agent in Venice, and is dated 7 November 1510. It reads:

> I have noted what your Excellency writes to me in your letter of the 25th of last month, informing me that you have heard that a picture of Night [i.e. the Nativity], very beautiful and characteristic, has been found among the effects left by Zorzo de Castelfrancho, and that, if this is so, you wish to inspect and acquire it. To this I reply that the said Zorzo died a few days ago of the plague; and wishing to be of service to you, I have spoken to some of my friends who were well acquainted with him. They assure me that no such picture is among his effects. Although it is true that the said Zorzo made such a picture for Thadeo Contarini, this, from the information I have received, is not so finished as you would wish. The said Zorzo made another picture of Night for one Victorio Becharo; this is, as I learn, of better design and is better finished than that belonging to Contarini. But as Becharo is not in these parts at present, and as, according to my information, neither the one nor the other is to be sold at any price, for they were commissioned for the enjoyment of their owners, I regret that I am unable to satisfy your request.

We learn from this letter the date of Giorgione's death: shortly before 25 October 1510. (According to contemporary records the plague became fierce in Venice in the second half of September.) We do not know precisely how old he then was, but all available evidence suggests that he was in his early thirties. The letter also shows that he was already an artist of high repute, not only in Venice; that he had many friends and worked for a new type of patron, the private collector; and that there existed two representations of the *Nativity* by him; but the later fate of these pictures cannot be traced.

Now, going through this source material, one may wonder whether any solid assessment of Giorgione's significance can be based on it. Fortunately, this is not all the information that we possess. There exist a few works which, according to a tradition never broken and in some cases fixed in writing at early dates, were from his hand. They are the foundation of any serious attempt at reconstructing Giorgione's work and should, therefore, also be our first concern.

One of these works is Giorgione's only altarpiece, a comparatively small *pala*, six and a half feet high (Plate 52). It was painted for a family chapel in the Gothic church of Castelfranco. This church has long been replaced by a large Baroque building, but shortly before the last war a simple chapel was constructed in the present building, and in it the picture can again be seen above an altar and in very good light. This arrangement was preceded by a thorough investigation into the condition of the *pala* and a cautious cleaning of its surface. The result, although not favourable, is not as alarming as rumours would have it. It is true that there are a few unusually large holes and, of course, many smaller ones, filled with the restorer's paint, but the rest—and this is by far the greater part—is in good state, neither rubbed nor overpainted. This applies particularly to the Virgin and Child and her throne, including the cloth of honour and the carpet. One detail seen in old photographs has changed: the Greek temple on the right has disappeared; it covered the ruins of a farmhouse.

Judging from the probable time of his birth, Giorgione must have spent his years of apprenticeship in Bellini's studio some time in the 1490s, and so one may expect reflections of the works of that decade in his art. In fact the method according to which his picture is painted—tone set against tone, modulated shading instead of continuous modelling, shadows rendered in colour and so on—is what we found in those works. The luminous effect of the brocade, based on silvery white, dark-green and dark-blue, which produce a broad halo above the Virgin's head, is clearly derived from prototypes such as the Loredan portrait in the National Gallery. The figure of St. Francis is borrowed from the S. Giobbe altar; and so on. But we also find some characteristic differences; for instance, the male saints represented in Bellini's works of the 1480s and 1490s are, although united by common sentiments, still individuals and appear to be painted, directly or indirectly, from the life. Giorgione's figures are highly idealized: his S. Liberale is the ideal of the Christian knight, and his St. Francis is the Seraphic saint, blessed already in his earthly habit, his face a variant of that of the Virgin. The closest parallels to these types are to be found in Umbrian art, in the paintings of Perugino, and in the works of artists strongly influenced by him, such as the Bolognese Francesco Francia and Lorenzo Costa. Paintings by the latter were easily accessible to a Venetian; but it is

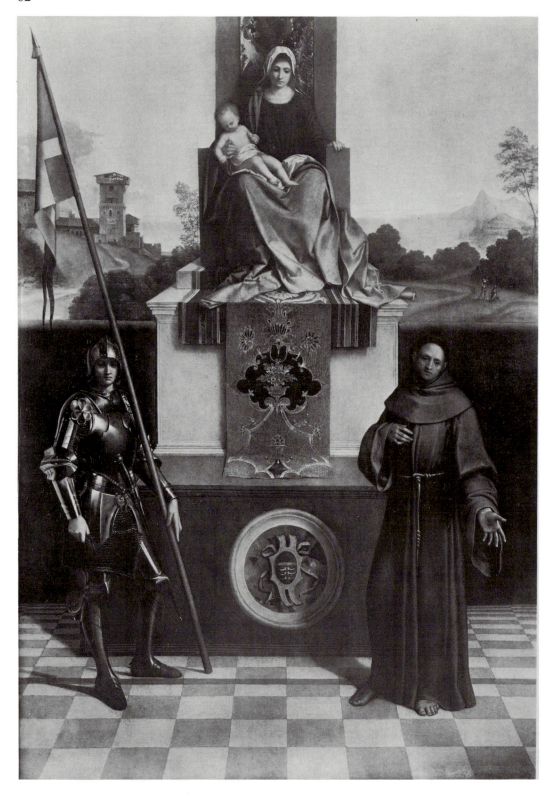

52 (*left*). Giorgione.
*Madonna and Child with
St. Liberale and St. Francis*
(the *Pala di Castelfranco*).
Castelfranco, Church of San
Liberale.

worth while mentioning that in 1494 Perugino himself went to Venice to sign a contract with the Signoria for histories in the Palazzo Ducale; this fact proves that his art was known and highly appreciated in the Republic.

The list of connections between Giorgione's *pala* and earlier works could be continued. But as the picture certainly belongs to the first decade of the sixteenth century, it is also legitimate to compare it with Bellini's principal work of that period. We then find that the pupil has given up the scheme introduced by Bellini and Antonello da Messina thirty years earlier and accepted as a canon in all subsequent altarpieces of this subject. In Giorgione's work there is no centralized chapel, or choir, or apse—instead we find a conception of space new in Venice. This space is not delimited, nor are its zones of depth measurable. The central motive is a piled-up throne, formed, as in Perugino's early works, of simple, unadorned blocks; and even this high structure is cut at the top and must be continued by the imagination. This cutting off of the forms and opening up of the space also occurs at the sides, and the unarticulated dark-red (almost black) curtain is only a visual boundary between the two main sections of space. Within the limits of this seemingly arbitrary cutting, the plain forms of the throne, the distant view, the floor which is tipped up as in early Flemish paintings—all this suggests a kind of spaciousness unparalleled in Venetian art but again to be found in the art of Umbria. Figures and objects do not appear clearly fixed in this space. The figures of the saints are close enough to the throne to be perceived as an enlargement of the steep triangle which is established in small by the main group, the Virgin and Child, but they find no support in the architecture and are by themselves of little weight; nor are they broadened as in Bellini's picture but rather elongated and fragile. The Bolognese Lorenzo Costa particularly liked this type of figure.

Another interesting aspect is Giorgione's attitude to linear perspective. He used it both sparingly and inconsistently. The vanishing-point lies very high, and this means that the greater part of the setting—the part nearest to the spectator—is seen from above. This device has the effect of relating the figures to space rather than centring space round the figures. The result is a certain compositional dualism. One becomes fully aware of it by looking at the upper section isolated in a detail-photograph. This section could almost be regarded as a self-contained whole—something like a much expanded version of a Bellini triptych closed only by the far-away horizon and the endless, radiant sky. And, then, one is tempted to think that this infinite space is a corollary to the dream-like state of mind in which almost all Giorgione's figures appear to indulge.

Surveying the source material we possess on Giorgione, I mentioned

that there exists a small group of works, ascribed to Giorgione by a tradition which has never been broken and which was in some cases fixed in writing at a very early date, and that this group of works is the foundation of our knowledge of Giorgione's art. I have already referred to one of these, the altarpiece at Castelfranco (Plate 52).

The second of these works is this picture which is in Venice (Plate 53). It is on canvas and is two and a half feet high. It is listed in a manuscript by Marcantonio Michiel, a contemporary of Giorgione himself, a dilettante, a collector, and a writer on art, as follows: 'a small landscape with the storm, with the gipsy-woman and the soldier'. Somewhat later, in an inventory, it is called 'a picture of the gipsy-woman with a shepherd, in a landscape with a bridge'. These are descriptions of what one sees; but, undoubtedly, the figures and the storm have a meaning—a meaning that apparently was no longer clear twenty years after

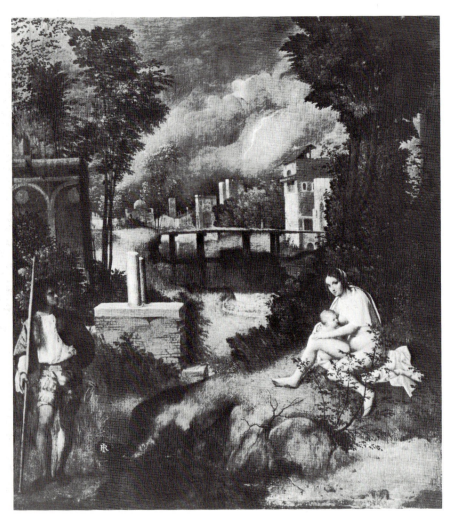

53. Giorgione. *Tempesta.* Venice, Accademia.

Giorgione's death. The iconographical problem of this picture became somewhat more complicated through the discovery of a figure which originally occupied the place of the soldier, or shepherd. This is a reconstruction of the first state of the picture based on an X-ray photograph (Plate 54): a female nude seated three-quarters to the right on the river-bank, with her feet in the water—a figure not merely sketched in but apparently quite finished. Taking into account this unusually radical *pentimento*, one modern interpretation[1] suggests that Giorgione's *Tempesta* was based on some unknown narrative of the legend of Paris, that its correct title should be *The Infant Paris Nursed by the Shepherd's Wife*, and that the other seated woman of the first version was a water-nymph. The same writer explains the town as Ilium and the lightning as an allusion to the fire caused by Paris, the fire by which Ilium was destroyed. I have mentioned this interpretation as an

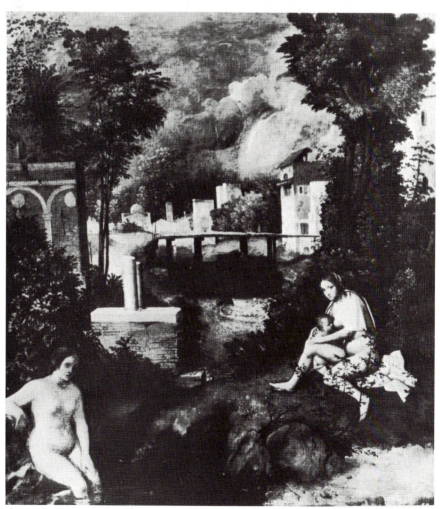

54. Reconstruction of the original composition of the *Tempesta* based on X-rays (after Morassi and Raimondi).

example of many concerning this picture and others of the early Cinquecento in Venice: they usually explain some of the features in an acceptable way, but ignore others or interpret them wilfully. Not until the actual text on which a picture such as this was based has been found can we claim that we understand its subject.

In present-day terminology this is a 'landscape with figures'. The figures fit their surroundings as well as any other 'motive' rendered in the picture. Indeed, they are inseparable from, because quite homogeneous with, all the other things one sees. Looking at the original, this effect is very striking. All the colours used in the figures recur in other places, even the red and orange of the soldier's dress. Moreover this *ensemble* is of a curious softness and instability: all the forms, including the architectural ones, seem to be to some extent in movement. No line is really straight; no vertical is vertical, no horizontal is horizontal. One cannot measure the volumes either, for the artist has used perspective in a rather unorthodox way. Nevertheless, the illusion of reality conveyed to us is perfect. It is an exceptional reality, romantic both with regard to its forms and to the moment in which it is represented. A flash of lightning descends in irregular curves from the gathering clouds; it is pale yellow like sulphur, and this colour is reflected by the towers in the centre. Beyond the horizon there is a storm: it darkens the sky and produces reflections on the water. These contrasts—the unusual light and the falling darkness—mingle on the river-bank with the hot daylight which foretells the arrival of the tempest. All these effects contribute to making the atmosphere strikingly apparent: it envelops all the objects, and it fills the space between them. Similar effects had not been seen in modern art before. It was Giorgione's achievement to produce this unified vision—to envisage nature in a particular mood that corresponds to the feelings of its inhabitants, and thus to render man's communion with nature.

This seems to be the real content of yet another authentic work of Giorgione. It is generally known as *The Three Philosophers* (Plate 55), a title taken, as in the case of the *Tempesta*, from Marcantonio Michiel's notes. It is a canvas just four feet high. According to Michiel's description the best detail in it was the 'wonderfully painted rock'. This part, a strip about eight inches wide on the left, was cut off in the eighteenth century, and therefore I should like to draw your attention to this reconstruction of the original state which is based on seventeenth-century copies and on the old measurements of the picture which are known to us (Plate 56).

I think the most plausible explanation of the subject is that it is the Magi waiting for the apparition of the star which was to announce the birth of a new King. The story is told in an early Christian legend, and it was illustrated before Giorgione as an episode in the background

of pictures representing the Adoration of the Magi—for instance, in Gentile da Fabriano's famous altarpiece of 1423. I proposed this interpretation some thirty years ago. Quite recently, the Vienna picture was cleaned, and the cleaning has revealed an important detail which was entirely painted out in the original and which is blurred in the copies. There is a fig-tree in the cave and next to it an ivy shrub, isolated from the rest of the vegetation by their dark background. Now, these two plants, the fig-tree and the ivy, are, as has been shown in a well-documented paper by a Viennese scholar, Dr. Friderike Klauner[2], attributes of the Messiah, and were widely used as such both in the literature and the art of the Renaissance, particularly in Venice. In art they occur in representations of the Nativity and the Adoration of the Magi, and in those of the Pietà, for instance Bellini's late *Man of Sorrows* (Plate 51) at Stockholm—there the Messianic symbols are seen to the right and left of the dead Saviour. I think this fine discovery settles the dispute about the subject of the Vienna picture.

In this painting a greater significance has been given to the figures than in the *Tempesta*: they are united in a group of monumental appearance. This group is placed on a kind of pedestal of steps, or a stylobate, which defines its plan and clarifies the spatial relations between the figures. These offer the classical triad of the views of the human figure: profile, front view, and three-quarter. At the same time, the trees, their immediate background, are portrayed on the same scale as they are—an ideal that was early realized by Piero della Francesca in his *Baptism of Christ*, painted about sixty years before, and which was then neglected for a long time. This change of proportion makes it natural that the forms are cut by the frame, and the composition demands to be continued in one's imagination. The contrast between the large motives of the raised foreground on both sides and the simple forms of the hill-side which one perceives in the centre has the same widening effect. One is led to feel that the aim of the artist, in this picture as well as in the *Tempesta*, was to render the life of nature in a fragment that stands for the whole.

This painting, too, underwent some changes during its execution, though none of them was as radical as the one traceable in the *Tempesta*. This is an outline drawing of the main part as shown in X-ray photographs (Plate 57). Its importance lies in the fact that it helps us to understand the general direction of the development in Venice at this important moment. In the final version some contrasts have been made less sharp; for instance, that between the distant view and its framing by the linear arabesque of dry branches (the tender tree serves visually as a link); some interesting details have been removed (the fur-cap of the seated figure; the fluttering end of the turban; the sharp profile and the exotic headgear of the third figure); and the co-ordination of

parts has been replaced by their relative subordination under the dominant form of the central figure on the level of the middle of the canvas (the horizontal division has been lowered to a point where it links up with the drapery of the seated figure). This tunic is red. The changes indicate a reorientation of the artist towards ideals which at this time began to change the character of Italian art as a whole. I also show one of the X-ray photographs on which my outline drawing is based, with two versions of the head (Plate 58). As you see, the present form was painted very thinly over the first version, which was used as solid underpainting. This first version, which was doubtless meant as a specifically oriental feature, recurs in a picture by Carpaccio of the *Adoration of the Magi* in the Gulbenkian Collection.

55. Giorgione. *The Three Philosophers*. Vienna, Kunsthistorisches Museum.

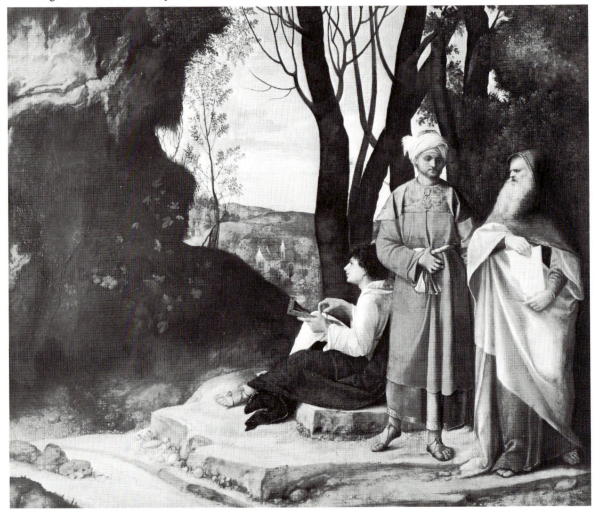

56. Reconstruction of the original size of *The Three Philosophers*, based on early copies.

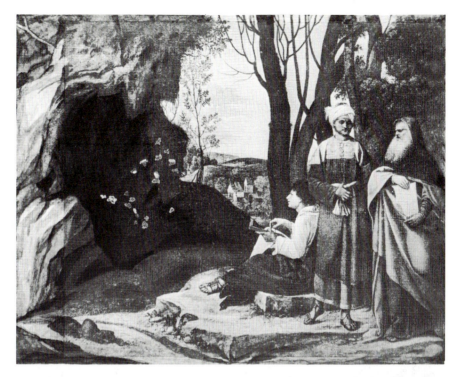

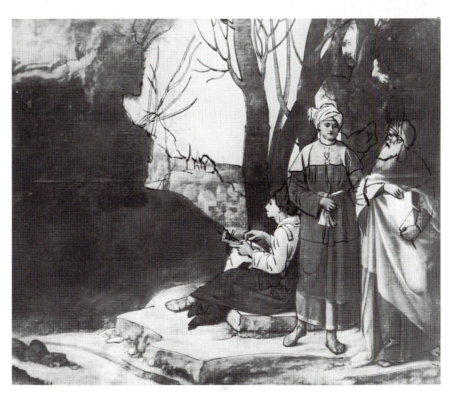

57. Outline drawing of the first state of *The Three Philosophers* as shown by X-rays.

The picture of *Laura* in Vienna (Plate 59)—so called after the laurel-twig (*laura* in Italian) which in all probability is an indication of the sitter's name—is authenticated by a contemporary inscription on the back of the panel, which also states that it was finished on 1 June 1506. Since this is the only certain date connected with a work of Giorgione still in existence, the little picture (it is sixteen inches high) has a key position for us. In the eighteenth century it was given an oval shape—an operation by which it was enlarged on all sides but unfortunately also lost unequal pieces at the corners. The enlargements have been taken off, and the corners have been made up, because it appeared essential to show the composition exactly as it was intended by the artist. This is

58. X-ray of the head of the figure on the right of plate 55.

59. Giorgione. *Laura*. Vienna, Kunsthistorisches Museum.

a new type of composition. Instead of the traditional parapet of Quattrocento portraits, this half-length figure has been given a base of its own in the resting fore-arm (the figure is obviously seated), the large fold of the coat, and the right hand resting as it were on the bottom edge of the frame. On this base a full pyramid has been built up. Although the background is black, the figure stands free in space and seems to be enveloped in atmosphere—an effect mainly produced by the way in which the laurel leaves, with their olive-brown and green tints, have been spread behind the figure. All the forms invite the eye to go round the figure. The picture is strong in colour.

The four pictures we have seen so far—the altarpiece at Castelfranco, the *Tempesta*, the *Three Philosophers*, and the *Laura*—are those to which any attempt at reconstructing Giorgione's œuvre should constantly refer. They are of varied types, not all in the same style and, therefore, not all of the same date. The *Laura* seems to be the most advanced among them, the Castelfranco *Madonna* perhaps the least advanced.

For completeness' sake I must mention two more works. One is a portrait of the artist disguised as the victorious David. The evidence concerning it is intricate, and is partly unpublished, and I cannot discuss it in full.[3] But three facts appear to be well established: that such a picture existed in the sixteenth century; that an engraving by W. Hollar of 1650 (Plate 60) is, directly or indirectly, based on it; and that a fragment in the Museum at Brunswick is in all probability autograph (Plate 61). However, there are difficulties. Our two main documents, the engraving and the painted fragment, do not quite agree; moreover, the fragment is in a rather poor state of preservation: thinly painted on top of another picture, it has been ruined by repeated rubbing, and now large passages in it are in fact restorer's work. And so, apart from its iconographical importance, this self-portrait could hardly add to the testimony produced by our group of four. Even the question whether it preceded, or followed, the Vienna *Laura* is difficult to answer.

The other picture—the *Venus* in Dresden (Plate 62)—probably dates from Giorgione's latest period because it was left unfinished by him. According to Marcantonio Michiel, Titian completed the landscape and the Cupid. The Cupid, seated at the feet of Venus, is very much damaged and was later painted out. X-ray photographs reveal a part of the outline, but only a part, because a fairly large piece of the original canvas is missing at this point and the reconstruction as suggested in this drawing is therefore far from being certain (Plate 63), though it may give some help to the imagination.

This Venus is a classic figure, a mature and fully representative product of Cinquecento art (Titian painted a free version of it thirty years later in his *Venus of Urbino*). There are critics who believe that Michiel's

60. Wenzel Hollar's engraving of the *David* by Giorgione.

74

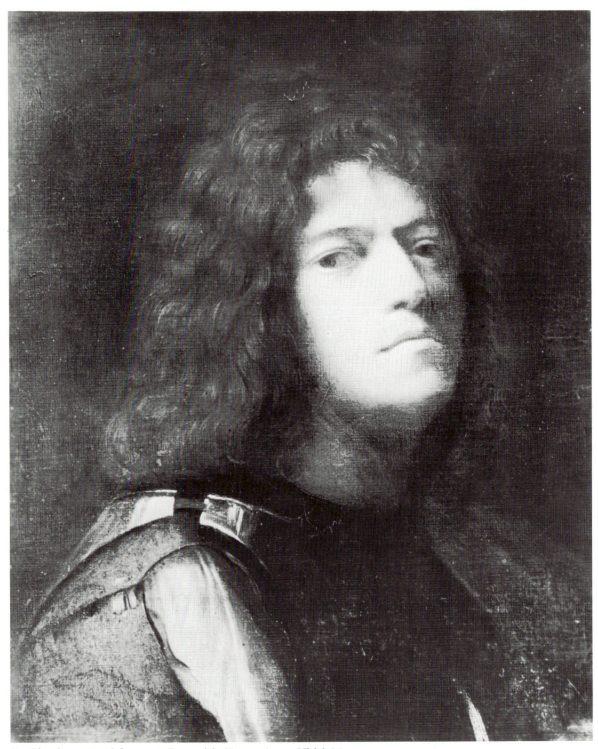

61. Giorgione. *David*, fragment. Brunswick, Herzog Anton Ulrich Museum.

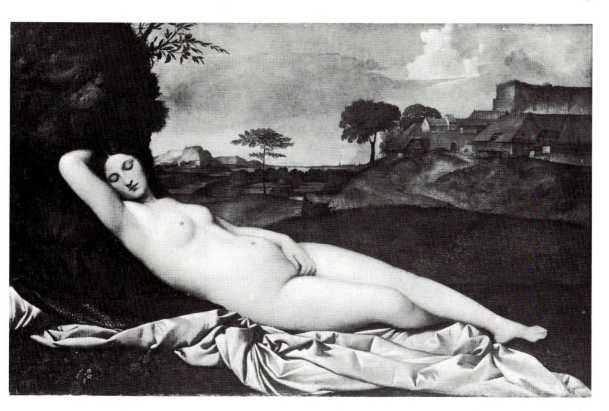

62. Giorgione. *Venus.* Dresden, Gallery.

statement, made not long after Giorgione's death, was mistaken and that the whole Dresden picture should be assigned to Titian. But apart from its being methodologically questionable to contradict a source which otherwise is considered reliable, the new attribution does not appear to be quite convincing. There is a great similarity in sentiment and in the poetical conception of the whole between the *Venus* and authentic works of Giorgione. The broad oval of the *Venus* is one of his favourite types, and the forms round her head can well be compared with details of the *Three Philosophers* and with the background of the Vienna *Laura.* On the other hand the landscape is by Titian—he used its motives in other works which are certainly his own conceptions—and it may well be the case that the pupil had some share also in the execution of the figure and the drapery, that is to say of parts which are not mentioned in our source. And so there remains enough uncertainty to exclude this picture from our group for the time being.

However the basis formed by the four authentic works can be widened to some extent by copies after authentic works, although these, of course, must be used cautiously. We may begin with the partial copies from Giorgione's principal work, which is also his best-documented: the façade decoration of the Fondaco de' Tedeschi. The house, in which the German merchants had to live and transact business under state

63. Reconstruction of the original state of Giorgione's *Venus* (after Posse).

control, was destroyed by fire in 1504. Owing to the importance of the trade with the North for the Venetian budget, a palatial new building was begun almost immediately and was roofed as early as May 1507. The decoration of the façade facing the Canal Grande must have been begun soon after this date and was finished in the autumn of 1508— rather quick work, considering that it had to stop during the rainy winter months. It is a high and very long façade. As for the system of its decoration, we know that in the spaces between the windows in at least two of the three storeys there were figures, or groups of figures, well over life-size. The rest, and that is twice as much surface, was filled with friezes of trophies, heads, garlands, and the like. About the underlying programme we are left entirely in the dark; as was Vasari, when he inquired in vain into its meaning—an example of the free way in which iconography was used in Venice from the time of Giovanni Bellini onwards. This decoration was the first and, according to the sources, the most remarkable monument of its kind. But the frescoes flaked off soon. Their last surviving fragment was transferred to canvas and placed in the Gallery during the last war—much too late. I show you the upper and best-preserved part of this fragment (Plate 64). The only impression it may still convey is one of colour. One can revive faded frescoes by pouring plenty of water on them. Once I was allowed to

64. Giorgione. Fragment of the frescoes on the Fondaco de' Tedeschi. Venice, Accademia.

make this experiment when the fragment was still in its place, and I found that the old writers who call the colour of Giorgione's frescoes glowing or inflamed (*colori accesi*) are perfectly right. As in the small portrait in Vienna, the flesh has been rendered in a variety of tints, among them a very intense red. The same applies to the shading of the nude, which is all done in colour. One has similar colour sensations in the south in the deceptively transparent air which precedes a sudden storm in the summer. This figure is one of the uppermost row, just under the roof, and therefore must have been painted in 1507. It is interesting to see that the pose, a somewhat timid *contrapposto*, is a replica of that of the central figure in the *Three Philosophers* (The same pose occurred before in Bellini's *Baptism of Christ*, painted in the first years of the century).

Two more fragments existed in the mid-eighteenth century and were copied and published, as was the last one, by the historian of Venetian painting, A. M. Zanetti (Plates 65 and 66). They belonged to a lower register of figures, and they seem to show that the trend which directed

65. Zanetti's engraving after a figure by Giorgione on the Fondaco de' Tedeschi.

Giorgione in correcting the first design of his *Three Philosophers* later became stronger. We notice a new canon of the human figure, one that can hardly have been acquired without studying examples of antique art: figures with well-articulated limbs and free movements, and with

66. Zanetti's engraving after a figure by Giorgione on the Fondaco de' Tedeschi.

67. Giorgione (?). *Shepherd boy*. Milan, Ambrosiana.

draperies of broad, natural forms, serving as a support as in ancient statuary. But also in these sections of a monumental decoration every-thing is done to show that figure and surroundings are inseparable, and that plastic form only exists in a space full of light and atmosphere.

We also possess visual records of some smaller works which were in private collections at Venice in the early part of the sixteenth century, though these two heads perhaps have a claim to be something better than mere copies. One, in the Ambrosiana at Milan (Plate 67), is certainly connected with an entry in Marcantonio Michiel's lists that reads 'testa del pastorello che tien in man uno frutto' (the head of a shepherd boy who holds a fruit). The fruit is a golden ball and, therefore, this

68. Giorgione. *Boy with an Arrow*. Vienna, Kunsthistorisches Museum.

shepherd boy in his Sunday best can only be the young Paris. It is quite a small panel—eight and a half inches high—and is very beautiful. In 1937, when the Castelfranco *Madonna* was being examined in the Brera, I was given permission to compare the two directly; but my request that the little panel should be freed from its brown varnish was rejected because my cautious suggestion that it might turn out to be an original, or a workshop replica, was regarded as absurd by the authorities. I do not know whether it has been cleaned since.[4]

No such hopes can be entertained with regard to the other picture, which is in Vienna (Plate 68). This panel was cleaned, probably more than once, in the past—cleaned rather radically—and its pigment is worn; but even in this ruined state it is a very fine picture. Michiel saw a 'testa del garzone che tien in man la saetta' (the head of a young fellow who

69. Teniers after Giorgione.
The Finding of Paris.
Formerly Florence, Loeser
Collection.

holds an arrow), ascribed to Giorgione, in the collection of Zuan Ram in 1531. The Vienna picture is identical either with this, or with another, seen by Michiel in the following year in the collection of Antonio Pasqualigo, and commented upon with these words: 'La testa . . . della quale . . . M. Zuane ne ha un ritratto, bench egli creda che sii el proprio' (a picture of which Mr. Ram possesses a replica, though he believes that it is the original). As you see, the troubles of the collector and the art historian started early. The subject is probably the young Apollo (not Eros); Apollo is a god and therefore his dress is half-antique. Both these heads can well be compared with the *pala* at Castel-franco; the Apollo with the St. Francis and the Virgin; the Paris with S. Liberale.

A third picture described by Marcantonio Michiel is known to us from a small seventeenth-century copy (Plate 69). Michiel saw the original in the collection of Taddeo Contarini, who also owned the *Three Philosophers*. The two pictures remained together until the end of the eighteenth century, when this one disappeared; let us hope that it will be rediscovered one day. It was a large canvas, six feet wide, nearly as large as the Castelfranco altarpiece and somewhat larger than the *Three Philosophers*. The copy is by the Flemish artist David Teniers the younger and was made to serve as the model for an engraving. We know many copies of this kind from Teniers's hand, copies of works still in existence, and so we are able to assess their reliability. In spite of some unintentional baroque distortions one may safely deduce from this copy that the compositional form of the *Three Philosophers* was not an exception, that this was a new type of painting, invented by Giorgione.

In this case there is little doubt about the subject: it is the story how the infant Paris, who had been exposed by his parents on the slopes of Mount Ida, was found by shepherds. The Greek legend has been given an Arcadian setting, and once again the communion of man and nature appears to be the real content. It is interesting that Michiel remarks that this *Finding of Paris* was one of Giorgione's early works ('fu delle sue prime opere'). The motives are similar in the *Paris* and the *Philosophers* but they have been used in different ways. In the earlier one the stage-set formations of landscape follow one another according to the scheme which was adopted by Bellini in the works of his maturity, and the recession towards the chain of mountains that indicate the horizon is continuous; the foreground is more distinctly tilted, and the impressive contrast between the nearest zone and the farthest is missing. As for the figures, at first they were used much in the same way as the landscape forms. In the later work, a group with its natural foil (the trees) could be balanced with a mighty formation of nature (the rock), thus achieving a high degree of monumentality.

I repeat once more: these are Giorgione's works authenticated either by an uninterrupted tradition or (in the case of the *Laura*) by a contemporary inscription, and surviving either in original or in reliable copies. Chronologically they range, shall we say, from about 1503 or 1504 to 1507 or 1508. They are of varied types and form a sufficiently wide basis for further attributions. In fact many attributions have been suggested since the standard work of Crowe and Cavalcaselle on Venetian painting was published in 1871. We have not got the time to go through all of them, but perhaps we should do well to inquire whether there are works among them with which we might extend the series of authentic works at its two ends—that is, to put the questions: 'do we know works by Giorgione which preceded the *pala* of Castelfranco?' and, 'do we possess works later than the façade frescoes of the Fondaco?' I shall show you only pictures on which there is a fair degree of agreement among students, and whose acceptance I should like to advocate.

First, early works. This picture of *Judith* is in the Hermitage in Leningrad (Plate 70), but in 1935 it was possible to study it in an exhibition in Paris. It was painted on panel and was later transferred to canvas—an operation seldom done without losses; but apart from a number of small holes, the condition in this case is not unfavourable. The figure itself is three and a half feet high. The picture was called Raphael in the collection of Charles I, and it retained this name until Cavalcaselle's new attribution, which has generally been accepted.

The theme, the figure of Judith shown in isolation, is unusual in the Renaissance; there is no tradition for it. Iconographically it is based on representations of the victorious David, and on pictures such as Bellini's *St. Justina* (Plate 16). In Bellini's paintings of single saints

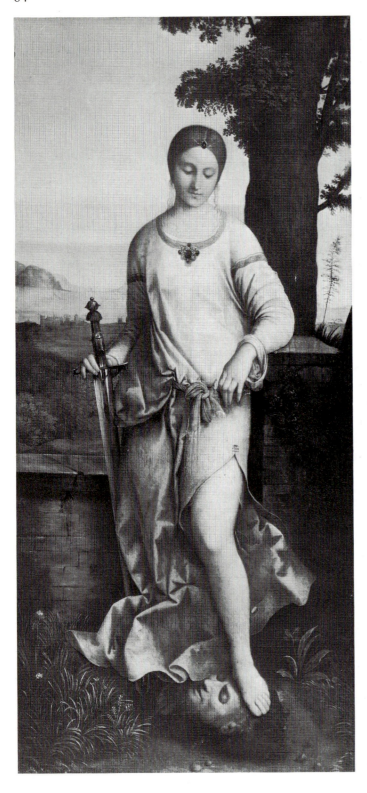

70. Giorgione. *Judith*. Leningrad, Hermitage.

space is always centred on the figure; here it is opened up in all directions; it is a scheme like that of the Castelfranco altarpiece, but less accomplished. Notice the careless use of perspective and the orthogonals leading outside the picture. I should like to point out in this connection that in the textbooks you mostly find this figure reproduced together with an engraved copy of it which shows it considerably broader, and you read the statement that the panel has been cut on both sides. This is not correct: reproductions earlier than the engraving show the picture exactly as it is now, so that the later enlargements were rightly taken off when the picture was transferred to canvas. We find here the first appearance of the oval face as known from the Virgin in the *pala*, and that dream-like state of mind which we saw in the *St. Francis*, an expression which is not really appropriate to the heroine of the Old Testament. The timid *contrapposto* is already well known to us; this and the entirely Umbrian landscape probably account for the old attribution to Raphael. The motif of the big tree-trunk is of German origin, and so is the style of the drapery: Dürer's engravings were very popular in Venice. Altogether parallels in German art can easily be found; on the other hand, it is worth while mentioning that this early and immature painting by Giorgione was already known and imitated in Germany in his lifetime: a picture by Lucas Cranach, at Kassel, representing *St. Catherine*, is clearly based on it.

The *Madonna* at Oxford, too, must be a very early work (Plate 71). You find in it the same wilful perspective; a haphazard composition (where is the Child lying?); notice the *pentimento*: the parapet has been prolonged to suggest a support, but it does not really do so. The draughtsmanship is incompetent (where are the Virgin's knees?); and the whole is a collection of incongruous motives. Attempts at dating it late, made when the picture was first introduced in the literature, were prejudiced: they derived from a conception of Giorgione's art as one entirely belonging to the last phase of the development in the Quattrocento. I think one is probably right in connecting this picture with a statement by Vasari which reads: Giorgione 'lavorò in Venezia *nel suo principio* molti quadri di Nostre Donne'[5] (Giorgione made, at the beginning of his career, many pictures of the Virgin and Child). It means that this young man from the provinces also belonged for some time to the *Madonnieri*, the Madonna-makers; that secured him a certain, though modest, income. We know from the inscription on the back of the *Laura* panel that as late as 1506 Giorgione was still working in the studio of a well-to-do colleague of his, Vincenzo Catena. The Oxford picture proves to be a 'modernization' of a homely composition by Carpaccio at Frankfurt (Plate 72). There are two drawings preparatory to this painting of Carpaccio, and those are even closer to Giorgione's replica. The only drawing which can be attributed with some degree of

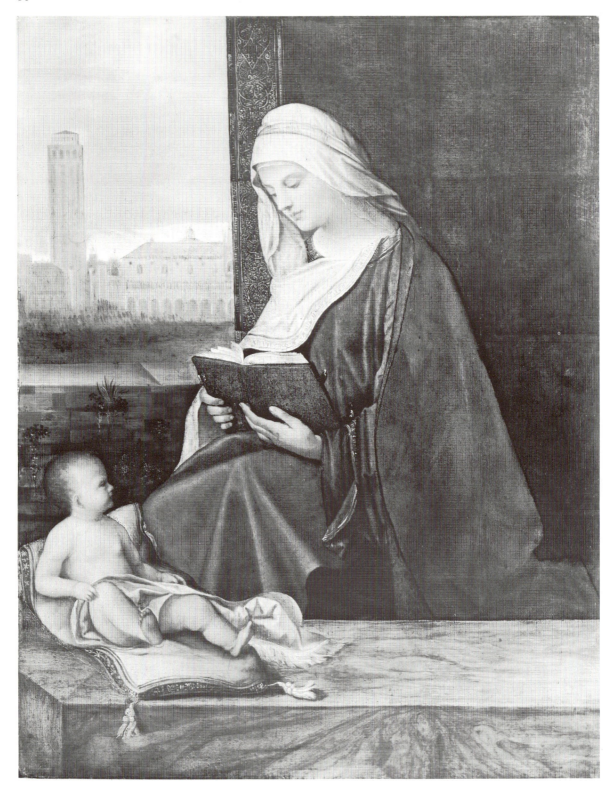

71 (*left*). Giorgione.
Madonna and Child. Oxford,
Ashmolean Museum.

certainty to Giorgione, a study for a *Nativity* at Windsor (Plate 73), closely follows Carpaccio's characteristic brush-drawings. Further, Carpaccio was also a great master of colour and his art must have interested Giorgione who was his junior by at least twenty years.

This charming little panel formerly belonged to the Benson Collection (Plate 74); now it is at the National Gallery in Washington. It is one of the most poetic *Holy Families* of the period soon after 1500. Here the affinity with contemporary German art is even greater than in the case of the *Judith*; also its size, eight inches high, reminds one of engravings. And how much does it contain! It is a kind of programme of what later

72. Carpaccio. *Madonna
and Child with St. John.*
Frankfurt, Staedel Institute.

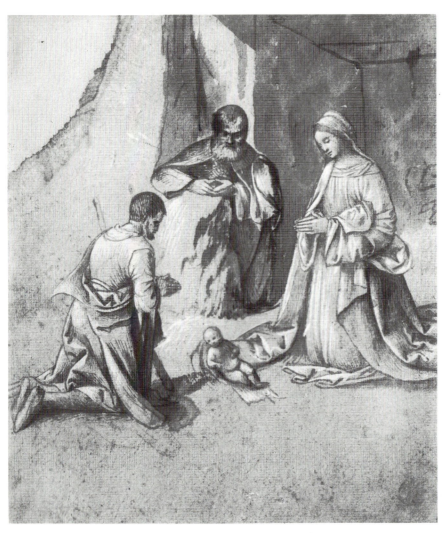

works of the artist were to display; in the figures it is an early attempt to form a well-knit composition. The Virgin's mantle has been spread out to serve as a natural pedestal, and on this the figures are placed one behind another and are kept together by nearly symmetrical outlines. On the right, where the base is further extended, you find the lovely motive of a picture within the picture: the landscape framed by an arched window. This is yet another motive of northern origin; but the way it is used here, balancing a plain wall-surface, painted like the rock in the *Three Philosophers*, with a great variety of tones, is by contrast Venetian. And the link between these two planes, the scarcely defined dark foil, is also purely visual: it would not be easy to draw the ground plan of this wall-section. In contrast to the Oxford *Madonna*, such a masterpiece as this was doubtless made for the sensitive and cultivated eye of a connoisseur.

73. Giorgione. *Nativity*. Drawing. Windsor, Royal Collection (reproduced by gracious permission of H.M. The Queen).

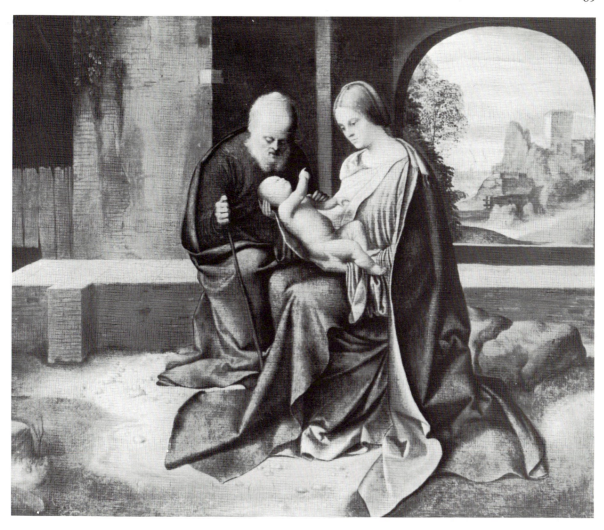

74. Giorgione. *Holy Family*. Washington, National Gallery.

The *Adoration* in Washington (Plate 75) was also acquired from an English collection (the Allendale Collection). It is a panel just under three feet high. Perhaps it is one of the two Nativities mentioned in the correspondence of Isabella d'Este after Giorgione's death. If it had reached Mantua then, it would probably have provoked a comparison with a picture already there, painted forty years earlier (Plate 76), a comparison not necessarily to the advantage of the later work. Giorgione borrowed the general scheme from Mantegna but replaced the parts with forms which were drawn from his knowledge of nature. It is a somewhat crowded composition in which every motif seems to be present in its own right, as plants are in a botanical garden: this is not the atmospheric vision of the *Tempesta*, nor is it the grand synthesis of the *Three Philosophers*. The details of the lost *Finding of Paris*, known to us from the Teniers copy, must have looked rather similar. The scheme

77 (*right*). Detail of plate 75.

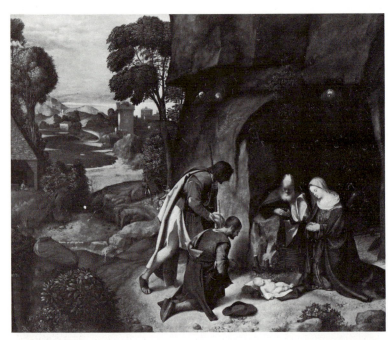

75. Giorgione. *Adoration of the Shepherds*. Washington, National Gallery.

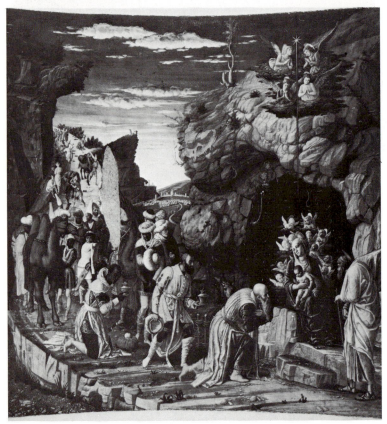

76. Mantegna. *Adoration of the Magi*. Florence, Uffizi.

78. Detail of plate 52.
79. Giorgione. *Adoration of the Magi.* London, National Gallery.

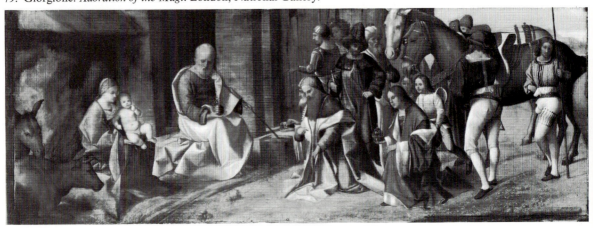

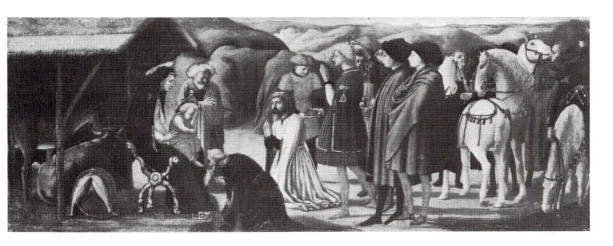

80. Masaccio. *Adoration of the Magi*. From the Pisa altarpiece. Berlin, Dahlem Museum.

first adopted here for the representation of the Nativity had many descendants, first in Venice, later also elsewhere. This detail of the distant landscape (Plate 77) shows how close this picture must be placed to the Castelfranco *Madonna* (Plate 78). The comparison is reliable, for both these details are in excellent condition.

I conclude with the early work best known to English students, the *Adoration of the Magi* in the National Gallery (Plate 79). The unusual format, and the composition which demands a continuation upward, suggest that it was either part of a predella, or of a cassone (however, as a predella it would not fit the Castelfranco altarpiece). The rhythm of the whole, the clear definition of depth, some lovely details, such as the idyll of the animals on the left, and the serious mood of all the participants, all these features may recall to your minds Masaccio's predella once at Pisa (Plate 80), painted eighty years earlier, and may indicate the great line of tradition that characterizes the development of painting in Renaissance Italy.

Giorgione, Sebastiano del Piombo and the young Titian

THERE is another group of works, also attributed to Giorgione for reasons of style but assumed to be contemporary with, or later than, the latest of his known authenticated works, the façade decoration of the Fondaco de' Tedeschi. But before discussing them, it appears to me advisable to draw your attention to the activities of two artists who belonged to a generation following that of Giorgione, the generation born in the mid-1480s. For in the years in question, that is to say in the last years of the first decade of the sixteenth century, these two artists, Sebastiano Veneziano and Titian, worked in close contact with Giorgione. They were, like him, former pupils of Giovanni Bellini; and their relation to Giorgione was defined by Vasari, who knew both of them personally, with the words: 'duo suoi creati'—and he says that Giorgione created these two men in order that his art should be continued. We also learn from early sources how their works were often confused with those of their second master.

So, first, Sebastiano Veneziano, better known by his later name Sebastiano del Piombo. He was Titian's senior by a year or two, and he left Venice for good a few months after Giorgione's death. According to the notes of Marcantonio Michiel, who was a friend of Sebastiano, Giorgione's *Three Philosophers* was partly Sebastiano's work. Attempts at distinguishing two hands in the Vienna painting have not been successful, and it may well be the case that the pupil's part was quite subordinate. However, the influence of this painting on Sebastiano is indisputable. It is clearly shown by his first authenticated and datable work, the organ-shutters in the little church of S. Bartolomeo al Rialto at Venice of which the altarpiece was painted by Dürer in 1506.

The insides of the organ-shutters in S. Bartolomeo were begun at the end of 1507 (Plates 81 and 82). They are the works in which Sebastiano's art is nearest to Giorgione's. The two saints, Louis and Sinibaldus, stand in wide niches of warm grey stone and gold mosaic, enveloped in an atmosphere which seems to have been made visible by sunlight coming through one of the church windows. The shadows which they cast double their existence and make a warm foil to the glowing colour of their garments. They reflect a motionless, calm existence, in the bishop-saint Louis, with that dream-like fullness of sentiment which is common

to all Giorgione's figures: indeed, some of the spaces between the windows on the Fondaco de' Tedeschi may well have had very similar decorations. The types too are Giorgione's: St. Louis is the twin-brother of S. Liberale, and the pilgrim saint closely resembles the oldest of the *Three Philosophers*. I show you details of the two heads (Plates 83 and 84), because the obvious connection that exists between them also reveals some characteristic differences. One may perhaps say that in Giorgione's picture the volume of the head, its space-filling mass, is convincingly suggested by means of a very rich modulation of tones, and that at the same time the forms have remained undefined in detail: they are filmy, vibrating, covered, as it were, by a thin haze. The younger artist, while making full use of his master's technique, tries to give a greater solidity to his forms. The outline becomes clear, the parts of the face are set off one against another, convexities and hollows are emphasized. And so in a way the plasticity has been increased; but an underlying tendency towards simplification has produced a silhouette less suggestive of the volume as a whole. One has the feeling that it was an attempt at something new, an attempt that for the time being was not entirely successful. This becomes even more obvious if one extends the comparison to the common prototype of the two heads, to the *St. Jerome* in Bellini's *pala di S. Zaccaria* of 1505 (Plate 42)—a figure on the same scale as Sebastiano's St. Sinibaldus. It is perhaps the most advanced of the three heads, in the sense of the programme that was to dominate Venetian painting after the short period of the High Renaissance.

This is how Sebastiano's work looks when he is at his closest to Giorgione. The outside of the same organ-shutters shows a change of style (Plate 85). On this side the colour is subdued. With a very fine artistic sense the artist has made the organ with its shutters closed part of the church architecture. The main motif is the classically shaped and proportioned triumphal arch. It is painted architecture, carried to a high degree of illusion. The precision of its drawing and the correctness of its perspective are reminiscent not of Giorgione but of Giovanni Bellini's large altarpieces. However, this type of deliberate classicism was altogether new in Venice. The contents of the whole square picture-space are constructed with the same sense of balance and harmony as any edifice of the High Renaissance. The forms have been left bare to demonstrate the forces that function through them, and the two figures play active parts in this structure. Placed like orators near the edge of the platform, they stand erect between the columns and, turning slightly inwards, they echo the foreshortening of the archway. They look like antique statues; their poses copy, their forms emulate such prototypes. The energetic heads, the clearly defined limbs, the large folds of drapery —all these forms derive from classical art. St. Sebastian is a spirited variant of the Apollo Belvedere (Plate 86), that is to say of one of the

81. Sebastiano del Piombo. *St. Louis*. Venice, Church of San Bartolomeo al Rialto.

82. Sebastiano del Piombo. *St. Sinibaldus.*
Venice, Church of San Bartolomeo al Rialto.

83. Detail of plate 82.

models most admired by the classicists of the sixteenth century, which Sebastiano may have known through a drawing. There were at that time in Venice, as well as in Rome and Florence, many admirers of the beauty and harmony of antique sculpture and architecture; but the artists, the sculptors in particular, had only just begun to choose these relics as their standard, and this work of a pupil of Giorgione was in the van of Cinquecento classicism in Venice.

This new standard was boldly tested on a still larger scale in the most monumental composition of Sebastiano's early period: I mean the *Judgement of Solomon* in the Bankes Collection at Kingston Lucy (Plate 87). It is seven feet by ten and a half feet and, though unfinished, it is one of the most imposing monuments of the Venetian Cinquecento. Some of the *pentimenti* are still visible; the figure of the executioner is only sketched in; the babies are altogether missing; but the rest is more or less finished, is in relatively good condition, and is admirable both in design and colour. I think it is mainly due to the beauty of its glowing colour that this picture was long attributed to Giorgione, although nothing like it can be found among his authentic works. The recent restoration of the organ-shutters in S. Bartolomeo al Rialto, a docu-

84. Detail of plate 55.

85. Sebastiano del Piombo. *St. Bartholomew and St. Sebastian.* Venice, Church of San Bartolomeo al Rialto.

mented work of Sebastiano, will probably help to support the attribution
to the young artist, an attribution first suggested by the late Bernard
Berenson many years ago.[1]

Instead of the central part of a triumphal arch, you have here the
whole interior of a Roman basilica, reconstructed with the delighted and
accurate curiosity of an archaeologist and used as a stage to set the
scale of the figures and to enhance the monumentality and solemnity
of the group. Here, too, the figures are homogeneous parts of the
structure: the standing ones repeat the vertical axis, those in movement

widen the base of the group and lead the eye to the centre of the scene. The general outline of the group is reversed in the converging orthogonals of the cornices. Once again many of the figures derive from ancient prototypes. The sharply delineated nude on the right doubtless follows some statue of the type of Agasias' *Gladiator* in the Louvre; in representing violent movement the classicists, among them Sebastiano, liked to draw on the rich store of Hellenistic art. However among the selected classical specimens there are types of purely Giorgionesque origin.

The most harmonious result of the young Sebastiano's attempts at attaining architectural unity in painting is his *pala* of S. Giovanni

86. Amico Aspertini. Drawing of the *Apollo Belvedere*. London, British Museum.

102

Crisostomo (Plate 88). As a recently found document shows, it was painted some time after April, 1509, at any rate only a few years after that little church and its high altar had been erected, a circumstance the consideration of which greatly assists the true appreciation of the work. Actually on the spot, one can see that Sebastiano has indeed taken into account the simple rhythm of the interior, built with wide arches on a Greek-cross plan set in a square, and that he has repeated this rhythm in the general layout of the painting. For in this picture the component parts are figures; architecture and landscape provide only an accompaniment of changing rhythm. An evenly warm colour-scheme corrects the contrasts between these different elements. In the figures Sebastiano has tried to achieve something of the solidity of architectural forms rather than that of statues. The two saints on the right are Giorgionesque only in their expression. The figure of the Baptist seems to be an attempt to imitate the simplified nudes of the Florentine Fra Bartolommeo, who in 1508 came to Venice with the message of a new art, as Perugino had done fourteen years before. In the group on the left you will probably recognize the artificially broadened draperies, flattened on the surface, of Bellini's late works. But here too Sebastiano reveals the tendency

88 (*right*). Sebastiano del Piombo. *San Giovanni Crisostomo Altarpiece*. Venice, Church of San Giovanni Crisostomo.

87. Sebastiano del Piombo. *Judgement of Solomon*. Kingston Lacy, Bankes Collection.

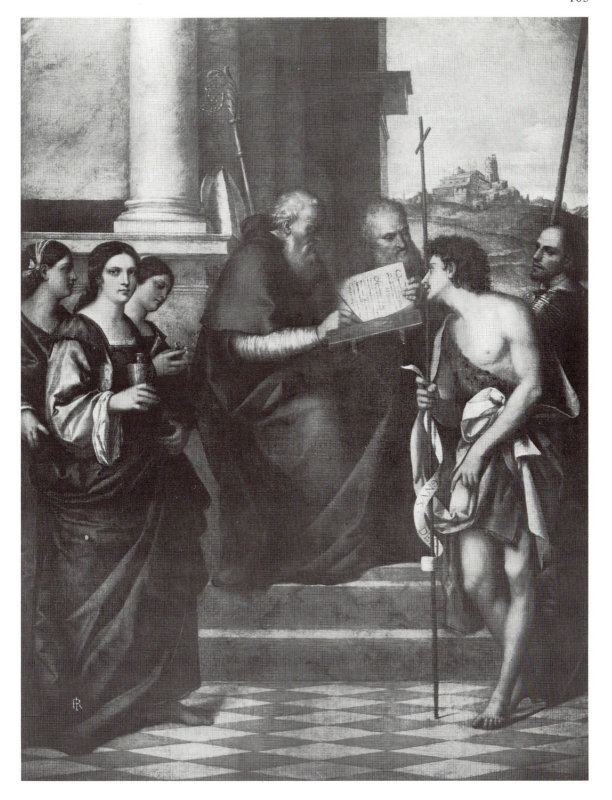

to reduce the outlines to geometric forms: circles, semicircles, ellipses; the figure of Mary Magdalene shows some striking examples. As a whole, this picture represents a definite new stage in the evolution of Venetian classicism.

It is no accident that Sebastiano's approach to Central Italian ideals is most obvious in the latest of his Venetian works, the *Salome* in London (Plate 89), although this work is of a type of purely Venetian origin, one which was made popular by Bellini and Giorgione. But this half-length figure, rather under life-size, has a solidity of structure which can stand enlargement on any scale. Its date, 1510, is that of the last year of Sebastiano's stay in Venice. This painting was conceived in strict accordance with the rules governing classical high-relief. This means that the convexity it suggests is clear and continuous: the highest point is in the centre, and further from the centre the forms are nearer to the relief-ground. As in a marble relief a stone-slab indicates both the surface of the block and the base; here it also serves as a support for the stretched-out right arm with the charger. The figure, firm in its pose and of vigorous expression, is in complete equipoise: each form is immovably fixed in a system of horizontals and verticals. You will have noticed that, for instance, the blue rectangle of the sky, above the yellow sunset stripes, exactly repeats the proportions of the whole panel. As in the altarpiece, the outlines are simple and as far as possible regular. The flesh is harder than in any other Venetian painting of the period, and is in contrast with the free brushwork of costume and hair. Indeed one is right in thinking that a picture of this sort would have found admirers in Rome and Tuscany as well. Sebastiano's change of residence appears to have been well motivated.

So much for the Venetian period of Sebastiano. The works I have shown all belong to the three and a half years between the autumn of 1507 and the spring of 1511. Now, the first certainly datable works of the other pupil 'created' by Giorgione, Titian, his frescoes at Padua, were executed in 1511, the year following Giorgione's death, the year in which Sebastiano left for Rome.

The frescoes are in the Chapter House of the Scuola del Santo. Whereas Renaissance churches hardly contained any wall space which could be decorated with histories, the houses of the lay confraternities in Venice did. In their spacious but not very high rooms the pictures were arranged in continuous series like tapestries, separated one from another by pilasters, and filling the space between the stalls and the coffered ceiling. The Scuola of S. Antonio at Padua was built between 1499 and 1505. The Chapter House on its first floor is wide and nearly a double square in shape. It contains eighteen pictures representing miracles of the Saint. One of the three frescoes which cover the short side opposite the altar is by Titian; two other scenes by him are on the

89. Sebastiano del Piombo. *Salome*. London, National Gallery.

long wall opposite the windows. According to a document all three were finished by December 1511.

In the *Miracle of the Speaking Babe* the picture space, though in fact square, almost looks like an oblong (Plate 90); the figures form a multi-coloured frieze, which is continued in the neighbouring frescoes which were added by followers of Titian. However the figures stand firmly and the group is as solidly built as in a fresco by Masaccio. It is closed on both sides, and there are movements leading the eye from the sides to the centre. The composition is very simple and is further emphasized

90. Titian. *Miracle of the Speaking Infant*. Padua, Scuola del Santo.

91. Detail of plate 90.

be colour. The centre is brown. On the right, large planes of dark-red and black appear against the bright landscape; on the left, you see many bright colours against a dark, warm background, with a stronger accent in the statue. The event can be perceived at a glance; this had been the main quality of all good history paintings in Italy ever since Giotto's time. In the centre are the Saint and the infant who was given speech to bear witness to his mother's innocence. The other figures form a wide, shallow niche round these two; on the right the jealous husband and his wife, with some friends, on the left onlookers. Only one figure on each side is shown completely and is not partly covered by another. They are large figures, whose heads have classical features. Their gestures are simple and expressive.

Titian appears to have favoured fresco in his youth: he found its open, improvising method appropriate to his new pictorial ideas. A detail will show you what sort of freedom he wanted (Plate 91). At first glance some of the heads might appear to date from the heroic phase of French Impressionism, for those broad strokes in the face and in the

108

dress were not done by the restorer's brush (this photograph was taken after a thorough cleaning of the fresco in the late 1920s): all these strokes were done in fresh colour, tone over tone, dark-red, brown and olive over yellow and orange. They, too, are 'inflamed colours', as was said of Giorgione's frescoes. You get the immediate effect of plasticity based on colour. This kind of plasticity has two great advantages: it connects the form with its surroundings, and it gives emphasis to the picture plane.

This then is the stage which had been reached by the young Titian by the date when, in consequence of Giorgione's death and Sebastiano's move to Rome, the situation in Venice changed so suddenly and so radically. Now I should like to show you some pictures which can safely be accepted as works from Titian's hand and as being earlier than his Padua frescoes, although their exact dates are unknown.

First the votive picture of Jacopo Pesaro in the Antwerp gallery

92. Titian. *Jacopo Pesaro before St. Peter*. Antwerp, Museum.

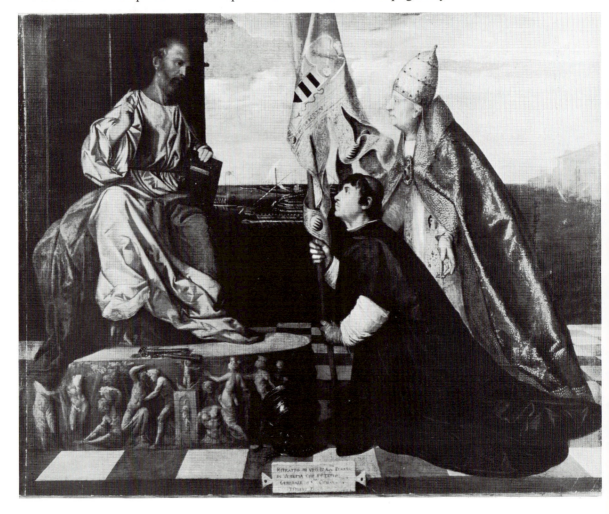

(Plate 92). In this case we at least have a certain *terminus post quem*. This picture commemorates the sea-battle at Santa Maura, victoriously fought against the Turks under the command of Bishop Pesaro as a general of the pope. Some time after his return to Venice in the summer of 1503, this young prelate commissioned the picture from Titian. We do not know exactly when this happened, but in all probability this is Titian's earliest surviving work. In it the young artist followed the traditional scheme of votive pictures as it is known to us from that of Giovanni Mocenigo in the National Gallery (Plate 35). Like Bellini, Titian tried to replace the monotony of the simply co-ordinated uprights of the scheme with a unified structure. The donor with the Borgia flag and his patron, the pope, are linked in an expressive silhouette, and the somewhat disproportionate and rather Quattrocentoesque figure of St. Peter is supported by the broadened forms of his drapery and the architecture. The caesuras are filled with deep, unifying colours. All these means were doubtless studied by Titian in the late altarpieces of Giovanni Bellini. This is a typical 'early work', with promises of works to come. Its composition becomes really intelligible only by reading its brilliant colour. Its drawing is uneven, partly almost incompetent, partly bold and ignoring difficulties. The fictive antique relief on the throne-base is, one would like to think, an improvisation of genius.

Next, this small altarpiece (Plate 93) painted for the Gothic church of S. Spirito in Isola, which was rebuilt about 1540 by Jacopo Sansovino and dismantled in the seventeenth century; the picture now decorates the altar in the sacristy of S. Maria della Salute. Here again the principal figure is an impressive silhouette against the sky. Actually there are two viewpoints, and the figure of St. Mark, seated on his throne like a Roman emperor, appears more foreshortened than it ought to be, but this foreshortening connects it more closely with the plastic groups below. For the same reason Titian abandoned the symmetry of the architectural setting. In the square part of the panel you see massive, vertical forms, partly with uninterrupted, straight outlines, and you also find restrained gestures. The colour-scheme is based on a contrast between the simple, large and intensely coloured planes in this square and the more delicate ones, variegated by cast shadows, within the semicircle. You find Giorgione's influence both in the types and the draperies. But all the forms have been rendered with a somewhat heavy-handed energy—a quality which is, as we shall see, common to all Titian's authentic early works.

Another small altarpiece, that of *Tobias with the Angel* (Plate 94), was painted for the late-Gothic church of S. Caterina, for the altar at the end-wall of the right aisle; now it is in the Accademia. In the church, which still exists but is no longer in use, it is easier to understand the meaning of the main compositional feature: the powerful silhouette

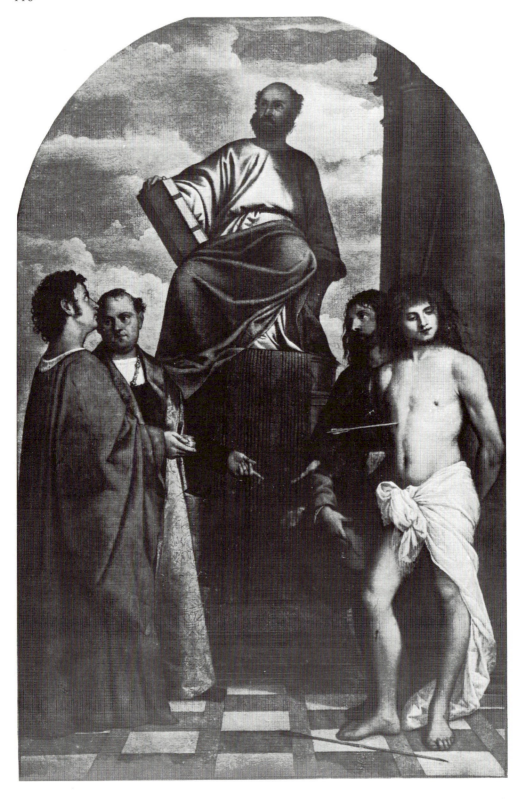

93 (*left*). Titian. *St. Mark enthroned*. Venice, Sacristy of the church of Sta Maria della Salute.

94. Titian. *Tobias and the Angel*. Venice, Accademia.

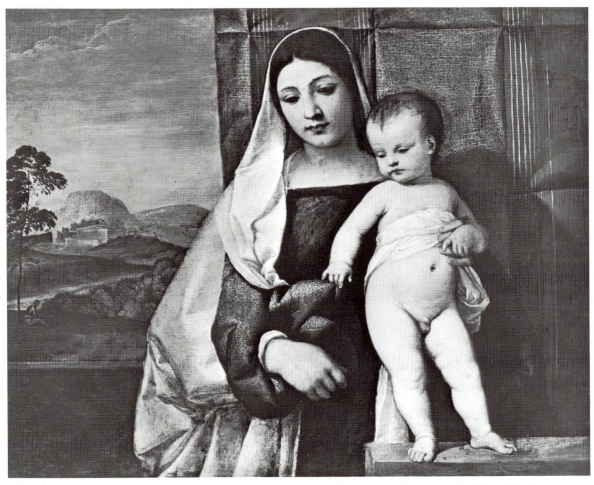

filling the whole picture, in movement and yet in perfect equipoise: it once provided a focus for the spectator's gaze from the moment he entered the aisle. Vasari tells us on Titian's own authority that the picture was painted at the time when Venice was at war with the Emperor Maximilian. This, in all probability, means the year 1508 or 1509. It is a magnificent invention. Unfortunately the picture has been covered with an oil-varnish which neutralizes its colours—the wine-red of the angel's mantle, the golden-yellow and red stripes of the boy's dress, the brown, olive and green of the landscape, the orange and the pale-blue of the sky, and the white of the clouds—a varnish which it will be difficult to remove. For the same reason it has remained unnoticed that the coat-of-arms is that of the Bembo family, and this altarpiece is therefore probably our earliest document of the close relation between Titian and the humanist Pietro Bembo, about which we possess some later documents. It also contains the earliest of those loving portraits of animals in which Titian's *œuvre* is so rich.

95. Titian. *The Gipsy Madonna*. Vienna, Kunsthistorisches Museum.

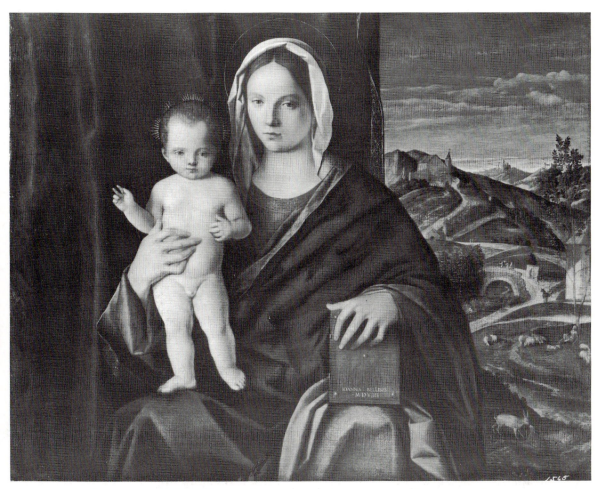

96. Giovanni Bellini. *Madonna and Child*. Detroit, Art Institute.

Finally, a picture painted for private devotion, the so-called *Gipsy Madonna* in Vienna (Plate 95). This name indicates that its painting of flesh has an extraordinary quality. It cannot be fully appreciated today because the surface has suffered considerably from rubbing: over the brownish tint of the Virgin there must have been red strokes as in the Padua frescoes, but they have almost entirely disappeared. Their effect was enhanced by the gold-green of the curtain and was in contrast to the bright-blue sky. The sky was covered by a dull overpainting, but this has been recently removed and the blue recovered, together with some of Titian's silvery white clouds in it. I have referred to this picture in connection with Bellini's late Madonnas. Its composition could well be compared with that of the Brera *Madonna* of 1510 (Plate 43), but perhaps even better with another Bellini, at Detroit, of 1509, our earliest example of the new form set in an oblong, invented by Bellini (Plate 96). Indeed, it is not impossible that there exists a concrete connection between these two works. X-ray photographs of the *Gipsy Madonna* (Plate 97)

have revealed a covered first version in which the resemblance to Bellini's Detroit composition is so great that one is inclined to see in the latter—or in an earlier version of it if one existed—the prototype actually used by Titian. I show you my diagram of the hidden version based on the X-ray photographs; it hardly needs comment. But you will also notice that this first version of the *Gipsy Madonna* contains some features which Titian must have borrowed not from Bellini but from his second master, Giorgione: the lightly bent head, the fine oval of the Virgin with the half-closed eyes, the playful curves of the veils surrounding both the Mother and the Child remind me of the Vienna *Laura* (Plate 59). The final version is considerably firmer and is more massive; in this respect it is reminiscent of Sebastiano's *Salome* of 1510 (Plate 89), with which it must be contemporary. The graceful head of the Virgin of the first version has been replaced by a stately oval which reminds one of late-antique representations of Juno; the right hand holds the drapery; the figure of the Child is like a statue, and like a statue it has a support in the hanging drapery. The whole composition has become more tectonic and is more clearly centralized. The interior forms are closely knit, and all of them lead the eye towards that heavy right hand of the Virgin which is a second centre, corresponding with the face. Here are the deepest colours in the picture: dark gold-green, dark-red, and blue. These alterations of the first version turned the *Gipsy Madonna* into a very personal creation of Titian and a worthy

97. Diagram of the X-rays of Titian's *Gipsy Madonna*.

monument of this important phase about 1510 in the development of Venetian painting.

Now this is perhaps the right moment to introduce the group of paintings which have often been claimed to be late works by Giorgione—the word 'late' of course in quotation marks. But, as you have seen, apart from the old Bellini, there were at least three highly gifted painters active in Venice in the second quinquennium of the sixteenth century: Giorgione, Sebastiano and Titian. All three were former pupils of Bellini, and the two younger ones were also students and assistants of the first who was their senior by not more than six to eight years; so we are told by reliable sources. Is it then surprising to learn that the same works have been and are attributed to Sebastiano and to Titian as well as to Giorgione? We must now look at the three most important paintings of this group.

First, the picture at Glasgow traditionally called *The Adulteress brought before Christ* (Plate 98). This title was challenged by the late Mrs. Tietze,[2] who pointed out that the figure supposed to represent Our Lord is a beardless youth, almost a boy, and that the scene is in

98. Giorgione (?). *Susanna and the young Daniel.* Glasgow, City Art Gallery.

open air, not in the interior of the Temple, as it should be according to the text. As the correct title she suggested 'Susanna and the young Daniel'; it refers to the apocryphal story, or novelette, added to the Apocrypha: how the 'young youth whose name was Daniel' convicted the two impostors 'who had waxen old in wickedness' of false witness, by examining them 'asunder one from the other'. This subject is rare in painting, but it does occasionally occur. The fact that the figure just mentioned is haloed is not an objection to this interpretation, for the prophets and other heroes of the Covenant were worshipped as saints, particularly in Venice, where there are churches of S. Moisè, S. Geremia, S. Giobbe—and, in point of fact, also of S. Daniele (the last suppressed). And another preliminary remark: the picture as we see it today is not complete; about a fifth of its original width has been cut away on the right. A small fragment of the cut-off part reappeared in the trade some twenty years ago and is now also in the Glasgow Gallery; the rest is known to us from a rather coarse early seventeenth-century copy at Bergamo, which for some mysterious reason has been ascribed to Giorgione's contemporary, Cariani. Originally the canvas was seven and a half feet wide, that is to say, larger than any known work by Giorgione.

This is a figure composition framed by two 'piers', the two soldiers seen from the back, and with movements leading from the sides to the centre. However it is a rather loose arrangement, differing in this respect from Titian's Padua frescoes. Further, in spite of the importance of the figures the horizon is unusually high and the ground is tilted and all the forms, architecture and trees, are abruptly cut off at the top. Action has been reduced to a minimum and more than one of the figures is depicted in a passive, or vaguely emotional, state of mind. The lovely landscape is a glimpse of a truly Arcadian world. One is, then, perhaps right in stating that, with regard to composition and content, there is little reason to object to the attribution of this picture to Giorgione, an attribution mentioned, by the way, as early as 1612. But some of the forms, especially those of the drapery, are larger and fuller than in Giorgione's authentic works. Motives such as the knotted mantle of Susanna or the tucked-up sleeve of Daniel appear as something new if we come from that world.

Only one of the engraved fragments of the Fondaco frescoes contains some indication that Giorgione's interest may have turned in this direction after 1507 (Plate 65); and the foreshortened head of this youth is not unlike Susanna's.

Then the *Concert Champêtre* in the Louvre (Plate 99). In this case, too, I must first comment on the present state of the picture. The original canvas has been enlarged on all four sides, more particularly at the top— enlarged rather wilfully, because its axis has been slightly tilted to the

99. Titian. *Concert Champêtre*. Paris, Louvre.

100. Reconstruction of the original format of Titian's *Concert*.

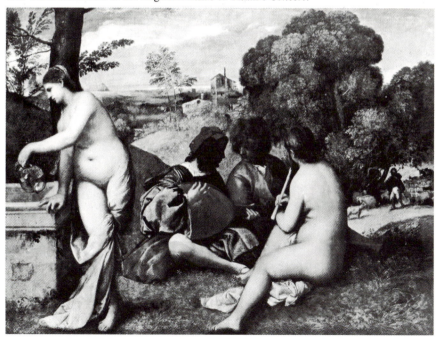

left. Plate 100 shows the original format, and it does not show the large branch which is in pigment of a later date. The dull strips along the edges are the overpainted traces of the original stretcher-frame. My reconstruction has been confirmed by two recently discovered seventeenth-century copies; one of them is a wash drawing dated 1672. We learn from it that the group of trees on the right has also been overpainted in places: the effect of the sky seen through the branches has gone.

I should also like to ask you not to see in this picture just an early version of the *Déjeuner sur l'herbe*. A paper by Patricia Egan[3] is the first serious attempt at interpreting the subject exactly. The world that is rendered in it is an ideal one, and is conceived on the lines of the Arcadian poetry of the early Cinquecento. It is, shall we say, the full realization of what Giorgione aimed at in his art, on the evidence of his authentic works. But was it painted by him? It is certainly fairly close to the Glasgow picture, though it is perhaps more advanced, or more mature. Now, both these pictures were called Giorgione in the seventeenth and eighteenth centuries, and have been given to other artists later. Recently the name of Sebastiano seems to have been definitely dropped—certainly correctly. But Titian's authorship has many serious supporters among students. They rightly point to the great similarities with Titian's works in details, in the colour-scheme, and in the handling. They draw attention to the indeed striking difference that exists between this figure at the well and, for instance, the *Judith* in the Hermitage. To this the adherents of Giorgione's authorship may answer that the two pictures, the *Judith* and the *Concert*, belong to the beginning and the end of the same decade which saw the rise of the young Raphael from, let us say, the *Crucifixion*, now in the National Gallery, to the *School of Athens* in the first Stanza. And they may perhaps once more refer to the Fondaco frescoes.

In conclusion, I show you a third picture of the group without comment, except that this comparatively small canvas in the Prado is unfinished (Plate 101)—the blue mantle of the Virgin and the lower region of the background are only underpainted—and that I have found a partial but very exact copy of the Virgin in a work dated 1511, and so the early origin of this picture is established.[4] It is just three feet high and is in perfect condition.

Vasari's devoted friend and helper, the Dominican Vincenzo Borghini, one of the finest connoisseurs in sixteenth-century Florence, possessed, among other things, two drawings which he placed side by side in his album: one by Donatello, and one by the young Michelangelo; and he wrote below them as a caption in Greek: 'é Donatos buonerotizei, é Buonarrotos donatizei' (é, é = either, or).

I have stated the problem and given the reasons why it is so difficult

101. Titian. *Virgin and Child with St. Roch and St. Francis*. Madrid, Prado.

to solve. There was great hope among students in 1955 that they would be able to see these three pictures, and the Dresden *Venus*, together with authentic works by Giorgione, by the young Sebastiano, and by the young Titian; and that they would be able to study them at close quarters and in the indescribable light of Venice in which they were painted. But the Giorgione exhibition of that year, unsatisfactory for many reasons, could offer such an opportunity only in part. The Glasgow picture and that from the Louvre were there, and they were placed on two easels in the same small room. This close vicinity turned out to be rather embarrassing, first because of the very different condition of the two—one recently and very thoroughly cleaned (but obviously cleaned before); the other covered with a thick layer of yellow varnish—secondly, because it became clear that they belong to different classes: one—the picture in the Louvre—destined for the intimate room of a collector, the other perhaps for a public place, to be seen from a distance, and therefore more summarily handled. The Venetian light greatly helped one to enjoy all the beauty of the *Concert*; it made the *Susanna* look naked (or worse). Still, before reaching them, the visitor did pass

in front of a great many Venetian pictures of the early Cinquecento, among them authentic works by Giorgione, Sebastiano, and Titian, and, entering the room, he was faced—whether he liked it or not—with the problem of attribution there exhibited. The solution arrived at in these circumstances was necessarily a personal one. The reviewer of the *Burlington Magazine*, my friend Giles Robertson, decided on Giorgione for both.[5] Should it be of any interest for you to know my vote, I could only confess that I saw Titian in every stroke in the *Concert*, and also in its design: it is inspired by Giorgione, yes, in the most concrete sense of the word, but it is not done by him. On the other hand, both the conception and the design of the *Daniel and Susanna* seemed to me to be by Giorgione, who, however, may have left the execution largely to his studio, which was, as we have seen, unusually well staffed in those years. And I would venture the suggestion that the Glasgow picture was the canvas commissioned from Giorgione for the Council of Ten while he was engaged on the decoration of the Fondaco façade.

So I have to conclude with a question-mark—a not unusual course in our field. It demonstrates once more that the individual work of art is both the beginning and the end of all our endeavours. But the query can and should be solved by your own good efforts of looking at and comparing the works. The young have some advantages in doing this. It is easier for them to clear themselves of all sorts of sorrows, to shut themselves off both from external and internal obstacles, and be alone with the work. Their perceptions are clearer, their receptivity is more vivid, and their memory more plastic. Older age may have the advantage of greater patience, and its range of experiences may be wider.

Experience led me to formulate certain principles which I used to repeat with a kind of obsession: look at the work of art, look at it long, look at it again, and think about it. Always study the whole and do not yet get lost in details. Try first of all to reintegrate the work in the form in which it was intended by its creator, the form which is rarely given us directly. Consider the purpose of the work: it is more often than not a determining factor in producing the individual features of the work. Works of the same date and by the same artist can be very different if they had to serve different purposes. And so on. Commonplaces, I agree, but I firmly believe in their importance for our studies.

Titian: the early years (1510–20)

So far I have tried to outline the changes which were brought about in Venetian painting in the first decade of the sixteenth century through the activities of Giovanni Bellini and three of his pupils, Giorgione, Sebastiano, and Titian. In the following decades the position of one of these, Titian, became predominant, and the further development of Cinquecento painting in Venice is mainly determined by this fact. A survey of his career is, therefore, our next subject.

The greatness of Titian as an artist was solidly founded on three great qualities. First, the exclusiveness of his choice of painting as the language in which to express himself. Unlike most of his great fellow-artists in Italy, Titian never felt any temptation to undertake experiments in arts other than painting. But this did not mean any sort of short-sighted specialization. The closest friends of Titian in his maturity were a sculptor and architect, and a writer; and for more than thirty years this triumvirate, Titian, Jacopo Sansovino, and Pietro Aretino, were able to exercise sway in all artistic matters in Venice. In addition, Titian's social abilities, his tact and amiability as a host, were praised by people of all ranks. Yet he always remained a painter, nothing but a painter.

On the other hand, as a painter Titian was universal—that was another of his great qualities. He was well acquainted with the whole range of tasks which were offered by the society of the sixteenth century to painters, and he devoted the same intensity of artistic passion to every one of these tasks. This universality of Titian is hardly matched even by that of Raphael: it is indeed unparalleled in sixteenth-century painting.

The third main quality of Titian is best expressed in the words of his contemporary Giorgio Vasari. Vasari writes: 'Titian has been very sound in health, and as fortunate as any man of his kind has ever been; and he has not received from Heaven anything save favours and blessing.' That this means something positive, or active, on the part of the subject himself—that it means man's ability to guide his own destiny—is made clear in Vasari's next sentence: 'Titian has had in Venice some competitors but not of much worth, so that he has surpassed them easily with the excellence of his art and with his power of attaching himself and making himself dear to men of quality.' What the lack of this faculty,

and of all it involves, meant for an artist of the Renaissance can be studied in many examples in other chapters of Vasari's *Lives*.

We have good reasons to accept Vasari's judgement on this point, He was a keen observer of the relation between artist and public and made it one of the central problems of his book; and this book largely contributed to bringing about a fundamental change in this relation and to freeing the artist from the remnants of his former status. On the other hand, Vasari also knew Titian very well. When he was thirty, in 1541–2, he stayed at Venice for half a year; and as he had gone there on Aretino's invitation he must have seen Titian very often. Four years later Vasari was given as a guide to his senior colleague when Titian visited Rome and lived for eight months as the pope's guest in the Vatican. And Vasari went to Venice once more, in 1566, when he was preparing a new edition of his history, in which he gave us a detailed account of his visit to Titian's studio. Although the chapter in which this account is included contains many errors of detail, it proves to be surprisingly correct in all essentials.

We may, then, repeat from Vasari that circumstances seem to have favoured Titian's career right from the beginning. The death of his second master, Giorgione, in the autumn of 1510 and the change of residence of his gifted fellow-student Sebastiano a few months later left him alone in Venice, without any serious competition. Giovanni Bellini was at that time well over seventy, and all his other pupils were comparatively insignificant; the best among them, Jacopo Palma, had not yet found his own way. Without having to struggle much to make a career, Titian was able to concentrate all his energies on the many and diverse tasks which he was required to undertake. But he did more than that. He immediately challenged Bellini's position, and by doing so he secured for himself the succession as the official painter of the Serenissima on Bellini's death in 1516. He was then probably about thirty. Since contemporary statements on Titian's age are hopelessly controversial, one has to find the appropriate date of his birth with the help of certain dates of his later career. These suggest that Titian belonged to the generation of Raphael and Andrea del Sarto rather than that of Fra Bartolommeo and Michelangelo; in other words, that he was born in the mid-1480s. But this statement does not mean much for Titian's art, for the law of generation is valid only within a closed cultural community, which Italy at that time was not.

In two of the Padua frescoes of 1511, and in other works of Titian immediately preceding and following them, a strong Giorgionesque influence is apparent. At the same time we notice how keen the young artist was to learn from works of modern art produced in centres other than Venice. Underneath the actual picture of the *Noli me tangere* in London (Plate 102) X-ray photographs have revealed a latent first

version—as they have done in so many Venetian paintings of these years. In that first version Christ is seen in profile, but stepping in the opposite direction, wearing a gardener's straw hat. His head is turned towards the Magdalene; her figure is closer to its typological origin, the Old King in representations of the Adoration of the Magi, and her silhouette is lower.

For the final version of the figure of Christ Titian has, I believe, used an engraving of Marcantonio after a design by Raphael (Plate 103). This print was, in all probability, published in 1510, and the picture must be of the same year, or of the next. The borrowing is indicative of a new orientation in Venice, for Raphael himself, in formulating this ideal of the female nude, followed the classic canon established by Leonardo in his *Leda* (Plate 104 is a drawing by Raphael after Leonardo). The filiation from Leonardo to Titian is part of the movement which led to the High Renaissance in Venice.

Leonardo was not the only source to attract Titian's attention. There exists, you will probably remember, a dashing composition study for one of Titian's smaller frescoes in the Scuola del Santo, the *Jealous Husband* who killed his wife (Plates 105 and 106), with its unsuccessful effort to design the foreshortened body of the victim on the lines of Bellini, though with more passion. Then Titian must have learned about the masterly solution of this artistic task by Michelangelo in the *Fall of Man* on the Sistine Ceiling (Plate 107) and decided to recast the whole design, though his attempt at finding an equivalent form for the other protagonist remained a failure. You will rightly ask: how could he know Michelangelo's fresco which was unveiled on 15 August 1511?

This trying to live up to the Florentine–Roman standard, but not always having proper prototypes to follow, also explains the weaknesses of the *Baptism of Christ* in the Gallery of the Capitol (Plate 108), although the boldness of the composition is remarkable, and the pictorial details are superb. Like the *Noli me tangere*, this picture was probably painted for a small chapel, to be seen from close quarters, and therefore its handling is very delicate: the head of the donor is of a miniature-like fineness, and the red mantle of Christ is a masterpiece of naturalistic still-life painting. But how welcome it would have been to Titian to know a figure such as, shall we say, Leonardo's *St. Jerome* in the Vatican, when he designed his figure of the Baptist! Compare for the curious kneeling pose Dürer's early engraving of the *Prodigal Son*.

Titian used his handsome Venetian model once more, with greater success, and, therefore, perhaps one or two years later, in his picture of the *Three Ages*, now in the Duke of Sutherland's collection on loan to the National Gallery of Scotland in Edinburgh (Plate 109). In spite of its allegorical subject, this painting is still a Giorgionesque idyll and a truly Arcadian scene. But it is also a perfect realization of the High

102. Titian. *Noli me tangere*. London, National Gallery.

Renaissance ideal of balanced composition. Unfortunately, it is cut slightly at the bottom, and considerably more at the top; its original proportions were 2:3.[1] In fact it is a spirited adaptation of Raphael's famous scale of figures in the centre of the *School of Athens*. One of the figures appears smaller because it is further away, and so symmetry and counterpoise are the result of a process which is both visual and mental—an artistic play much favoured by the Renaissance. By their complexity of movement the groups are close-knit, and have almost geometrically regular outlines. They are larger than in any of Giorgione's authentic works, but their drawing and modelling are as delicate as

103. Marcantonio Raimondi, after Raphael. Engraving of Venus.

104. Raphael. Drawing after the *Leda* of Leonardo da Vinci.

those of some of the controversial pictures which I have discussed such as the *Concert Champêtre* (Plate 99), or the unfinished *Sacra Conversazione* in the Prado (Plate 101).

Vasari made Giorgione a follower of Leonardo, but in fact a full understanding of Leonardo's ideals and achievements in Venice came somewhat later, through the activity of Titian. In his *Madonna with the Cherries* (Plate 110) the basic geometric form has been extended over the whole width of the oblong picture space, and, although it is

105. Titian. Study for the *Jealous Husband* fresco. Paris, Ecole des Beaux-Arts.

106 (*right*). Titian. *The Jealous Husband*. Padua, Scuola del Santo.

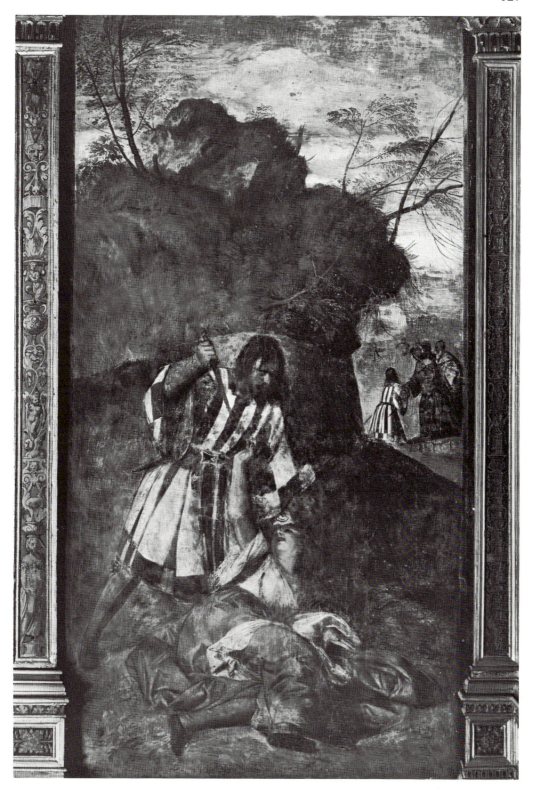

128

surprisingly regular it is not in the least rigid. The tender Child and the impetuous St. John—a motif characteristically borrowed from Dürer[2]—bring movement into the group from both sides, and the Virgin participates in these movements. It is a composition full of serene life. The heads of the two fathers, though they add to the significance of the content, are in the nature of accessories to the composition; and we know that they were an afterthought of the painter (they may have been suggested by the patron). In spite of the damage caused by age and repeated restorations, this picture is an emblem of the classical phase in the development of Venetian painting.

According to Vasari, Titian painted his *Tribute Money* (Plate 111) in Dresden for the door of the cupboard in the Alabaster Chamber in

107. Michelangelo. *The Fall of Man*. Detail from the ceiling of the Sistine Chapel, Vatican.

108 (*right*). Titian. *Baptism of Christ*. Rome, Capitoline Gallery.

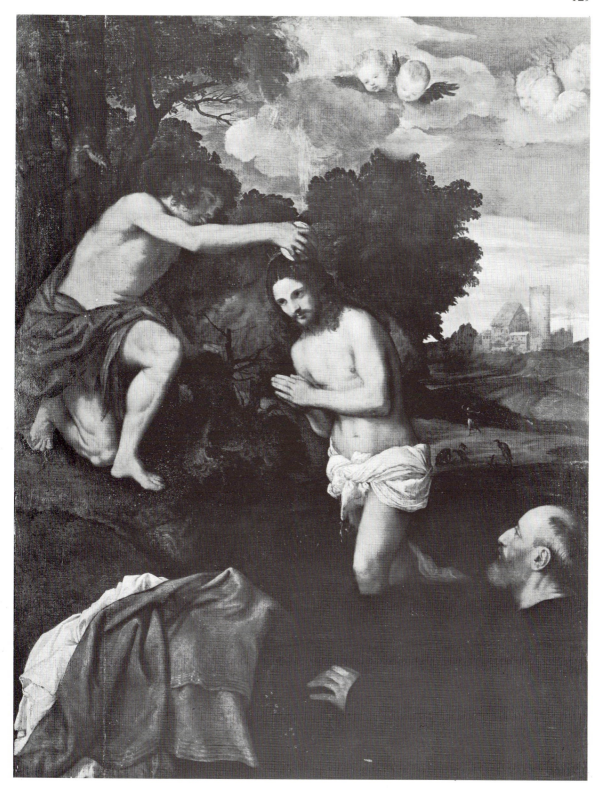

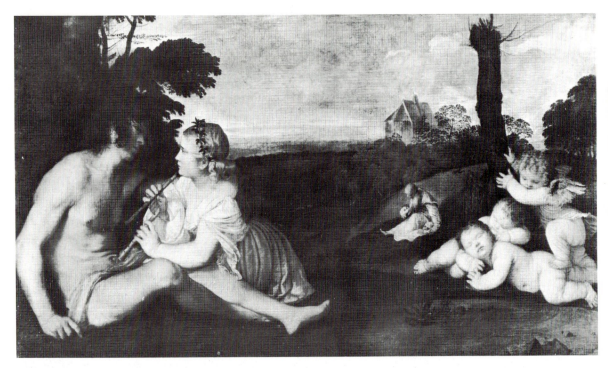

the Castle of Ferrara. This cupboard was probably Alfonso d'Este's safe, for some of the Duke's gold ducats show the same representation, together with the inscription taken from the Bible: *Quae sunt Dei, Deo*. As used by Alfonso this phrase was also an expression of his highly strained relations with the Church. Once again the execution of the picture is extremely delicate. The central motive, the contrast between noble and vulgar, has been emphasized by a dominant diagonal. The divine head was doubtless inspired by that in Leonardo's *Last Supper*, as is the juxtaposition of opposing characters, and the sharp profile of the Pharisee is reminiscent of his Judas. On the left, there are large planes of blue, red, and rose. The figure on the right is more plastic and shows many minute forms, rendered with unusually precise drawing. Here Dürer's influence is obvious. The flesh is brown on this side. The painter has humbly put his signature on the hem of the Pharisee's shirt.

The picture in the Borghese Gallery is the latest in the group of Giorgionesque paintings by Titian (Plate 112). It was commissioned, probably not before 1516, by the Great Chancellor of the Republic, Niccolò Aurelio, a humanist and collector. According to Professor Panofsky's convincing thesis, its subject was chosen from neo-platonic writings.[3] The right title should be *Geminae Veneres*, the Twin Venuses, the nude figure symbolizing the principle of universal and eternal love, the other that of a merely natural love. The painter has found an enchanting way of dealing with this abstract programme. The oblong

109. Titian. *The Three Ages of Man*. Edinburgh, National Gallery of Scotland. (Duke of Sutherland loan.)

panel of two and a half squares exactly repeats the form of the sarco-
phagus on which the nude is seated, just as in Sebastiano's *Salome*
(Plate 89) we found the blue rectangle of sky repeating the proportions
of the whole panel. The silver dish and the red copper spout indicate
the central axis. In the background there is a division similar to that in
the larger Padua fresco: a dark foil on the left, a bright landscape on
the right. So much is deemed sufficient to safeguard symmetry—a
symmetry with contrasts. The draped figure has been placed in the
centre of the left half; here there are only horizontal and oblique forms,
hardly any verticals. In shape and pose it closely resembles Michel-
angelo's *Joel*. The nude is framed by almost straight uprights: the
supporting arm and the drapery that has been broadened and spread
out on the surface as in Bellini's late works. In this way large planes of
warm colour have been arranged in the centre and help to build up a
unified group. Their riches are impossible to describe. They are the

110. Titian. *Madonna with
the Cherries*. Vienna,
Kunsthistorisches Museum.

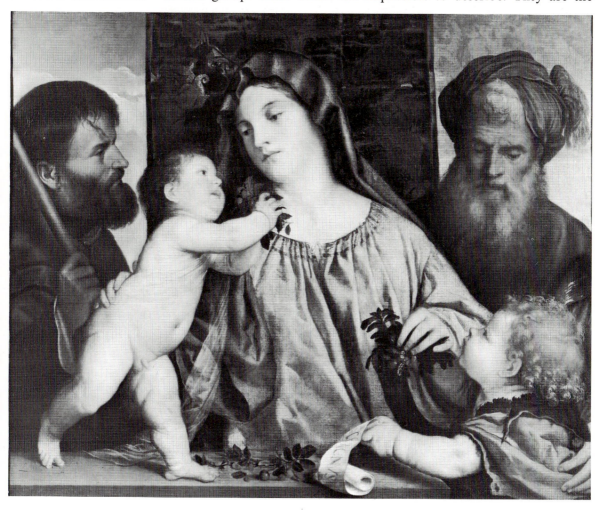

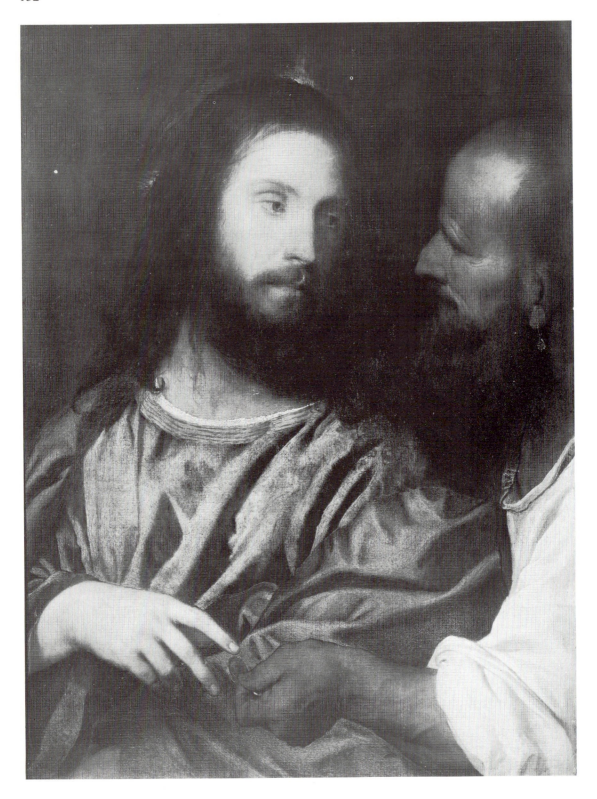

111 (*left*). Titian. *The Tribute Money*. Dresden, Gallery.

greatest contribution of Venice to the 'classical style' of the Cinquecento.

So far I have tried to group some of Titian's pictures round the only dated early work, the frescoes at Padua. Taken together, they cover a period of about twelve years, from about 1504 to 1516. And they cover the astonishing evolution that took place between the votive picture for Jacopo Pesaro and the neo-platonic programme painting for Niccolò Aurelio. But, it seems to me, the personality behind them is also manifest.

1516 is a significant date in Titian's biography: it is the date of his first public commission. For the following ten years we possess a very firm chronology of his works. This was a decisive period in his career. He established himself as a leading artist in Venice, and secured for his town as an artistic centre that significance which Rome alone had had before. All Titian's major works of this period are famous masterpieces, and are of as much concern for the rest of Italy as for Venice. They had a far-reaching influence, an influence which never ceased during the sixteenth century and had many revivals in the two centuries of the Baroque. This famous group of works consists of five altarpieces and three mythological paintings. Two of the altarpieces were executed for Venice, but all the other pictures were sent either to the west or to the south, to Treviso and Brescia, to Ancona and Ferrara. The two *pale* commissioned for Venice are the largest works in the series. Their execution covered the whole ten-year period from 1516 to 1526; the other works were executed concurrently. Titian's studio must have looked rather crowded in the years about 1520.

112. Titian. *Sacred and Profane Love*. Rome, Borghese Gallery.

The obvious stylistic differences which are apparent in the *Assunta* (Plate 113) and the *Pesaro Madonna* (Plate 114) should not be explained exclusively as symptoms of a change of style: they are, to a great extent, motivated or determined by the very different destinations

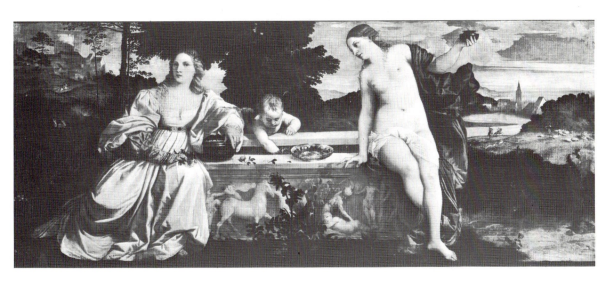

of the two pictures. They reveal the deep concern of the High Renaissance artist for the future setting of his work, and the inspiration which he derived from the particular circumstances connected with his task.

The *Assunta* is the altarpiece of the high altar in S. Maria dei Frari (Plate 113), the largest and the most beautiful of the Gothic churches in Venice. Titian's work was clearly inspired by the interior of this building, in which Gothic and Renaissance are in complete harmony. The elaborate curved structure against the back wall of the choir, which was to contain the altarpiece, was according to an inscription erected in 1516. It conforms with the character of the late-Gothic presbytery: it is very high, and both its framing columns and its entablature take account of the divisions in the church architecture. So does the picture, which was finished by Titian in May 1518.

It expresses, first of all, the natural movement towards the altar as a centre underlying the composition of all Gothic interiors. It is framed, a second time, by the opening of the screen; and in the painting the swag of angels repeats the arch of this opening reversed, thus completing the full circle. The figure of the Virgin is an isolated, dominant silhouette: she is the patroness of this church. But the composition also symbolizes the upward movement inherent in the forms of all Gothic architecture. The Virgin is placed high above the apostles, and the figure is, by her own force, moving upwards in a spiral. At the same time this figure is the peak of a high and very steep pyramid, the base of which is the central section of the group of the apostles. All gestures point upwards, as do the Gothic windows. A further correspondence: the horizontal *caesura* coincides with the division in the windows. Finally, the colour. The choir is built of red bricks and is ornamented with yellowish ones. These are also the two main colours in the picture. Thus the steep central pyramid is built up of three different reds: rose, vermilion, and crimson, and is surmounted by the brownish-red mantle of God the Father, while the Virgin is silhouetted against the golden-yellow halo of air. Both above and below light comes, as it were, through the neighbouring windows of the south side of the choir. As for the position of this work in the history of Italian painting, it is perhaps sufficient to point out that it preceded, and did not follow, Raphael's *Transfiguration*.

The *Pesaro Madonna* is above one of the side altars of the left aisle of the Frari (Plate 114). The Italians call such a large structure a chapel, even when it is erected against a church wall. This 'chapel' belonged to the family of Bishop Pesaro, the same prelate whose votive picture you have seen, and it was dedicated to the Immaculate Conception. It is also Jacopo Pesaro's burial-place. Its altarpiece is both a votive picture and a *Sacra Conversazione*, with some further connotations. On the left is the donor kneeling in prayer. He is a crusader and a missionary of the Church. Behind him the Borgia flag is held by the patron

113. Titian. *Assumption of the Virgin*. Venice, Basilica of Sta Maria Gloriosa dei Frari.

of the crusaders, St. Maurice, who leads the captured heathen, a Turk and a negro, to the Virgin's throne. Above the group is an olive branch, the symbol of peace; and still higher up the cross of the triumphant Church. The intercessor is St. Peter, the first head of the Church, holding open the sacred book of Christian Community. On the right are the two principal saints of the Franciscan Order, Francis and Antony— the Frari is the main Franciscan church in Venice—and some members of the donor's family. The picture was commissioned from Titian in 1519, obviously in consequence of the success of the *Assunta*, and was unveiled in December 1526.

Unfortunately, I have got no photograph to show you its actual place in the church. Whereas the *Assunta* sums up the whole interior of the church, the *Pesaro Madonna* is on its margin and extends the interior. It contains three large groups—one formed by a single figure and the surrounding draperies—groups distinct one from another also in their colour; they are arranged diagonally in space, and are surmounted by a canopy of clouds. Their oblique sequence is answered by a second diagonal, the end of which is the more distant column. It has been observed that the two huge columns, which were undoubtedly suggested to Titian by the giant round pillars that separate the aisles from the nave in the church, were an afterthought, and that originally he had chosen a coffered barrel-vault, that is to say a continuation to the arch of the altar-frame, for rounding off the composition. So the final solution has again taken into account the architecture of the whole church since one approaches the picture diagonally from the nave. However the forms which so powerfully indicate recession are of neutral colour and therefore their effect is not full (the black-and-white of the photograph is misleading in this respect). The consistency of the picture plane has not been given up. There is no rational ground-plan to this edifice—as anybody can realize by attempting to draw it—and at any rate the places which the donors occupy have not been fixed by the painted architecture: their compositional role is clearly to emphasize that surface.

Of the other three altarpieces—they are contemporary with the first stage of the work on the *Pesaro Madonna*—the one at Ancona is the most impressive (Plate 115). It was painted for the high altar of the late-Gothic church of S. Francesco della Scala, and was commissioned by a Venetian, Alvise Gozzi; the saint behind the donor is his patron S. Alvise; the other is St. Francis. This *pala* is signed and dated 1520.

This transformation of the Quattrocento scheme of the *Sacra Conversazione* has usually been connected with Raphael's *Madonna di Foligno* of 1511–12 (Plate 116) in which the saints stand free in the landscape with the Virgin and Child detached from them as their vision. No doubt this is the prototype which was followed by Titian. But we

also find some important differences. In Raphael's picture the Madonna is seen in a *mandorla*: that is to say, she belongs to another sphere of reality, marked as such also by differing colours. This device is a survival of the Quattrocento conception of Heaven as a second reality that exists beyond our sky, and at which one may occasionally throw a glance through some opening in the sky. In this case the Virgin has

115. Titian. *Madonna and Saints*. Ancona, Museum. 116 (*right*). Raphael. *Madonna di Foligno*. Rome, Vatican Gallery.

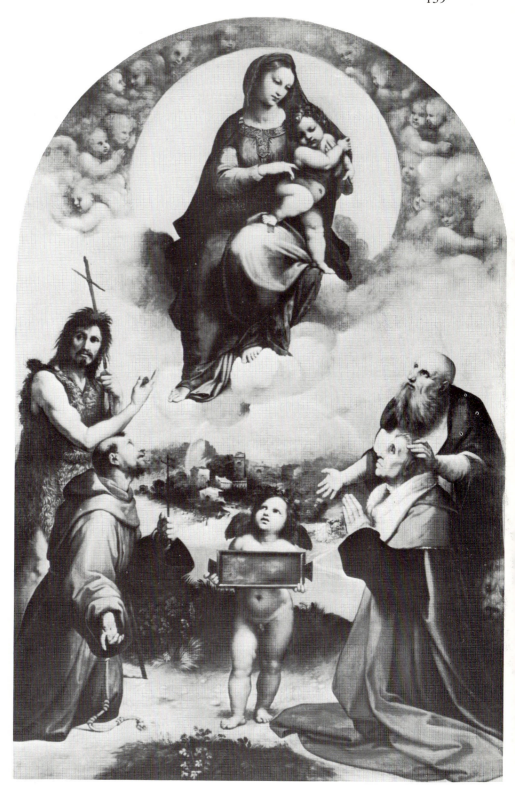

descended on the clouds through an opening (the *mandorla*) as a *deus ex machina*. Further, the mood in Raphael's painting is purely contemplative: in Titian's *pala* it is emotional, almost with a touch of pathos. Titian has created a unity of space, colour, and movement. The clouds have come from a distant region, their origin lies in the mist over the lagoons; they only become comparatively plastic in the nearest zone, where they serve as a foil to the figures. The outlines of the figures have been kept straight, in order to emphasize the surface. They are silhouetted against the distant vista and the sky, and so is the branch which serves as a link between them. Like the campanile on the faraway horizon, all forms point upwards: this is a means of expression. Raphael gave evenly modelled figures and clearly defined local colours. In Titian we find dark and broken tones, which secure a connection between figures and surroundings. No one else was able to achieve this kind of unity in Italy about 1520.

The altarpiece at Treviso is a particularly interesting example of the way in which Titian took his inspiration from the structure of the room which it was his task to decorate. The chapel was built by the Prelate Broccardo Malchiostro in 1519. It consists of a square, domed room and a semicircular apse, in which the altar stands. Titian's picture of the *Annunciation* (Plate 117) was finished by the end of 1522; it has suffered greatly from restorations, but its composition has not been altered. As you see, the painter has deliberately continued the architecture of the chapel in the picture, and has shown us this unity in a particularly effective way. The strongly emphasized linear perspective prescribes to the spectator a view-point which lies well to the right from the central axis of the room. It is a comfortable view-point, because standing there one is not blinded by the only window—the window through which, it is suggested, light is also falling into the painted room; while the supernatural light, the rays breaking through the foliage of the tree, drives the angel forward, and brings the eye back to the picture plane, to the wonderfully calm and humble figure of the Virgin. The donor has been given a place outside the room—very much as the hermit in the *Three Ages* is seated on a hill in the middle distance. But the equipoise and balance of that allegory have here been replaced by movement and dynamic concentration. So this comparatively small *pala* possesses something of the power of the *Assunta*.

A polyptych with the central scene of the *Resurrection* (Plate 118) was commissioned by Bishop Averoldo for the high altar of the early Renaissance church, SS. Nazaro e Celso at Brescia, at that time the westernmost town of the Republic. The church was rebuilt in the eighteenth century, and the original altar-frame was replaced by the present neo-classical one. The work is dated 1522, but we know from Titian's correspondence that it was in hand in 1520 at the latest. The form had

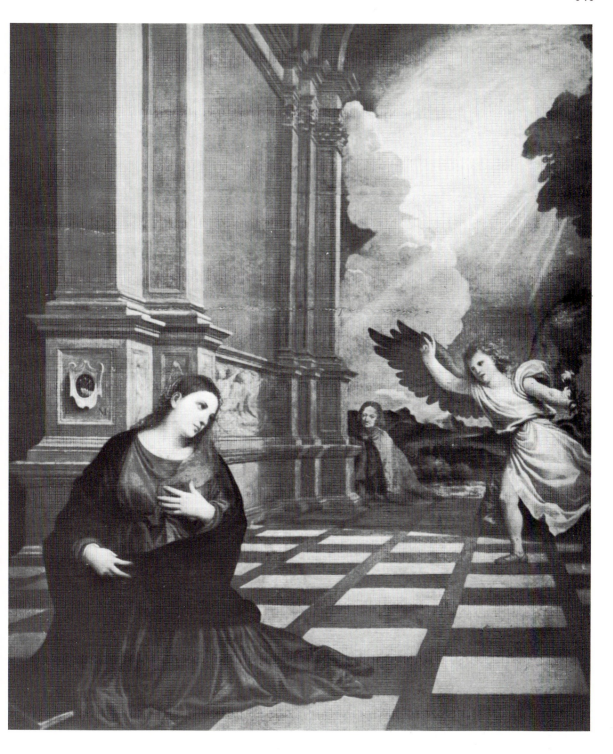

117. Titian. *Annunciation*. Treviso, Cathedral.

118. Titian. *Polyptych with the Resurrection, Annunciation and Saints.* Brescia, Church of SS. Nazaro e Celso.

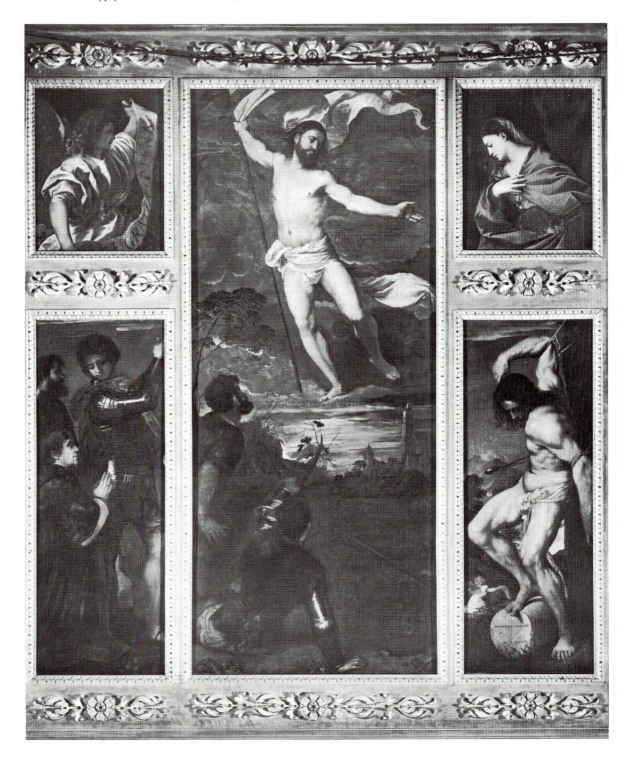

first been used in Venice in the 1460s to replace the Gothic polyptych, and it was already obsolete in the early sixteenth century, but it survived in the provinces. Titian used it in a rather unorthodox way. He filled each of the small spaces with large and highly plastic full-length or half-length figures; and, at the same time, he also tried to attain a compositional unity of the whole structure. You may notice even in a poor photograph what is rather conspicuous in the original: that the square of the polyptych is divided by a diagonal into two unequal halves, one bright and one dark. The lower left is also different in style: it is Leonardesque–Giorgionesque. Here the dark colours of the draperies prevail. The other half is dominated by the two plastic nudes and their pale-rose flesh-tints. The left side is calm, the centre and the right are full of movement. To paint these figures Titian again had to make studies from sculpture, as Sebastiano had done before him in Venice, and his fellow-painters in Central Italy were doing. Indeed the figure of Christ is obviously modelled on the Hellenistic Laocoön; and St. Sebastian is a combination of two slaves designed by Michelangelo for the Monument of Julius II between 1513 and 1516.

Titian: the middle years (1520–40)

OTHER traces of Titian's studies in sculpture can be found in the three mythological paintings executed for Alfonso d'Este's Alabaster Chamber between 1518 and 1523.

We know for certain discouragingly little about this monument which was dismembered before the end of the sixteenth century; therefore it is not surprising that the first attempts to reconstruct its appearance are quite recent. Vasari, who visited Ferrara twice, seems to have had no opportunity of taking notes on the spot, and his recollections were rather fragmentary and in part demonstrably confused. The information given by him can be supplemented to some extent from surviving fragments of the Duke's correspondence and from later inventories. Of the alabaster decoration of the room, which was executed by the Venetian Antonio Lombardo, scattered fragments have survived, but their context is entirely unknown; and of the eight pictures which were the main ornament of the room we only possess five, most of them more or less badly cut down. An article by Eugenio Battisti contains a reliable survey of the sources and some cautious suggestions as to their use for a reconstruction.[1]

The room seems to have been an oblong at least twenty feet long, with doors on its smaller sides and two windows in one of the long walls. The other long wall was ultimately decorated—ultimately, because there is some evidence that the scheme underwent changes during the execution —with three large pictures of equal size: Bellini's *Feast of Bacchus* (Plate 45) in the centre, Titian's *Cupids* (Plate 119) on the right, and his *Bacchanal* (Plate 120) on the left. Adjoining this series at right angles, that is to say on the short walls, were on the right Dosso's *Fest of Cybele* (now in the National Gallery), and opposite to it on the left Titian's *Bacchus and Ariadne* (Plate 121). There were three other pictures on the other long wall. Of the three pictures by Titian the *Bacchus and Ariadne* was the last to be executed: Titian was working on it in the summer of 1522 and it was finished on the spot early the next year. The two pictures now in the Prado were painted some time after April 1518, and it is generally assumed that the *Garden of Love* was executed first. One can understand that the *Cupids* were followed by the Treviso altarpiece and that the *Bacchanal* is contemporary with the *pala* at Ancona. The

119. Titian. *The Garden of Love*.
Madrid, Prado.

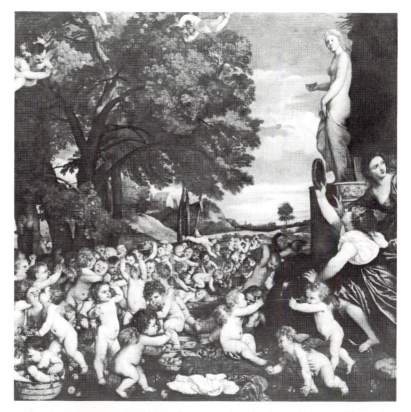

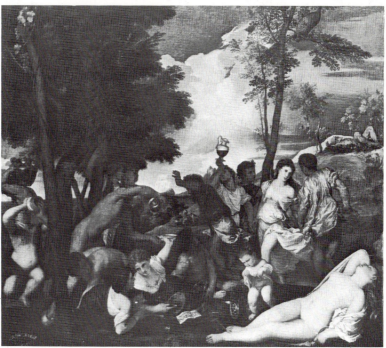

120. Titian. *The Stream of Wine on
the Island of Andros*. Madrid, Prado.

Bacchanal or, as it should be called, the *Stream of Wine on the Island of Andros*, seems to be the only one which has not been cut into to any extent. The subjects were chosen partly from the *Eikones* of the third-century Greek writer Philostratus, a book containing descriptions of imaginary paintings, and partly from Ovid's *Fasti*. It was also an Antique idea to make this consistent decoration at the same time a gallery of contemporary art in Italy. The alabaster decoration was finished in 1508; the Bellini was probably commissioned soon afterwards, and attempts were made to secure works for the series from Michelangelo, Raphael and Fra Bartolommeo. Battisti's reconstruction is supported by the peculiarities of lighting in the room and in the five surviving pictures.

121. Titian. *Bacchus and Ariadne*. London, National Gallery.

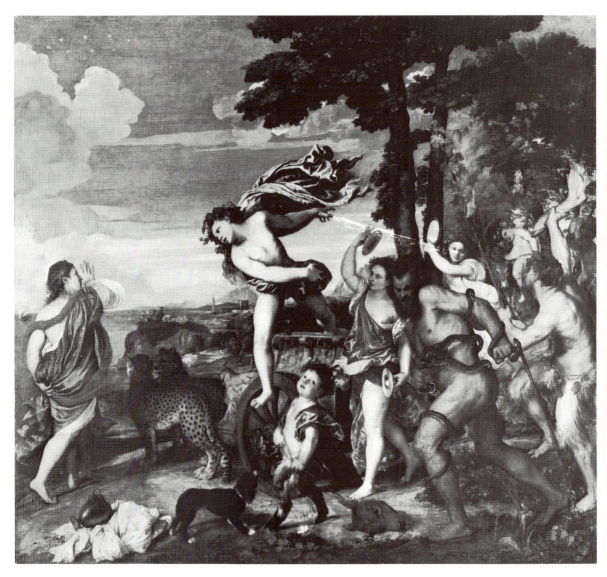

Looking at the cycle with the mind's eye, one can understand why Titian had to correct Bellini's 'still-life of figures'. How different is the way in which Titian dealt with his subjects which later he used to call *poesie*, poems. They look rather different from his religious paintings; and yet the unity of the creative power connects the two classes. For here, too, movement pervades all the figures and the whole of the composition, movement which is made more effective by the contrast between reclining figures and one sleeping one. It is this movement that had already led Titian beyond the harmony of the 'classic style', to a style founded on intense emotion. This emotion is present in the sleeping nude of the *Bacchanal* as well as in the angel-putti round the *Assunta*. The world rendered in these pictures has been ennobled by poetry, and also by exalted admiration for the ancients characteristic of the age of Humanism: in Titian's work it has been made real by an exuberance of vitality and gaiety. Nature itself has been changed in this sense: the large and tender trees are moved in all directions; a hundred tones of yellow, green, and red appear in the leaves round the old Silenus on the hill, who is pressing out the juice of the grapes with the weight of his body; the driving clouds reflect all these colours. The score on the ground beside the ladies is that of a French–Italian song:

> *Chi boit et ne reboit*
> *il ne çais che boir soit.*

This, then, is not merely illustration of a text: the artist felt as those ancients felt whom he admired. To give expression to this conception of Antiquity was a creative act of the highest order, entirely original and very far-reaching in its effect.

I feel that Titian must have known Michelangelo's *Bathers* (Plate 122)

122. After Michelangelo. *The Bathers*. Holkham Hall, Earl of Leicester Collection.

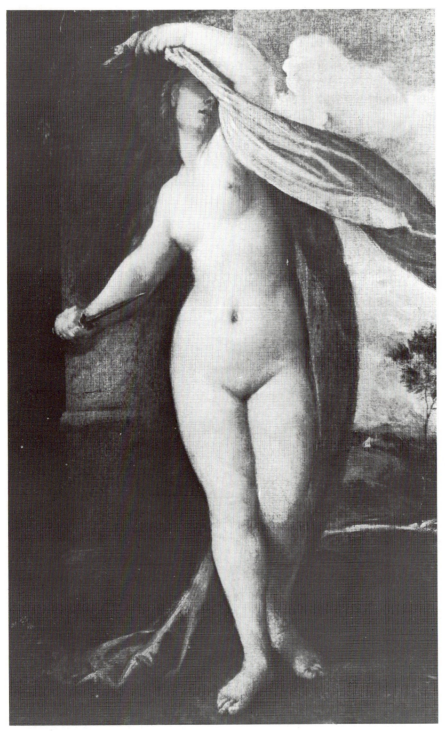

123. Titian. *Lucretia*. Hampton Court, Royal Collection (reproduced by gracious permission of H.M. The Queen).

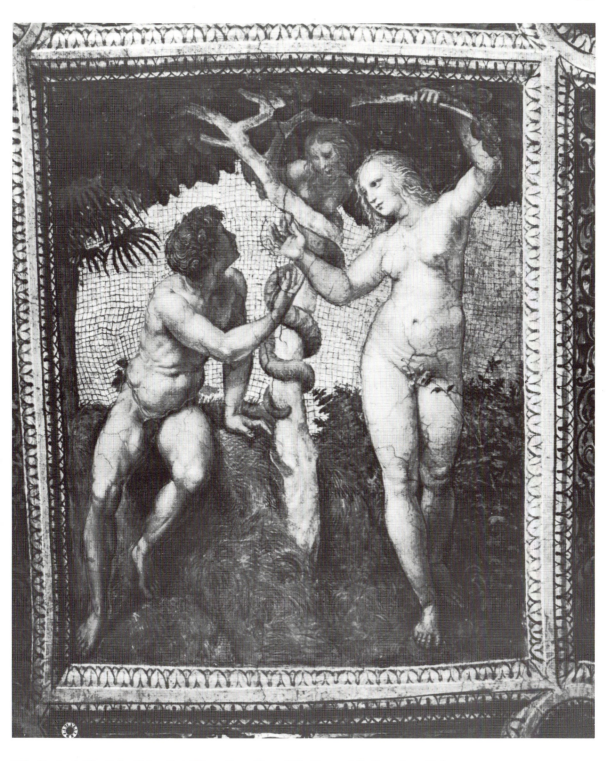

124. Raphael. *The Fall of Man*. Detail from the ceiling of the Stanza della Segnatura, Vatican.

from some copy when he conceived the group in his Island of Andros. As a matter of fact, there are at least two obvious borrowings, one rather precise. Other motifs are taken from antique sculpture. The male nude under the trees pouring out wine is one of Niobe's sons, both figures on the extreme left have antique prototypes, and, of course, the sleeping nude is taken from the *Ariadne*. But, unlike the works of ten years before, all these insertions have been completely assimilated, and are therefore difficult to recognize. However, I should like to mention as a telling curiosity that Titian's third picture, the *Bacchus and Ariadne*, is simply called in a late sixteenth-century inventory, 'the Laocoön', with reference of course to the bearded Bacchant with the snake in the group, on the right.

Little is known to us about Titian's activity in the second half of the 1520s, except the fact that in 1525, that is to say before he finished the *Pesaro Madonna*, he was the winner in a competition for another large altarpiece, that of *St. Peter Martyr*. Two pictures of his may date from this period: the *Lucretia* in the Royal Collection (Plate 123), and the *Entombment* in the Louvre. To associate the former with the nude in the *Bacchanal*, and the kind of landscape which we find in the same picture hardly needs explanation; but it is also a most informative case of the adaptation of a prototype. The model was, I believe, once more a work of Raphael executed soon after his arrival in Rome, in about 1509 (Plate 124). During the recent cleaning of the Hampton Court picture a first version of the head became visible: it was exactly the head of Eve, turned to the left, as on the ceiling of the Stanza della Segnatura. By changing this head and adding the drapery, Titian has not only hidden his borrowing, but he has also imparted a new feeling, an emotion, and an expressive power to his figure, very much on the lines of his other contemporary works, both pagan and religious.

The *Entombment* is composed like a frieze, or like a sarcophagus relief (Plate 125). It has been enlarged slightly at the bottom, more considerably at the top. Please do not regard this constant pointing out of enlargements and cuts as an obsession of mine. Cinquecento compositions were conceived and organized in such a way that any alterations of their size and shape can affect their meaning and, therefore, our judgement. In this picture *one* feeling determines all the movements, all gestures and gazes: it is pathos in the Greek sense of the word. The centre is overcast by deep shadow—but the spectator knows what is happening. The general outline of the group resembles that of the opening of a cave. The figures form an arch that protects the dead Saviour. The principal forms of the relief lie more or less in the same plane; a simple landscape and the sky form the background. Red and olive are the dominant colours in the centre; the dress of Mary Magdalene is orange, the Virgin's mantle is blue. All these colours reappear in the

sky. The execution is very careful: the brush-work is free in places as a calculated artistic effect; these passages are like precious stones set on a medieval casket.

The competition for the altarpiece of St. Peter Martyr was won by Titian against Jacopo Palma and Pordenone. The composition by the former, which was then executed for a church in the provinces, and the *modello* (a carefully finished drawing) by the latter suggest that all the particulars of the subject matter were exactly prescribed. They were certainly welcome to Titian at this stage of his development. He finished his picture in 1530 (Plate 126). It was taken down for cleaning and was destroyed by a fire some eighty years ago. Its original frame exists and now contains a copy. Vasari speaks of the lost original in these terms: 'This work is the most finished, the most celebrated, and the best conceived and executed that Titian has ever yet done in his life.' Another contemporary, Lodovico Dolce, in his *L'Aretino*, is dithyrambic about it. More interesting is Cavalcaselle's detailed description, the last based on knowledge of the original.

Like the *Pesaro Madonna* in the Frari, the *Martyrdom of St. Peter Martyr* was the ornament of a side-chapel in the left aisle of the second

125. Titian. *The Entombment*. Paris, Louvre.

126. Engraving after Titian. *Death of St. Peter Martyr*.

largest Gothic church of Venice, S. Zanipolo. Its composition some-
what resembles that of the Frari picture, with the trees taking over the
role of the columns. But the colour-scheme was based on a hot red,
white and black in the figures, on green and blue in the landscape. And
there is much more movement here, indeed more than in the mythologies.
This is something entirely novel in an altarpiece, and the fact that the
church authorities themselves chose this highly dramatic event as the
subject proves that taste in Venice had moved in the direction that
had been influenced by Titian's previous altarpieces and, before that,
by Michelangelo's ceiling. It is perhaps not too far-fetched to compare
the fleeing companion of the saint with Haman (Plate 127). We know
from later works by Titian that he did study this particular fresco. So,
once more, a quarter of a century after the *Tempesta* (Plate 53), we
have here a 'landscape with figures'. But this is a new application of
Giorgione's principle: the frenzy of the figures has been taken up in
the landscape. Plate 128 shows a contemporary drawing by Titian,
perhaps done when he was preparing his altarpiece: the trees are heroic
individuals and are as full of movement as the nudes in Michelangelo's
Last Judgement.

Now we may stop for a moment to consider the position reached by
Titian when he finished the third of his large altarpieces for the principal
Venetian churches. Since 1516 he had been the official painter of the
Serenissima. Then he had held his triumphal entries at the most important
princely courts in North and Central Italy—Ferrara, Mantua, and
Urbino—to work for yet another type of patron. In consequence of these
connections he appeared twice, in 1530 and 1533, at Bologna, painted
the Emperor and was knighted by him. Both his repute and his social
position were firmly established. One may say that in the second third
of the century, next to Michelangelo, who was in the service of the
popes, Titian was the best-known artist in Italy. His fame with his
colleagues derived mainly from his portraits and from the altarpieces
which he had executed between 1516 and 1530. These were his chief
contribution to the art of the High Renaissance. They represented an
altogether new class of religious painting, and had their only analogies
in, but were independent of, Raphael's *Transfiguration*, the works of
Correggio's maturity, and some of Andrea del Sarto's last altarpieces.
Later they were a constant source of inspiration for the Seicento. By
contrast some of Titian's early Giorgionesque pictures, as well as those
painted by him in the 1530s and 1550s—that is the works of the three
lyrical periods in his development—exercised a great influence in the
eighteenth century.

This newly won position greatly favoured Titian's universality as an
artist. From now onwards he became acquainted more rapidly than
before with the different trends in contemporary Italian art, and re-

127. Michelangelo. Detail of the *Crucifixion of Haman*. Ceiling of the Sistine Chapel, Vatican.

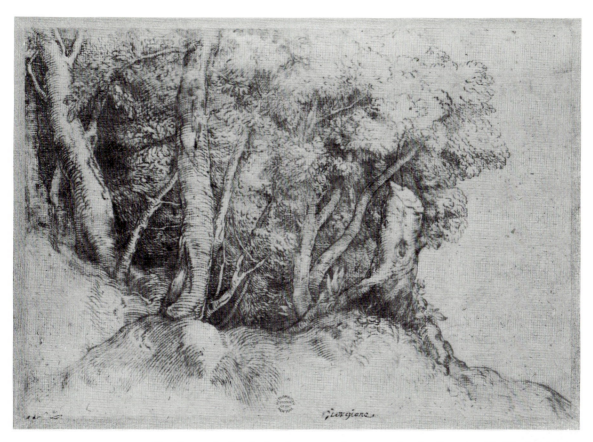

128. Titian. *Landscape study*. New York, Metropolitan Museum.

flections of what he had seen can be more clearly discerned in his paintings. But he also kept an eye open for what his Venetian colleagues were doing. For instance, in the Louvre picture, called *La Vierge au Lapin* (Plate 129), which is datable about 1530, he was obviously delighted at devising a composition in the manner of his fellow-artist Jacopo Palma. Palma died in 1528; that Titian was interested in his art is proved by the fact that he completed a picture left behind by Palma unfinished, a large *Sacra Conversazione* now in the Accademia in Venice. This picture, too, may be classified as a *Sacra Conversazione*, although there is only one saint here, St. Catherine, but it follows a new type of that iconographical scheme, a type which we associate with Palma. In its form this new type derived from the Giorgionesque idyll, which was moulded by Palma according to the rules of the 'classical style'. To this composition he would have added the symmetrical figure of a second saint on the right, whereas Titian still preferred the 'spatial balance', with figures on scales in different zones. Iconographically I believe the origin of this type lies with the idyll of the Rest on the Flight into Egypt; in fact, in its earliest examples one can often find St. Joseph and the donkey somewhere in the background as evidence of this origin. Here

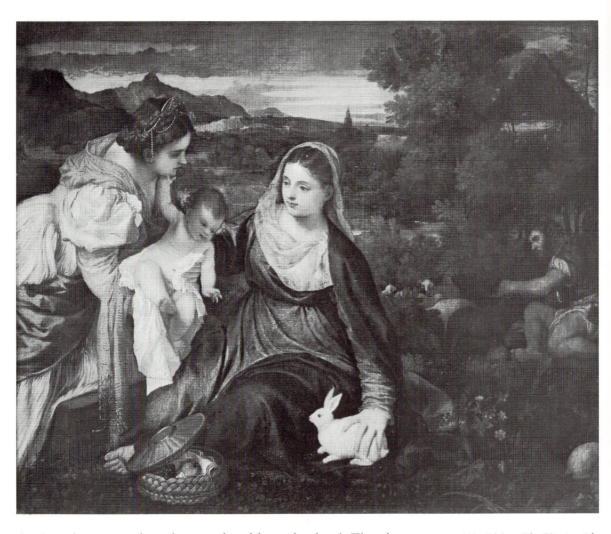

St. Joseph seems to have been replaced by a shepherd. The picture was very dark and has only recently been cleaned; it is small, under thirty inches high, but it has been trimmed on all sides. Titian has brought it almost to the finish of a miniature, and has filled it with a great variety of delicate details: to the minute still-life of the basket and the pattern of flowers have been added the richness of the dresses and landscape forms, all in deep and very beautiful colours, which represent the whole of the spectrum in a most harmonious arrangement.

In Titian's work this lyrical mood characterizes nearly the whole decade that followed the heroic period of the large altarpieces. We shall find that in a way Titian joined the then dominant current of Mannerism, the style best known to us from the paintings, drawings and other graphic products of Parmigianino. Its origin lies in the school of Raphael; it has parallels in Florence, and it had become known in Northern Italy

129. Titian. *The Virgin with the Rabbit*. Paris, Louvre.

130. Titian. *The Allegory of Alfonso d'Avalos*. Paris, Louvre.

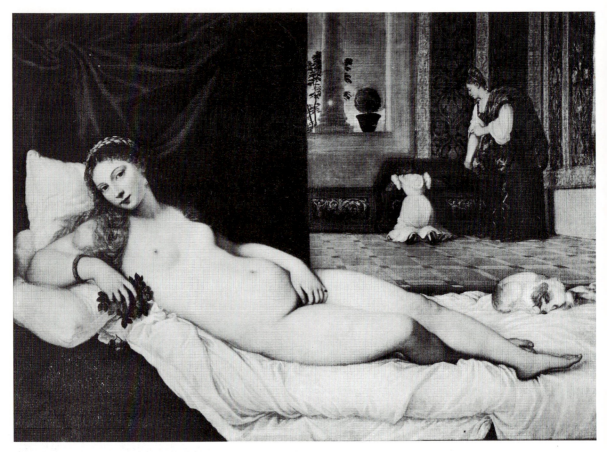

131. Titian. *The Venus of Urbino*. Florence, Uffizi.

mainly through Parmigianino. It is a somewhat artificial, decorative style, with a predilection for slender, flexible figures, curvilinear drawing, and a pleasant rhythm in the composition pattern. It could hardly be denied that works such as the *Allegory of Avalos* in the Louvre (Plate 130) have something in common with that style. For the benefit of those who, in explaining stylistic phenomena, like to refer to some hard facts, it should be mentioned that Parmigianino was working at Bologna at the time when Titian first visited the town—he, too, painted a portrait of the Emperor—and that he also went to Venice in 1530. Wherever you start reading the picture, your eye will be led by beautiful curves and loops further and further, and back again to your starting-point. The globe of glass in the centre is symbolic of the whole structure of form. This kind of abstraction in no way contrasts with the allegorical subject. This picture is known under the traditional but entirely wilful title *The Allegory of Alfonso d'Avalos*. Professor Panofsky, in his *Studies in Iconology*, has shown that it is a symbolic representation of Matrimonial Union, with Love, Faith, and Hope assisting, and with the sphere made of glass as the main symbol of a harmony which is as

complete as it is easily broken.² Unlike other representations of this style, Titian has also here displayed the most beautiful and harmonious colours of his palette. But this deviation is not unsuitable to the style, for the addition of deep colour to the ornament of lines imparts to the surface the same degree of aesthetic reality as that peculiar to enamels or oriental carpets.

In the *Venus of Urbino* (Plate 131), in the Uffizi, which was finished in 1538, this system of surface ornament is extended over the whole life-size figure and all its surroundings. The nude has been set in an interior of tapestry-like character in which all the main colours of the foreground, hot red, emerald green, white, and gold-brown, have been repeated on smaller planes but with the same intensity. This is an important fact. It means that, with regard to colour, there is no difference whatsoever between foreground and background, and that this distinction is valid only with regard to the form. It means the final triumph of a tendency which had been inherent in Venetian painting ever since the Trecento. As you remember, it became predominant in some of Giovanni Bellini's late works. Titian, in his earliest works, for instance in the votive picture of Jacopo Pesaro, made a radical attempt to achieve the same result. Later he partly abandoned it for other qualities which had

132. Titian. *Presentation of the Virgin.* Venice, Accademia.

become more important to him. Now, at this stage of his development, it was carried through to perfection. Eventually this principle became a governing one for Titian's late style, and for Venetian painting in general.

The largest but also the most sublime in this group of paintings is the *Presentation of the Virgin* (Plate 132). It is still in the place for which it was executed between 1534 and 1538. This place is one of the long walls of the Albergo, or committee-room, of the Scuola della Carità. This is an innovation: one large picture, instead of a series of histories, filling the space between stalls and ceiling. On the left a large rectangle was cut out when a second door was made in the seventeenth century; this has considerably affected the balance of the composition. Otherwise the condition of the painting is very good. In this long, tapestry-like picture groups have been arranged in shallow strata which are defined by the architecture. The groups follow one after another in a somewhat loose order, and they differ from the close-knit units of the works of about 1520. One has to read the composition figure by figure from left to right; the eye may rest for a while on some beautiful detail and then move on slowly, in the same tempo in which the little Mary is ascending the stairs with dignity and nobility. 'Piccola Maria'—this is the nickname of this very popular picture in Venice—is dressed in light-blue, and is surrounded by a golden halo. Now, these two colours are those of the original coffered ceiling of the Albergo. They also recur in many other places in the picture, set among other jewel-like deep colours. The antique torso and the market woman, to right and left of the original door, seem to belong to a different reality; they are a natural link between the spectator and the gay and solemn world depicted.

As far as we know, Titian executed only one altarpiece in the 1530s, and the subject of this was characteristically the simple rhythm of the *Annunciation*. The picture was finished for a church in Murano in 1537, but because of difficulties that had arisen about the payment it was sent by the artist as a present to the Empress. It disappeared in the Napoleonic Wars and has not been traced since, but its composition is known from the fine engraving by Jacopo Caraglio (Plate 133). Its style seems to have conformed to that of the works we have just seen. The figure of Gabriel is a perfect example of the Mannerist device of the 'figura serpentinata'; the theorists defined it as the principle of a maximum of movement without locomotion. Its nearest parallel is to be found in the woman with a basket on the extreme left in the fresco of the *Visitation* (Plate 134), painted by the Florentine Francesco Salviati in the Oratory of S. Giovanni Decollato in Rome in the spring of 1538. Both figures, that of Titian and that of Salviati, are descendants of Raphael's 'woman with a jar' in the *Borgo Fire* (Plate 135).

The right-hand section in Salviati's fresco is in a different style: there

133 (*right*). Engraving by Caraglio, after Titian. *The Annunciation.*

134. Salviati. Detail from *The Visitation*. Rome, Oratory of San Giovanni Decollato.

135. Raphael. Detail from *The Fire in the Borgo*. Vatican, Stanza dell'Incendio.

you see heavy, massive figures and the whole group is dense and highly plastic. In Titian's *Presentation of the Virgin* the foreground figure seems to indicate that his interest, too, was to turn in a similar direction. He came into contact with another later trend of Italian Mannerism, with a style which was not decorative and lyrical, but sculptural and dramatic. Some of Correggio's frescoes in Parma cathedral, Giulio Romano's later works at Mantua, and, above all, Michelangelo's *Last Judgement* were its prototypes. A whole generation of Florentine painters was busy making them known all over Italy. Two of them, Salviati and Vasari, stayed in Venice for long months in the years about 1540, and Titian himself travelled widely in those years, and must have studied these works at least in Mantua and Parma. The change of style in his art occurred almost as suddenly as the analogous change with Michelangelo a few years earlier, from the Cavalieri drawings of the early 1530s to the *Last Judgement*.

The picture of the *Ecce Homo* was finished in 1543 (Plate 136), five years after the *Presentation of the Virgin*, though there exist some earlier examples of Titian's new style. These two pictures lend themselves to a comparison, because both their scales and their destinations are rather similar. The Vienna picture was painted for the large room on the

136. Titian. *Ecce Homo.* Vienna, Kunsthistorisches Museum.

piano nobile of a Venetian palace. One may infer from a passage in Vasari that Titian was later commissioned also to paint a counterpart, for the corresponding section near the front windows of the opposite long wall of the room, representing *Golgotha*. This was seen by Vasari in Titian's studio, unfinished, in 1566.[3] I believe that a small fragment of this unfinished companion picture, containing the figures of Christ and the Repentant Thief, has survived: it is in the Pinacoteca at Bologna (Plate 137). In the *Ecce Homo* the loose order of the *Presentation*

137. Titian. *Crucifixion.* Bologna, Gallery.

has been replaced by dramatic concentration. The figures form compact groups; instead of the broad, pleasant rhythm of the architecture there are two single, highly plastic, motifs. The shieldbearer and the boy with the dog are not placed in front of—that is to say, outside— the composition, as is the market woman in the *Presentation*; they

138. Titian. *St John the Baptist*. Venice, Accademia.

take part in the general movement and suggest to the spectator the way in which to follow the unfolding of the action. Most remarkable is the function of colour. The dramatic tension has been emphasized by the contrast of the silky blue of Pilate's tunic and the glowing red of the pharisee's gown. The white figure of a girl in the centre underlines

139. Michelangelo. *Christ the Redeemer*. Rome, Church of Sta Maria sopra Minerva.

this contrast, whereas all the other colours have no value of their own, and make up a setting the effect of which is almost monochrome.

It was in this period that Titian could find a single figure in the round a satisfactory subject for an altarpiece. We have seen how he made studies from sculpture before, and how he used them on some special occasion; but the rendering of the borrowed motifs was always made in a more or less pictorial way. Now, on the contrary, his efforts were concentrated on preserving as much as possible of the sculptural appearance. Compare the limbs of this *St. John the Baptist* (Plate 138), once on an altar in the church of S. Maria Maggiore at Venice, with the statue of Michelangelo's *Redeemer* which was unveiled in S. Maria

140. Titian. *St. John on Patmos*. Washington, National Gallery.

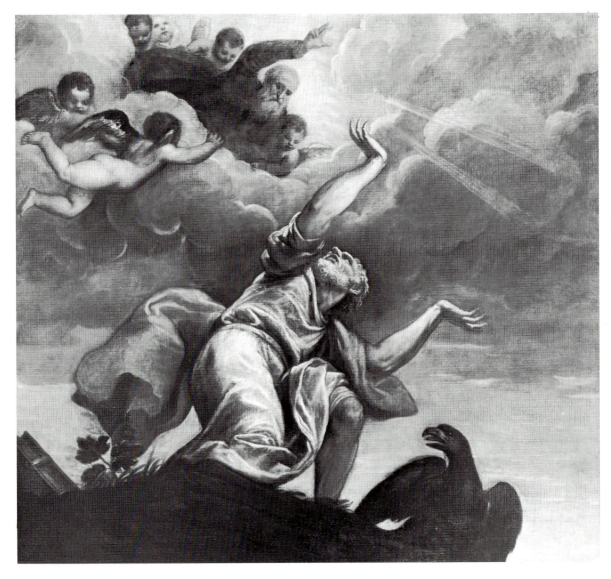

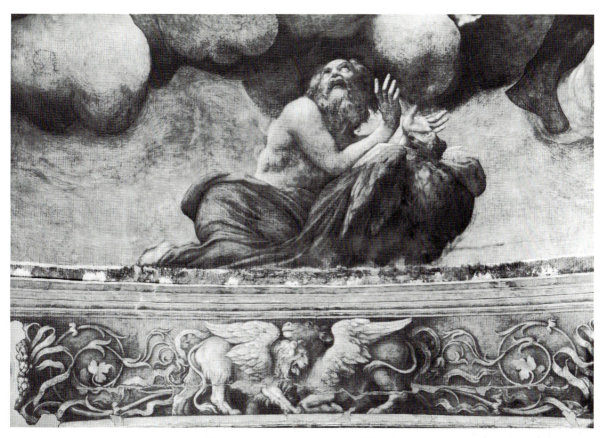

141. Correggio. *Vision of St. John on Patmos*. Parma, San Giovanni Evangelista.

sopra Minerva at Christmas in 1521 (Plate 139) and was the actual proto-type of this type of plasticity. Titian's figure of the Baptist lacks the impressive, tense silhouette-effect which characterizes his earlier altar-pieces; nor does it display any significant colour. The sharp forms of the rock provide an appropriate background to it.

Another new class in Titian's work, and in Venice in general, is that of ceiling pictures. Up to this period Venetian ceilings had been of carved and gilt wood, coffered or showing some other pattern, and sometimes with paintings in roundels or other small compartments of regular shapes, but without any kind of illusionist effect. As far as I can see, it was Pordenone who, in the first half of the 1530s, made the first attempt at breaking with this tradition, in a ceiling in the Scuola di S. Francesco; but the surviving fragments of this work are not sufficient to form a picture of the whole. Then, at the beginning of the fifth decade, between 1542 and 1544, Titian executed two ceilings: one in the church of S. Spirito in Isola, which had just been completely rebuilt by his friend Jacopo Sansovino; the other in the Albergo of the Scuola di S. Giovanni Evangelista (Plate 140), also a Renaissance building. The latter ceiling was taken to pieces in the Napoleonic era; subsequently

142. Titian. *Symbols of the Evangelists*, from the ceiling of the Albergo of the Scuola di San Giovanni Evangelista. Venice, Accademia.

143. Titian. *Sacrifice of Abraham*. Venice, Sacristy of Sta Maria della Salute.

144. Titian. *David and Goliath*. Venice, Sacristy of Sta Maria della Salute.

its large central panel was sold to a collector at Turin and was long lost; it has now been rediscovered and is in the National Gallery, Washington. It is interesting to compare it with a detail of Correggio's cupola in S. Giovanni Evangelista at Parma (Plate 141)—with a detail only, because the whole section of the fresco, representing the same scene, the *Vision of St. John on Patmos*, in a singularly similar way,

has never been photographed. Many other fragments of Titian's dismembered ceiling exist, for instance four long panels representing the symbols of the Evangelists (Plate 142), and smaller ones with cherubs and decorative masks, but they have been called products of his studio and neglected; and no attempt at reconstruction has been published so far, although the room still exists, and so the measurements of the whole are certain.[3]

The three large canvases which once decorated the ceiling of Sansovino's church on the island of S. Spirito were transferred in the seventeenth century to the sacristy of S. Maria della Salute. They formed a sequence, beginning with *Cain and Abel* on the entrance side, with *Abraham's Sacrifice* in the centre (Plate 143), and *David's Victory* above the high altar (Plate 144), and were surrounded by eight roundels with the heads of the Evangelists and of the Fathers of the Church. All these parts were set in a richly carved and gilt Renaissance framework designed by Sansovino. At first, Vasari was asked to execute the paintings in 1542; but he left Venice before starting on them, and the task was taken over by Titian. In this case he did not follow Florentine prototypes: his Abraham as clearly follows Correggio as does his St. John the Evangelist. We may compare with this figure two of the Apostles on the drum of Parma cathedral. However, more important is the fact that Titian has achieved a stable compromise between the two main systems of ceiling decoration: that of Mantegna and Correggio, and that of Peruzzi and Raphael; and by doing so Titian has established a new system, and has initiated a rich development of ceiling painting in Venice.

His device is simple and is very Venetian; it consists in a semi-adoption of Correggio's radical illusionism, of his complete *di sotto in sù*. You can look at these pictures without the risk of breaking your neck. Further, Titian has adopted the device applied by Michelangelo in the second half of his ceiling, of connecting the compositions in the large spaces one with another by a powerful zig-zag movement which leads through all of them. In this way, the passionate movements of the individual figures are echoed and supported by a general movement, and the dramatic unity of the whole is complete.

I also show you two of the medallions, the one with St. Matthew (Plate 145) and the other with St. Ambrose (Plate 146). (There are some which are even more impressive.) Titian painted these heads on unplaned boards, using their rough surface for the same purpose as he used herring-bone canvas. These contemplative heads were probably points of rest at the corners of the three dramatic canvases. How fine it would be one day to discover a picture which records the interior of the demolished church! For, with the exception of the *Muse* on the ceiling of the vestibule in the Biblioteca Marciana, none of Titian's ceiling

145. Titian. *St. Matthew*.
Venice, Sacristy of Sta
Maria della Salute.

146. Titian. *St. Ambrose*.
Venice, Sacristy of Sta
Maria della Salute.

147. Titian. *Mocking of Christ*. Paris, Louvre.

paintings has remained in its original place; and his largest undertaking in this field, the three allegories painted for the town-hall at Brescia in 1565–8, were completely destroyed by fire a few years later.

Contemporary with these decorations is the *Mocking of Christ* in the Louvre (Plate 147), painted as an altarpiece for a chapel in S. Maria delle Grazie at Milan. It illuminates the aims of this sculptural phase of Mannerism to the full. The staffs which converge above the head of the Saviour are so many axes of a cubic space, a space which, as in a composition by Bronzino, is the product of fully plastic figures superimposed one on another. The figure types, except that of Christ, which has once more been moulded on the Hellenistic Laocoön, are borrowed from Giulio Romano; and, for this picture as well as for the *Ecce Homo*, Giulio's buildings at Mantua seem to have suggested to Titian the forms of architecture. They are entirely homogeneous with the figures; perhaps I shall be forgiven for using the term 'rusticated sculpture' to characterize this type of plasticity; notice particularly the back of the executioner on the left. Colour, apart from the cruel red of Christ's mantle, and a few patches of greyish-green and blue, has almost completely disappeared. No other works by Titian lose so little in black-and-white reproduction as this group of paintings.

Titian: the last years (1540–76)

THE first half of the 1540s seems to have been one of the busiest periods in Titian's long career. After executing the group of works which I have just discussed there followed an event of symbolic significance in Titian's life: he visited Rome. He had twice previously refused to go there. Now, at the age of sixty, he accepted the invitation of the pope and spent eight months as a guest in the Vatican. It was the same pope, Paul III, for whom Michelangelo had painted the *Last Judgement* and was then painting the frescoes in his private chapel, and who soon afterwards put Michelangelo in charge of the building of St. Peter's and of his family palace. Titian had painted the portrait of the pope two years before, and now he painted yet another of him and also those of all the members of the pope's family. And while he was spending part of his time in looking at the miracles of ancient and modern Rome, he also executed a *poesia*, the *Danaë* (Plate 148) for the pope's grandson and vice-chancellor, Cardinal Alessandro Farnese, a youth of twenty-five, who was to become the greatest patron and collector of the sixteenth century.

Vasari has recorded for us two judgements on Titian's art, dating from this moment, when the two greatest artists of the High Renaissance, Titian and Michelangelo, met each other in the city in which the movement had seen its first great triumphs. The first judgement is by Sebastiano, the former fellow-student of Titian in Giorgione's studio, and a friend of Vasari. It reads:

In that work [the *Triumph of Faith*] Titian displayed boldness, a beautiful manner, and the power to work with facility of hand; and I remember that Fra Sebastiano del Piombo, conversing of this, said to me that if Tiziano had been in Rome at that time, and had seen the works of Michelangelo, those of Raphael, and the ancient statues, and had studied design, he would have done things absolutely stupendous, considering the beautiful mastery that he had in colouring, and that he deserved to be celebrated as the finest and greatest imitator of Nature in the matter of colour in our times, and with the foundation of the grand method of design he might have equalled the Urbinate and Buonarroti.

The other judgement is that of the greatest authority, and is given in the form of an anecdote:

Michelangelo and Vasari, going one day to visit Titian in the Belvedere, saw in a picture that he had executed at that time a nude woman representing Danaë, who had in her lap

Jove transformed into a rain of gold; and they praised it much, as one does in the painter's presence. After they had left him, discoursing of Titian's method, Buonarroti commended it not a little, saying that his colouring and his manner much pleased him, but that it was a pity that in Venice men did not learn to draw well from the beginning, and that those painters did not pursue a better method in their studies. 'For', he said, 'if this man had been in any way assisted by art and design, as he is by nature, and above all in counterfeiting the life, no one could do more to work better, for he has a fine spirit and a very beautiful and lively manner.[1]

As you know, Sebastiano after a brilliant beginning was ultimately frustrated as an artist by his efforts 'to unite the drawing of Michelangelo with the colour of Giorgione', as his programme was later formulated by the theorists. But Florentine drawing and Venetian colour were evolved from, and were subordinate to, two different visions of reality, and therefore, though they could be united in theory, they could scarcely be so in practice.

The contrary happened to Titian. In fact one observes with some surprise that, while he was in Rome, Titian again became fully conscious of his own strength. His works of that time display a new splendour of colour, though in contrast to his early practice Titian's new colour range is more restricted and still shows some tendency towards monochrome. It is based on no more than two or three warm and harmonious colours. Their selection changes from picture to picture. In the case of the *Danaë* it consists of red and olive; but both are given in a hundred tones. At the same time the figures, if compared with their immediate predecessors, those of the works which Titian left behind in Venice, prove to be much less plastic. Instead one perceives as a corollary of the new colour-scheme a new reality of space and of air, a reality more intense than that suggested by the works of Titian's master Giorgione.

And so the months spent in Rome were not altogether lost for Titian's art. After having paid his tribute to the plastic ideals of the Cinquecento and after discovering a restricted but all the more intensive use of colour, Titian in his next works returned to that fundamental trend in all Venetian painting, the spreading out of forms on the surface; and by doing so, he discovered a new form of monumentality. The votive picture of the Vendramin family in the National Gallery (Plate 150) is a good example of this change; another is the altarpiece of S. Giovanni Elemosinario in Venice (Plate 151). It is difficult to overlook the indebtedness of a work such as this to the prophets on the Sistine ceiling. This magnificent picture, still on the high altar of the little Renaissance church for which it was painted, is indeed a summary of all Michelangelo's conceptions of prophets! But how different is its style! There are no plastic contrasts, no tangible forms in this picture. The saint's appearance is imposing and calm. The colours do not disturb this calm: plum-red, the blue of ripe figs, and a gold-green have been extended on broad planes and are shown in innumerable tone values.

148. Titian. *Danaë*. Naples, Capodimonte Gallery.

149. Michelangelo. *Dawn*. Florence, Basilica of San Lorenzo, New Sacristy.

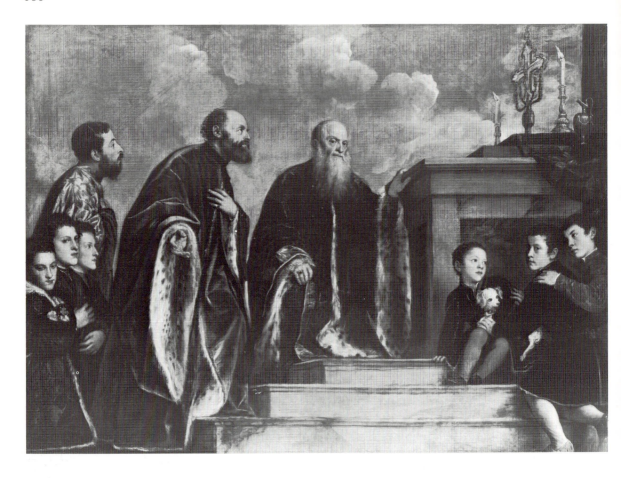

A similar form of monumentality characterizes the large composition, commissioned from Titian by the Emperor probably in 1548 and finished five years later. It is called *La Gloria* (Plate 152), and its subject is that of Dürer's altarpiece of 1511: the adoration of the Holy Trinity by the host of angels and saints, patriarchs and prophets in Heaven; and the idea of showing the created world in the form of a beautiful flat landscape below seems to have been directly borrowed from Dürer's work. Titian sent this proof of his understanding of Roman monumentality to the Ruler of the Holy Roman Empire, whose soul, together with those of the Empress and of his son, are introduced into this Adoration by their guardian angels. It is this historical symbolism that gives a particular note to the composition. Another work of the same period, in which one can find many traces of the studies Titian had made in the Sistine Chapel as well as other recollections of his visit to Rome, is the large altarpiece of the *Martyrdom of St. Lawrence* in the church of the Jesuits in Venice (Plate 153). It was commissioned some time before 1549 and was executed slowly in the early 1550s.

150. Titian. *The Vendramin Family*. London, National Gallery.

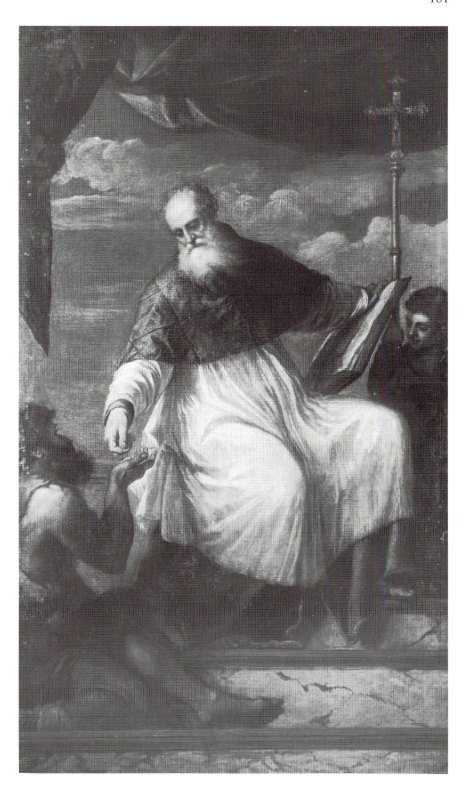

151. Titian. *San Giovanni Elemosinario Altarpiece*. Venice, Church of San Giovanni Elemosinario.

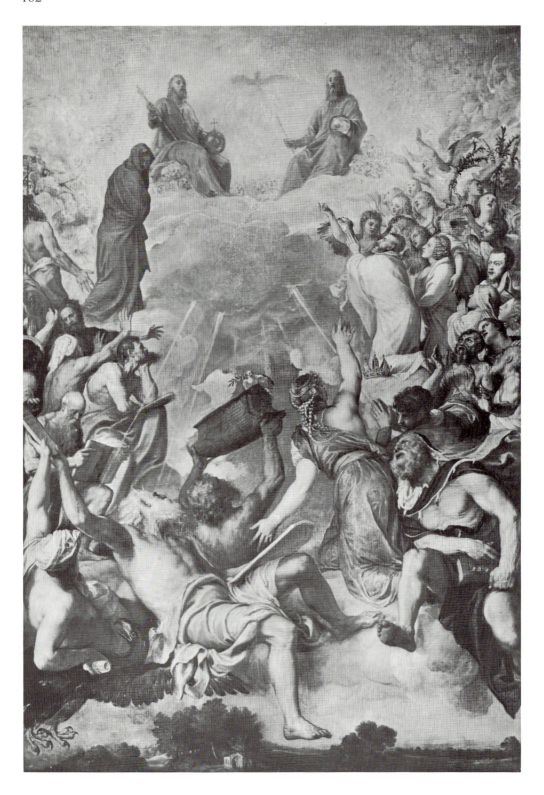

We now come to the last two decades of Titian's activity, the period of his late style, and I am afraid I shall have to deal with it even more sketchily, leaving the demonstration mainly to the illustrations. One may roughly divide this period into two halves: the first is dominated by mythological paintings, created for the Emperor's son, Philip II of Spain, which in a way show a return to the ideals of the 1530s; and the second produced a last sublime form of Titian's religious art.

The *Danaë* for Philip of Spain (Plate 154). was finished eight years after the one for Cardinal Alessandro Farnese. Generally speaking, the characteristic feature of this picture is a further transformation, one might almost call it disintegration, of plastic form. The broad strokes of the brush, which appeared again and again in Titian's works in places, have now become a general constituent of his rendering of form. This picture has a surface rather similar to that of a mosaic. In it Titian has revived his beautiful colours of the 1530s, but once more their new depth, transparency and glowing intensity remind one of mosaics rather than of oriental carpets. From this moment onwards Titian does not use continuous planes of colour any longer. One may say that the colours too have been split up and dismembered, and have been distributed in small particles all over the picture space. The latter has now quite a homogeneous character: not the smallest point in it has been left neutral; and, potentially, every single brush-stroke contains all the colours of the picture. For this reason it is quite impossible to try and describe their riches. Instead I show you these details of the first and the second version of the *Danaë* (Plates 155 and 156). In this juxtaposition the first might appear as a contrast, the form in it is relatively so much more solid. One is puzzled to know how Sebastiano and Michelangelo would have judged Titian's art looking at this second version of his *Danaë*.

Contemporary with this painting was a representation of *Venus and Adonis*, of which there is a workshop replica in the National Gallery. The female figure is an undisguised borrowing from a Roman relief of the first century B.C., of Psyche and Cupid, which once belonged to Ghiberti and which, under the title 'Il letto di Policleto', was one of the most admired works of antique art in the sixteenth century.[2] Then in 1556 there followed the *Perseus and Andromeda*, now in the Wallace Collection; and in 1559 the two masterpieces in the Duke of Sutherland's collection, *Diana and Actaeon* and *Diana and Callisto* (Plates 157 and 158). All these 'poems' are based on Ovid: the Metamorphoses had replaced the Bible for Titian for a time. I shall not try to speak about the changed mood in Titian's late mythologies; that has been done admirably by Professor Waterhouse in his essay on the Sutherland pictures.[3] This calculated looseness of the arrangement, this continuous interplay between the figures and their surroundings, this delicacy of

152 (*left*). Titian. *The Adoration of the Holy Trinity*. Madrid, Prado.

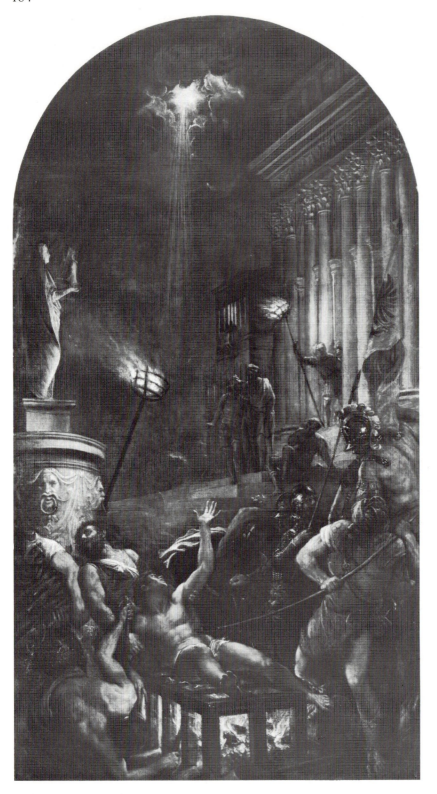

153. Titian. *Martyrdom of St. Lawrence*. Venice, Church of the Gesuiti.

handling, and this magic of the invention were really first understood by Rubens in his later period, after he had spent many years studying Titian's art. Rubens bequeathed his knowledge to Watteau. In Plate 157 a double chain of figures connects the principal ones; in the centre there is a nude seen from behind—and this figure was to become the centre of one of the loveliest compositions by Watteau, his *Judgement of Paris* in the Louvre. But this figure is a literal quotation from a design by Parmigianino made in about 1525 and engraved several times in the second half of the sixteenth century (Plate 159). The intense ornamental beauty of the so-called *Allegory of d'Avalos* (Plate 130) has now been fully expanded and has been set in space and atmosphere but at the same time imbued with tragic feelings: notice the dark trees moved by a hidden force, the sea of uncertain horizon, the torn clouds, and the changing lighting.

The Vienna version of the *Diana and Callisto* (Plate 160), as well as the London version of the *Venus and Adonis*, and many other paintings which belong to this late group of mythological paintings are what used

154. Titian. *Danaë*. Madrid, Prado.

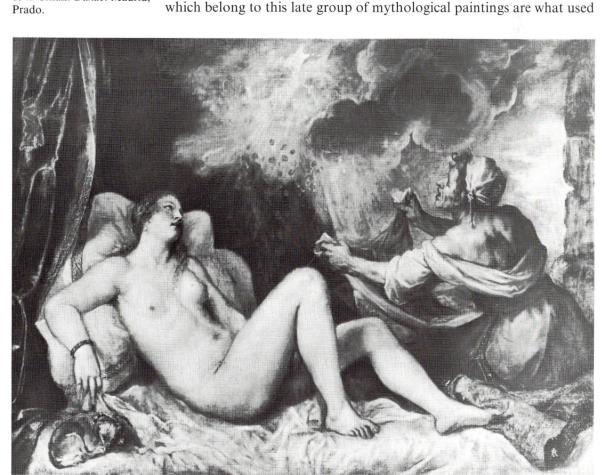

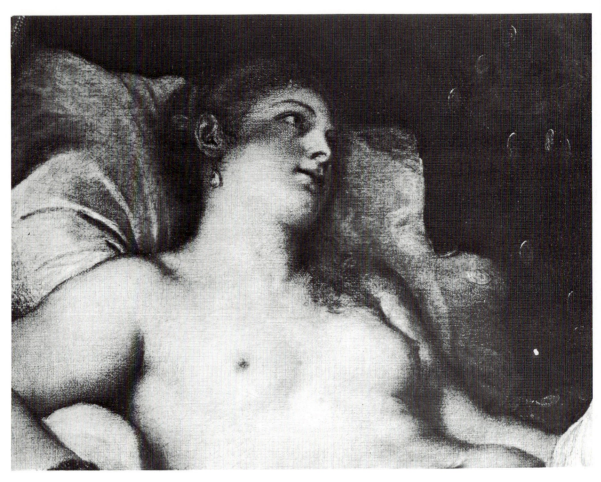

155. Detail of plate 148.

to be called workshop replicas. This is a rather ambiguous term and can
mean practically anything. Therefore, it is perhaps useful to try and give
it in one case at least a more concrete meaning, by comparing the replica
with what is generally accepted as its first version, the picture sent by
Titian to Philip II in 1559. Half a century ago the whole layer of
pigment of the Vienna picture had to be transferred to fresh canvas.
On that occasion the outline drawing of the composition became visible
and was photographed. Surprisingly it exactly corresponds to that of
the Bridgewater version. I think it is reasonable to infer that this tracing
was done for the sake of setting assistants the task of beginning the
replica, which they did do. Then the master intervened and made some
alterations. In the fact that they are alterations, and of course in the
high pictorial quality of these passages, lies the proof that they are due
to Titian. The parts which have not been changed are all dull. But they
are outweighed by the rest: the two figures on the left, one on the right,

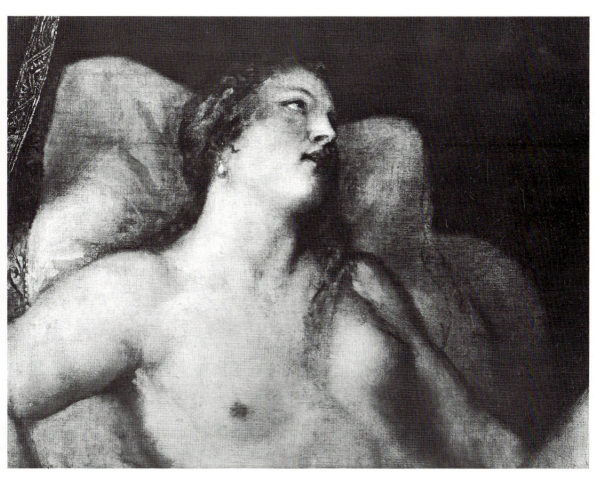

156. Detail of plate 154.

and the whole background. The figures on the left enhance the dramatic effect and round off the group more effectively; the cancellation of a figure in the centre has produced a dramatic *caesura* between the unhappy victim and the cold goddess; the new background is in harmony with the more pathetic mood of the whole. Titian has lessened the chiaroscuro in the foreground and has thus increased the contrast.

The last of the *poesie* painted for Philip of Spain is the *Rape of Europa*, now at Boston (Plate 161); it was finished in 1562. I show it to you together with the *Allegory of Poetry* (Plate 162), on the ceiling of the vestibule to the Biblioteca Marciana, which followed it immediately. This ceiling epitomizes the whole class of Titian's paintings we have been looking at, and is certainly one of his loveliest creations. Once more you have the soft curves of the 1530s, but any kind of linearism is lacking here. The mosaic effect as a product of a particular type of brush-work, which we first met in the Prado version of the *Danaë*, is now complete. And

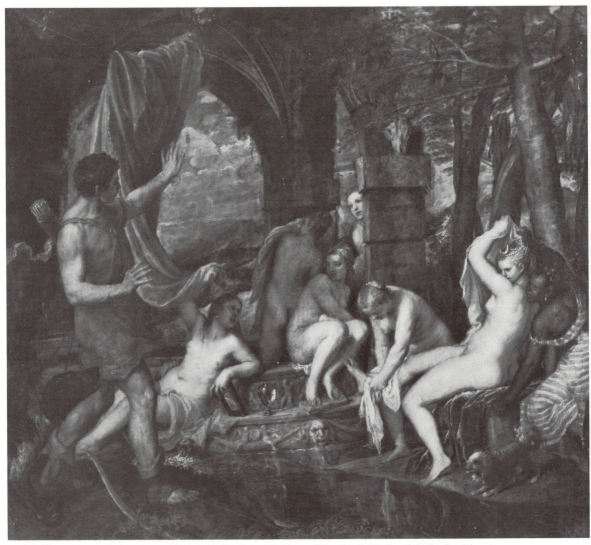

157. Titian. *Diana and Actaeon*. Edinburgh, National Gallery of Scotland (Duke of Sutherland loan).

that minimum of foreshortening wanted for a ceiling decoration has
been so well disguised that the surface is nowhere interrupted. You will
be greatly surprised by seeing the surroundings for which Titian designed
his group, that *tour de force* of two specialists in the difficult science of
quadratura, of illusionist architecture painting (Plate 163).[4] Contrary
to his practice in his early days, Titian here consciously denies the given
surroundings of his work, because certain qualities have become all-
important to him and were to be fully displayed. The group forms a
lozenge built up of the most brilliant rose, yellow, and warm-grey
changing to olive, which is set against the light-blue of the hexagonal
frame. Like the *Presentation* of the thirties (Plate 132), this allegory,

which concluded the *poesie* of the 1550s, is a bouquet of pure colours. I am assured by friends who have seen the original that the *Europa* in Boston was painted with exactly the same palette. At any rate, its pictorial structure is certainly the same.

Now I should like to examine a few more mythologies belonging to the second half of Titian's late period, in which, as I said, religious painting was again predominant.

Once there existed two almost identical versions of the *Punishment of Actaeon*, and the one which disappeared in Vienna in the eighteenth century was perhaps the better one; but this version is undoubtedly

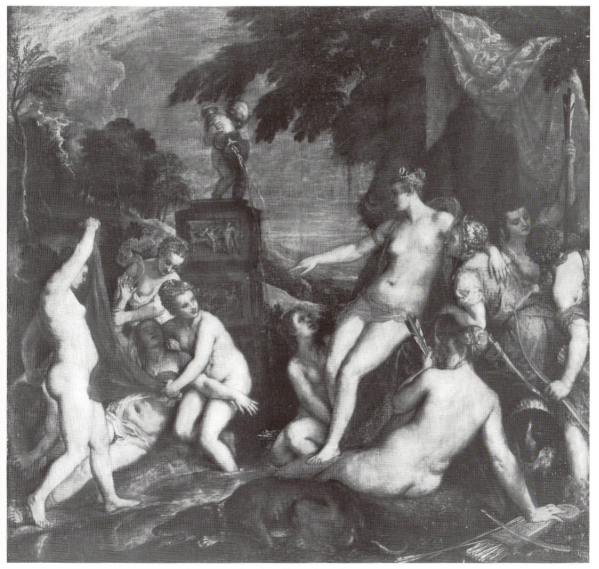

158. Titian. *Diana and Callisto*. Edinburgh, National Gallery of Scotland (Duke of Sutherland loan).

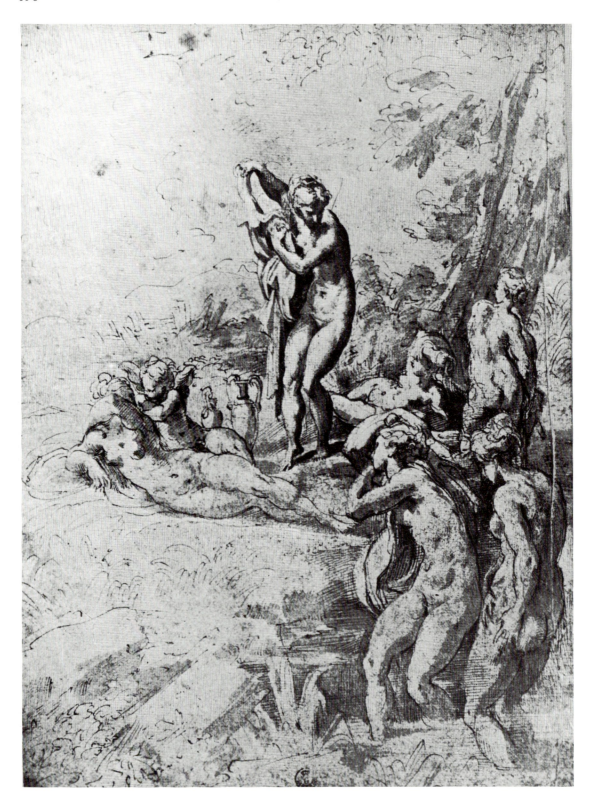

159 (*left*). Parmigianino. *Study of bathers*. Florence, Uffizi.

160. Titian. *Diana and Callisto*. Vienna, Kunsthistorisches Museum.

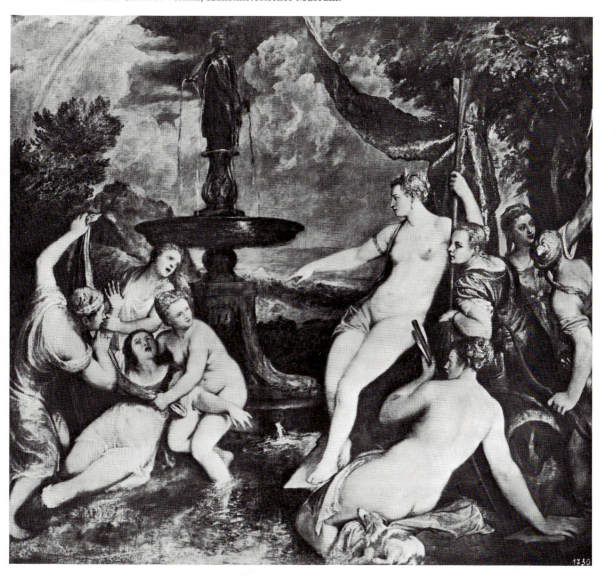

entirely from Titian's own hand (Plate 164). Only in subject-matter and format is this a companion picture to the *Diana and Actaeon* in the Sutherland Collection (Plate 157). While in the latter one finds the greatest splendour of colour, in the *Punishment* the tendency towards monochrome, which we met in the works executed in Rome and immediately after his Roman visit, prevails. In fact there are only two colours here: a dark-red (in the two draperies) and a brownish green; and these have been brought close to each other by manifold reflexions, and have been drowned in places by black. The event is gloomy and this monotony seems to be appropriate. The hounds by which the transformed Actaeon is torn to death are expressive symbols; they are ghosts rather than creatures known in nature. One can say that Titian has here discovered yet another way of using colour.

The picture of *Apollo and Marsyas* belongs to the same class (Plate 165). It is later than the *Actaeon* and may have been painted about 1570. It was only discovered after the First World War in the country residence of the archbishops of Moravia and is therefore very little known. The picture brings together in one scene three moments of the story; on the left Apollo is playing; on the right is Midas, who gave the verdict in the competition; and in the centre Apollo again with the victor's laurel-wreath, helped by two satyrs, is punishing Marsyas for his hubris. Once more a rusty red and olive are the only colours, but they are so dark that it is difficult to read the composition in the original, and the photograph is a great help. Pictures like these are purely personal creations and can hardly be connected with any current in contemporary art.

The picture of the *Nymph and Shepherd* in Vienna is the latest of Titian's surviving *poesie* (Plate 166). We know from an eye-witness account that Titian often kept his pictures in his studio for years, working on them from time to time and changing them in places considerably. You find such a change in this detail (Plate 167), where there was originally a castle with a tower on a far-distant mountain. This was painted out and replaced by the curved silhouette of the tree-stump with the goat, a vigorous motive, which now dominates the background and to some extent counterbalances the figures. The subject of the picture is still to be found—Diana and Endymion has been suggested—but the content is that of a Giorgionesque idyll: man's communion with nature. Accordingly Titian appears to have used for the female figure an invention of his master, the reclining nude in the landscape known to us from an engraving by Giorgione's contemporary Giulio Campagnola (Plate 168). But Titian has also made some characteristic changes: by turning the head to the front and showing the left arm he has given a twist to the figure, a movement underlined by the drapery. In consequence of this and of the position of the seated figure the group

seems to turn slowly to the right, round the axis formed by the left edge. This slow movement is in harmony with the vibration of all the surfaces and all the forms of the surroundings, produced by the floating strokes of colour.

Finally I show you some examples of Titian's late religious painting. All of them are altarpieces, or were intended to serve as altarpieces. First the *St. Jerome* in the Brera (Plate 169), painted in the second half of the 1550s, and perhaps the earliest instance of Titian deliberately using colour as a means of expression. For this is a representation of penitence, and its colour-scheme seems to have been chosen accordingly: brownish yellow and brown, dark wine-red and olive, for a consistent dark texture, lit up only in places by a ray of the sun, behind which small patches of the blue sky become visible. Remember the *St. John the Baptist in the Desert*, in the Venice Academy (Plate 138), painted not more than fifteen years earlier. This nude figure, in spite of its complicated pose, is rather different from that 'painted sculpture' in the Venetian picture; it shares the characteristics of its surroundings and is indeed, as well as the tree, the animals, and the rock, a part of nature. Once more the communion of all created things—and the still-life of books, hour-glass and skull also belongs to them—is the real content of the picture.

The high altar in the Dominican church at Ancona was erected about 1560, and this means that Titian's *Crucifixion* (Plate 170) is about contemporary with Michelangelo's famous series of representations of Calvary. In this case no direct connection between the two artists can be assumed and, therefore, the striking similarities which exist between their works are historically all the more important, and are a warning not to neglect this side of Titian's art. Unfortunately, I have no time left to demonstrate this.

The large picture of the *Annunciation* (Plate 171) was executed in the first half of the 1560s for a church, S. Salvatore, that had been finished and for an altar that had been built by Titian's friend Jacopo Sansovino. As you see, it is a revised version of the composition which Titian designed for a church in Murano and then sent to the Spanish court, nearly thirty years earlier. These replicas of earlier inventions are a phenomenon generally characteristic of Titian's latest period; they are numerous, and it remains a task for future research to investigate and fully explain this phenomenon. You remember the marked differences which we found in roughly contemporary works of Titian's maturity, and how we tried to explain them as the results of inspiration derived from the particular destinations and future surroundings of those works. Titian then appeared to us as an artist who liked to take his start from something objectively given—from nature, from a chosen prototype, or from the requirements of a given architectural setting,

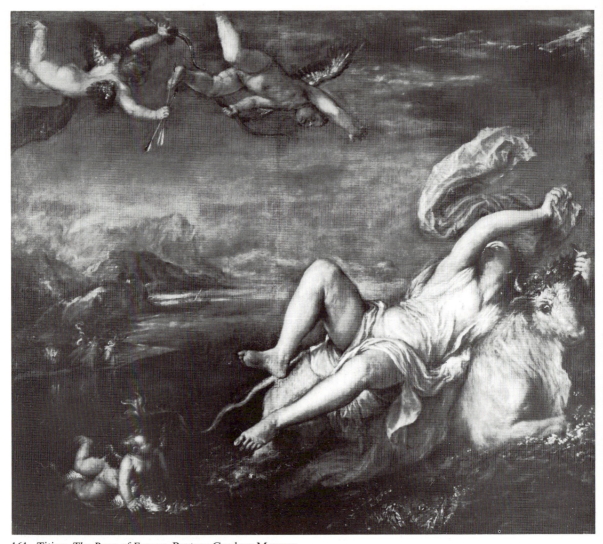

161. Titian. *The Rape of Europa*. Boston, Gardner Museum.

and, one may add, in portraiture, from the social position of the sitter.
It might appear that at the end of his career a composition of his own
could have played the same part in the artistic process. But it is also
possible that at this late stage Titian had the feeling that he was at last
able to 'realize' his ideals more fully than before, and to render reality
in painting 'in the right way'. (I am using the term 'realize' in the sense
in which Cézanne used it in his old age: it has the same double meaning
in our context.) Whatever the reason for the replicas may be, it appears
that the new method of rendering form has become more important for
Titian than new inventions. You can see this method applied also in
his drawings. The study in the Uffizi (Plate 172) is contemporary with
his *Annunciation* in S. Salvatore, but not necessarily a preparation for

it—it may have been intended for another composition unknown to us. Its technique is new and is entirely Titian's. You will remember that the first version of the *Annunciation* showed signs of an influence of Central-Italian Mannerism. Now all traces of that influence have been radically eliminated. Vasari saw this altarpiece on his visit to Venice in 1566, and it will perhaps be useful to learn how he understood and described Titian's new method of painting. This is what he says:

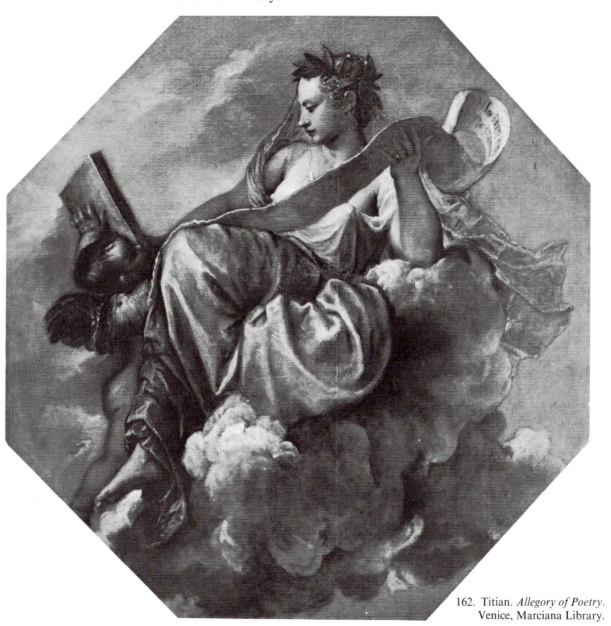

162. Titian. *Allegory of Poetry*. Venice, Marciana Library.

163. Titian. *Allegory of Poetry* in *quadratura* setting. Venice, Marciana Library.

The method of work which he employed in these last pictures is no little different from the method of his youth, for the reason that the early works are executed with a certain delicacy and a diligence that are incredible, and they can be seen both from near and from a distance, and these last works are executed with bold strokes and dashed off with a broad and even coarse sweep of the brush, insomuch that from near little can be seen, but from a distance they appear perfect. This method has been the reason that many, wishing to imitate him therein and to play the practised master, have painted clumsy pictures; and this happens because, although many believe that they are done without effort, in truth it is not so, and they deceive themselves, for it is known that they are painted over and over again, and that he returned to them with his colours so many times, that the labour may be perceived. And this method, so used, is judicious, beautiful, and astonishing, because it makes pictures appear alive and painted with great art, but conceals the labour.

164. Titian. *The Death of Actaeon*. London, National Gallery.

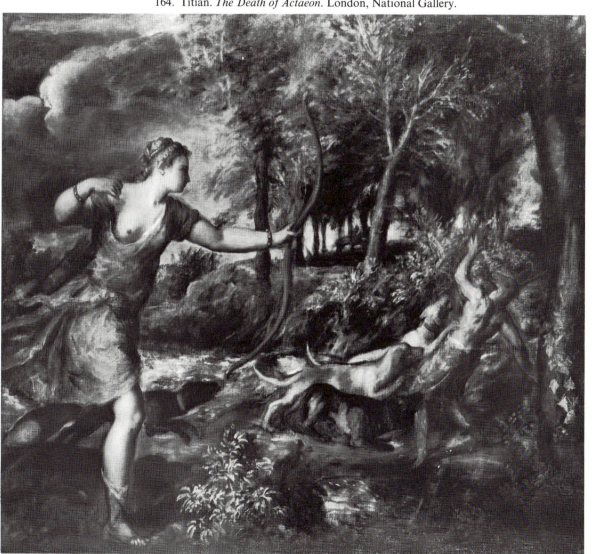

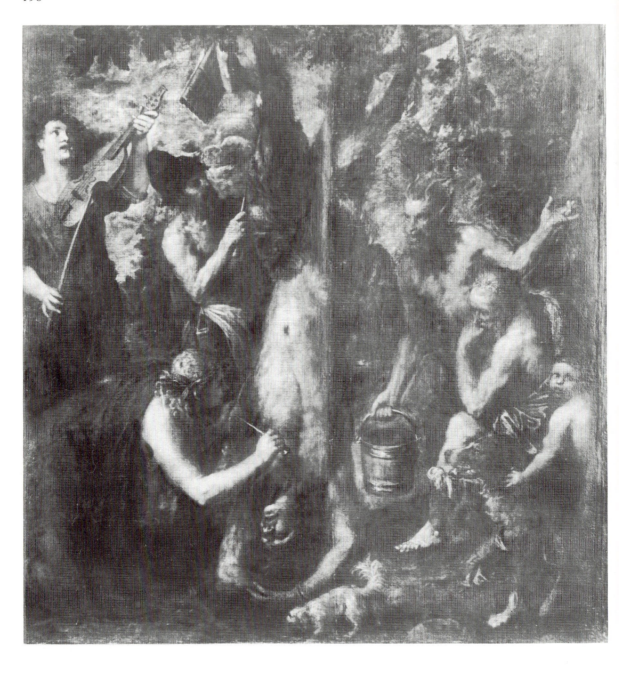

165. Titian. *The Flaying of Marsyas*. Kromieriz, National Gallery.

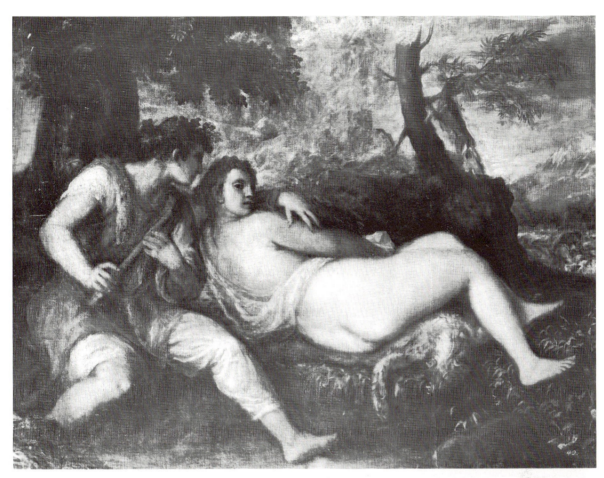

166. Titian. *Nymph and Shepherd.*
Vienna, Kunsthistorisches Museum.

167. Detail of plate 166.

Another very large altarpiece—it is fourteen feet high—is a revised version of the *Martyrdom of St. Lawrence* in the Gesuiti (Plate 153), which had been executed by Titian in the years after 1548, in the monumental style of his post-Roman period. This new version (Plate 173), finished in 1567, was intended for the church of the Escorial which had not yet been erected. Therefore the picture was provisionally placed in the so-called Old Church, the Iglesia Viéja, an oblong room in the first floor of the monastery, not very large and with only one window opposite the altar; and there it has remained to this day. Titian's picture covers the whole altar-wall, right up to the ceiling. So actually on the spot it is difficult to see more than some disconnected flashes of light. But this effect is partly the result of the particular form of composition which Titian chose. The forms have been modelled from dark to light, as in many of the late works by Rembrandt. Whereas the first version of the *St. Lawrence* is partly a product of the workshop, this one was carried out by Titian alone. It is one of his most expressive works. The picture is a literal illustration of a passage in the Saint's legend. Lawrence was told by the Emperor that for his faith he must face a night of torments. The Saint's answer was: 'My night is without darkness; it is illuminated by the light of Heaven.' This supernatural light is shown by the two little angels who bring the wreath of martyrdom for the Saint. Titian has quoted them from his most famous work, the *St. Peter Martyr* of 1530. But it is easy to overlook this connection because of the differences of style: in the late work all the forms are vibrating, and all the persons are deeply moved, the good and the

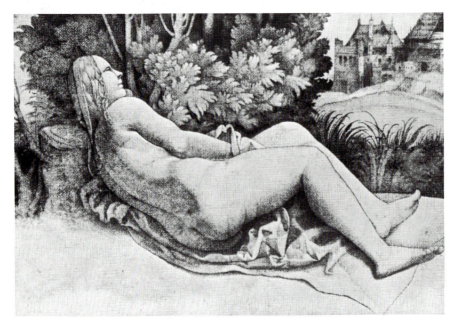

168. Campagnola. *Engraving of a Nude in a Landscape* (after Giorgione?).

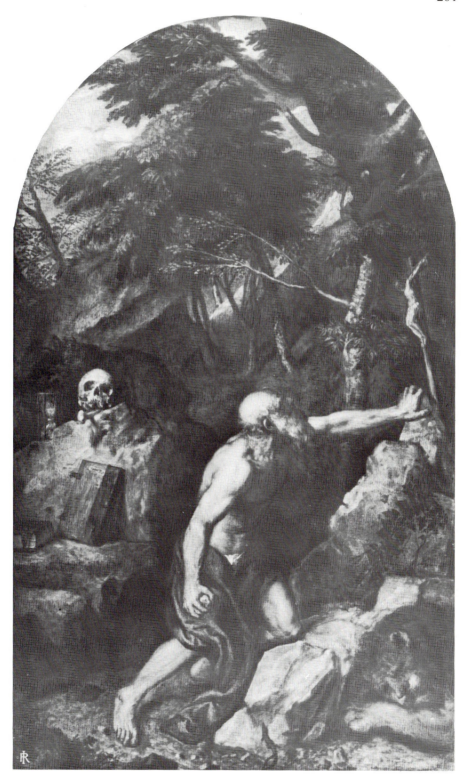

169. Titian. *St. Jerome*.
Milan, Brera.

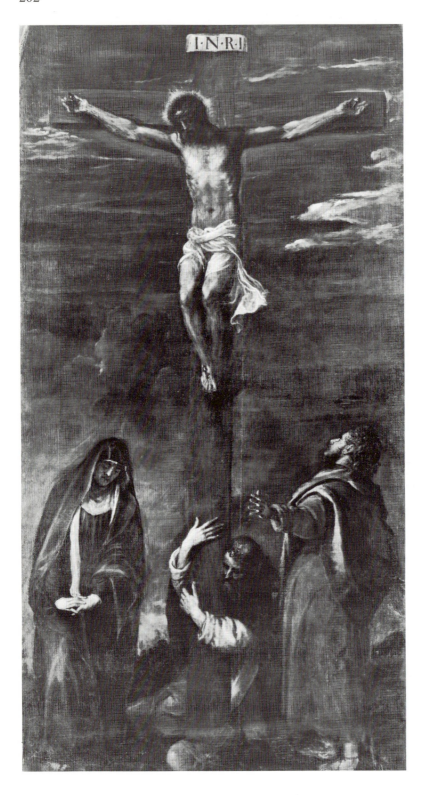

170. Titian. *Crucifixion*.
Ancona, Church of San
Domenico.

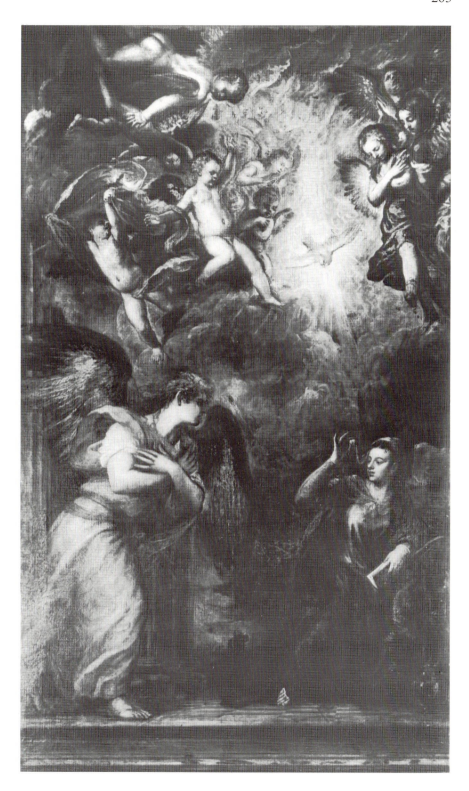

171. Titian. *Annunciation*.
Venice, Church of San
Salvatore.

204

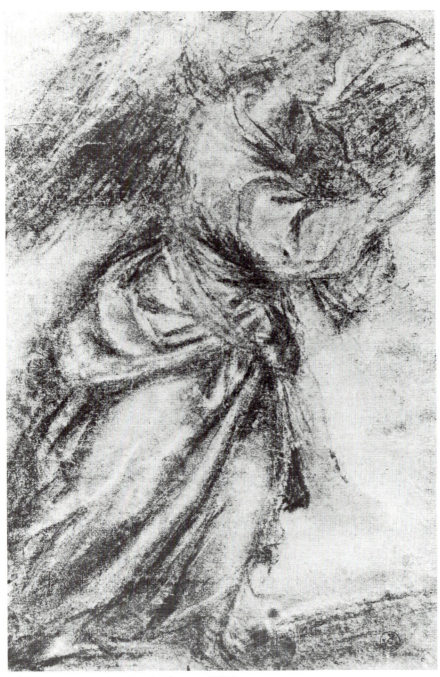

172. Titian. Study of an Angel. Florence, Uffizi.

173 (*right*). Titian. *Martyrdom of St. Lawrence*. Escorial.

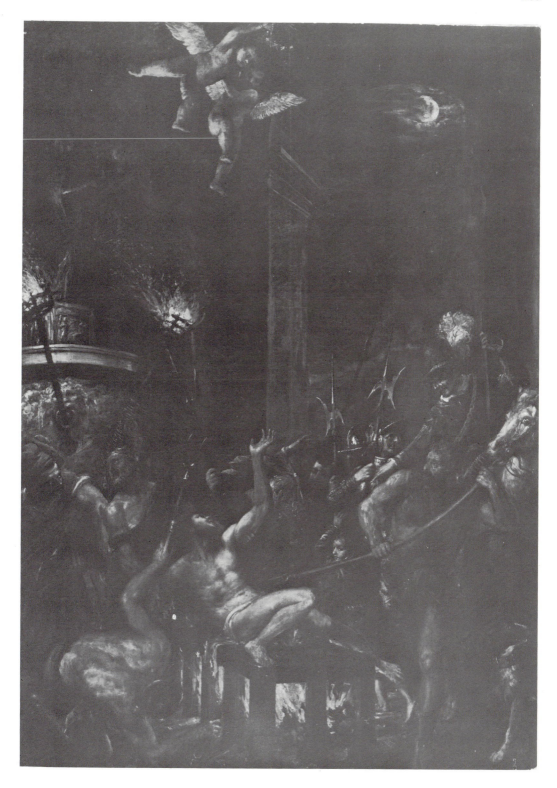

174 (*left*). Detail of plate 173.

175. Titian. *Pietà*. Venice, Accademia.

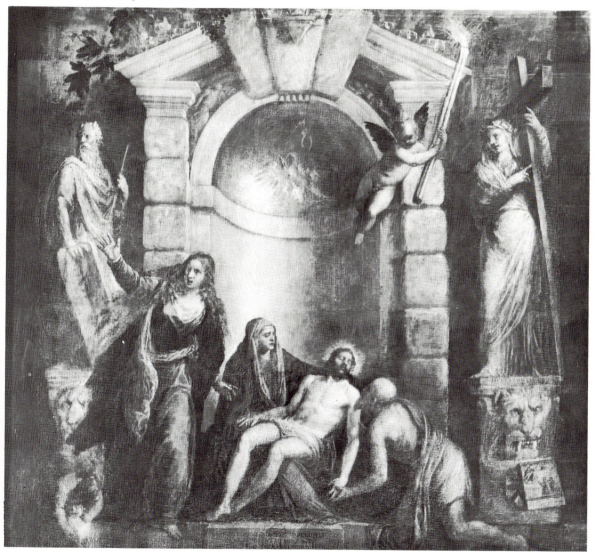

208

wicked. So is the *creatura* (Plate 174); there exist few portraits of animals to match this detail.

The *Pietà* in the Venice Academy is said to have been painted by Titian for his own burial chapel (Plate 175). This is possible. In his new edition which was published in 1568, Vasari speaks of the work which Michelangelo had destined for his tomb. There may or may not be a link between these two works. But it is important to notice that Titian's picture, as we now possess it, is the enlargement of a composition which the artist had carried out considerably earlier, in the late 1540s or early 1550s, and which shows—and shows very clearly—the influence of Michelangelo's early *Pietà* in St. Peter's. The fact of two distinct periods of execution can, I believe, be established on stylistic evidence; but it is confirmed by a physical examination. In 1935 I had the opportunity of examining the canvas and found that the central part was painted on canvas which had been fixed on a stretcher-frame just the size of this oblong (Plate 176). The additions have transformed this image of the mourning mother into an explicit *Confiteor* of Christian faith with a direct appeal to the spectator. All the additions are in Titian's latest style; the share of Palma Giovane, referred to in a somewhat pompous inscription, is negligible. The final composition is a square.

In concluding, I show you Titian's last religious painting (Plate 177). It was doubtless intended as an altarpiece, but its destination is unknown. Later it belonged to Tintoretto; now it is in the Munich gallery. This

177 (*right*). Titian. *Mocking of Christ*. Munich, Alte Pinakothek.

176. Detail of plate 175.

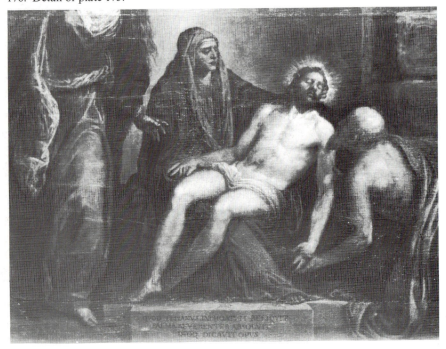

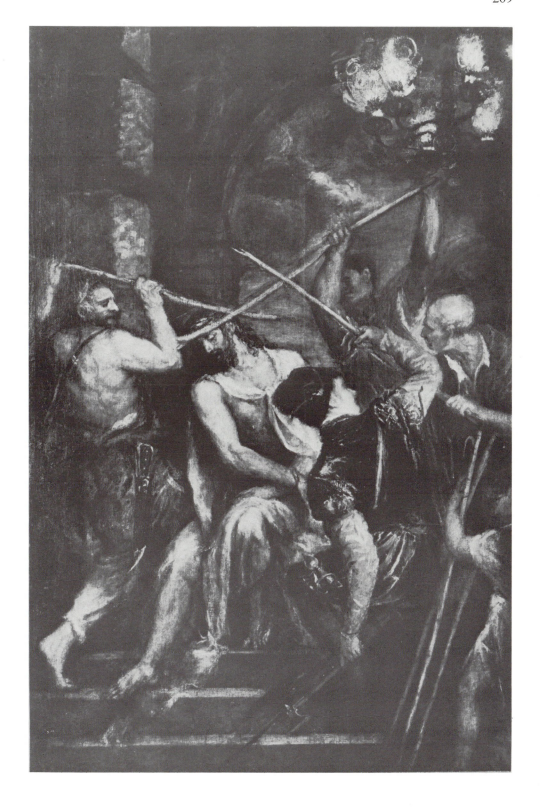

178. Detail of plate 147.

179. Detail of plate 177.

picture is clearly a replica of the *Mocking of Christ* which Titian painted for a church at Milan in the first half of the 1540s, but it is also a summary of all Titian's experiences of life and art. The heavy architecture, the 'rustic' plasticity of the earlier work have disappeared. Every form has been turned towards the surface, has been spread out and flattened; and yet, there is a mysterious depth in this picture which attracts the eye more intensely than any illusion of plasticity. Colour seems to be the only substance of this reality, which is sublime and emotional at the same time. The drama itself is mute: it happens in the souls of those who represent it and of those who behold it. I show you one more detail: the head of Christ (Plate 179), contrasted with the Laocoön-head of the earlier version (Plate 178). Notice how form melts into form, and yet how everything remains quite clear and is of a greater clarity than any mastery of draughtsmanship has ever produced.

Three and a half centuries after Titian Paul Cézanne said 'Colour and form are not separate entities. In the same measure that you paint, you also draw. The fuller the colour, the more precise the drawing will be' ('Quand la couleur est à sa richesse, la forme est à sa plénitude'). It is known that Cézanne was thinking of the great Venetians when he formulated this life-principle of his art.

Titian as a portrait-painter

IN the short survey of Titian's career which I have tried to give in these
lectures, I referred more than once to his universality as a painter. This
universality means two different things; first, that Titian was, by his
own practice, well acquainted with the whole range of tasks which
were demanded of painters by the society of the Cinquecento, and
secondly that, better than any other Venetian artist of the century, Titian
was acquainted with the general trends and currents in Italian art, and
that this knowledge was a constant and important source of inspiration
to him.

So far we have followed Titian's activity in religious painting and in
the mythologies and allegories. Now I propose to consider the third
main class of his products, the portraits. This is a very large class; we
still possess between seventy and eighty portraits from Titian's own
hand, and dozens more are known to us from copies or from literary
sources. They cover a period of at least six decades, and they reflect all
the main stages in the evolution of his art. But I am not going to show
you a selection of these works in chronological order; this inevitably
would lead to tedious repetitions. Instead I shall try to discuss some
aspects of this art as a whole—aspects which are also characteristic of
Cinquecento portraiture in general. In other words, Titian will be
considered as the chief representative of portrait-painting in Italy in
the sixteenth century.

As Titian was a master in all branches of painting, one may rightly
expect to find that there was some correlation between his creations in
portraiture and his other works, and that this correlation had some
significance for the Titianesque portrait. In fact we find that experiences
which he had gained in one field he advantageously applied in the
other, and we also find a continuous sequence of problems and solutions
developing on parallel lines in all fields. Nevertheless history painting
undoubtedly holds the chief place. The same applies to Titian's great
predecessors, Leonardo and Raphael: the new portrait of the Cinque-
cento was a creation of monumental painters, not of specialists.

I have selected three examples to illustrate the relation between
monumental painting and portraiture.

This picture at Copenhagen is one of the earliest portraits of Titian's

that we possess (Plate 180), and there are unlikely to have been many earlier examples; as far as we can see, portraits were comparatively rare in the early period of his career. This type of portrait is well known to us from the second half of the fifteenth century, particularly in the Netherlands: the bust, with one hand showing just above the bottom ledge, seen in a narrow room that allows a view of a distant landscape. The Italian element in this solution is the predominance given to the figure within the narrow limits of the picture space: only the figure has been portrayed, not the room as well. One can hardly perceive that this is a corner of an interior; and the landscape is not framed by a window— the room has simply been left open on one side. The almost ornamental simplification of form and the broad outlines are characteristic of Titian. The figure occupies the whole width of the canvas and is of a characteristic flatness. The area of the head is counterbalanced by the hand, the centre to which all the folds of the dress converge. Colour is concentrated in these two centres, the head and the hand, and the landscape, with its dabs of green and blue, gives the necessary complement to the warm flesh-tones. This simple and convincing unity of appearance has not been achieved without a certain heavy-handed energy; we found the same in Titian's early religious paintings, the votive picture of Jacopo Pesaro and the *St. Mark Enthroned*.

The way in which life and sentiment spring from the face, as well as the slight twist and slant of the hand, with the unfixed gaze of the eyes, seem to express a profound state of mind in the sitter. These features are not found in the traditional type of portraiture. This expression is usually called Giorgionesque; but it was not altogether new. In fact it had been in general use in religious painting during the last two decades of the fifteenth century. There it meant the self-denying attitude of attendant figures or their absorption in the sacred events. What is new is the secularization of this, an originally religious motive, and its adaptation to portraiture.

We find this in one of the frescoes painted by Titian in the Scuola del Santo at Padua in 1511 (Plate 181): St. Anthony is healing the repentant boy who punished himself for having kicked his mother. Like the large fresco of the *Speaking Infant*, this composition, too, has the suggestiveness of a work of Giotto (after all, the Arena Chapel is only a quarter of an hour's walk from the Scuola del Santo); indeed, this is perhaps even simpler and more monumental than the large fresco, and is reminiscent of the *Lamentation* in the Arena. Now one finds among the onlookers a portrait of a member of the confraternity; he is no doubt the donor, the man who paid for this particular fresco. But he is not represented in profile, nor in the traditional act of prayer: he has been given that expression of inward participation in the event of which I have just spoken. Clearly it was only a small step to impart to a self-

180. Titian. *Portrait of a Man*. Copenhagen, State Museum.

181. Titian. *Miracle of the Unfaithful Son*. Padua, Scuola del Santo.

182. Titian. *Portrait of a Man*. New York, Frick Collection.

contained picture what had been achieved in the fresco figure. The man in Copenhagen wears the gown of a lay brotherhood—perhaps he, too, was a member of the Confraternity of St. Anthony.

There are later and richer variants of the same invention. I think we may safely date the picture at Copenhagen about 1510, contemporary with the *Gipsy Madonna* in Vienna—the two landscapes are almost identical. The sitter of the beautiful portrait in the Frick Collection is dressed as a nobleman and has a sword, but his expression has not changed (Plate 182). This picture is probably contemporary with, or only slightly later than, the *Three Ages of Man*. The sitter of the portrait in Munich is more self-reliant, his gaze is firmer: the 'Giorgionesque' air is hardly noticeable any more (Plate 183). This painting probably belongs to the period of the *Assunta*.

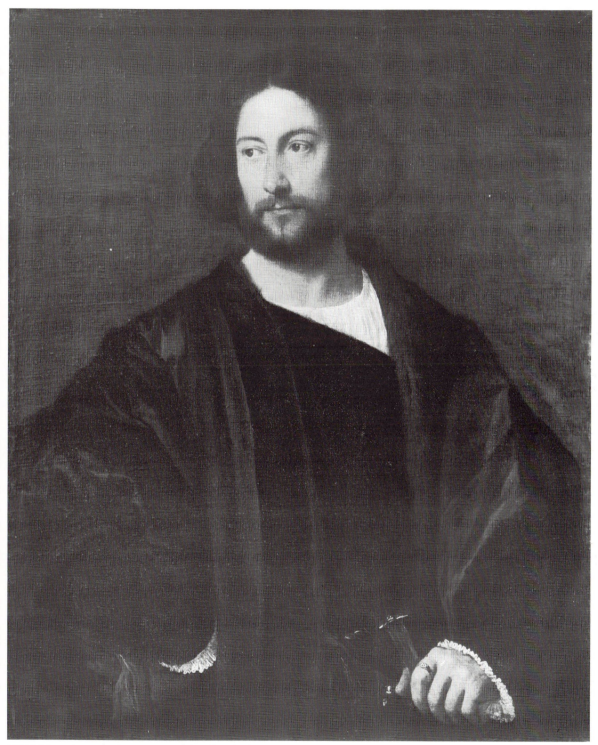

183. Titian. *Portrait of a Man*. Munich, Alte Pinakothek.

218

My second example is of a date a quarter-century after the Copenhagen portrait. In the years 1537–8 Titian completed a monumental history painting. Originally it was to represent one of the battles of Barbarossa, but the Venetians took it for the battle which they had fought at Cadore against the Emperor Maximilian in 1508 (Plate 184). It was painted for the Hall of the Great Council in the Ducal Palace, and perished in the fire of 1577. We know it from descriptions and from copies of which this engraving is the best. For the moment we are interested in the principal figure, that of the commander who was in charge of the attack of the Venetian cavalry against the Imperial force. The figure is placed right in the foreground and so low that it is cut by the edge; an arrangement which invites the spectator to enter the picture by following the gesture of this figure. His outstretched arm, resting on the marshal's baton, finds its continuation in the barrel of the cannon, which in its turn is pointing towards the place where the decisive action is being fought. There the diagonal fades away in the slope of the mountain. We are probably right in assuming that the colour-schemes emphasized the

184. Engraving after Titian's *Battle of Cadore*, formerly Doge's Palace, Venice.

D. CLAVDIVS CAESAR.

185. Engraving by Sadeler after Titian's portraits of Roman Emperors for the Ducal Palace at Mantua.

structure, for from Ridolfi's description we learn that the commander's horse shone 'like white silk', and it is this horse which rounds off the main group.

At the time when this large picture was being completed, Titian received the commission to paint, for one of the rooms in the Ducal Palace at Mantua, the *Twelve Caesars*. To help him in this task, all available archaeological material was placed at his disposal by his patron. His problem as an artist was how to avoid monotony in a cycle consisting of twelve half-length figures (Plate 185). Obviously his

experiences as a painter of historical subjects were a great help to him in finding impressive variations on the theme; for instance, you find Claudius repeating the pose of the commander in the *Battle of Cadore*. Again the diagonally extended right arm, supported by the forms of the armour, is the main compositional feature.

Another portrait by Titian, also painted between 1536 and 1538, is that of Francesco della Rovere, Duke of Urbino, in the Uffizi (Plate 186). This Duke twice lost and subsequently regained his state. He was also commander of the Venetian army, and in 1537 he was appointed commander-in-chief of the League formed by the Pope, the Emperor and Venice against the Turks. In the last years of his life the Duke became a great admirer of Titian's art, and both he and his Duchess were portrayed by Titian. The Duke had his armour brought to Titian's studio, and in this picture he is represented as the Commander of the armies of the League, with the treble baton and the helmet as the only decoration. His pose is the same as that of Claudius; although turned towards the spectator, he still gives the impression of being an officer in action.

Here is my third example, the last dated portrait from Titian's hand that we possess (Plate 187); it is unlikely that there were any later ones, for Titian's latest pictorial style, in which plastic structure was almost completely dissolved into patches of colour, was unsuitable for rendering individual appearances. This was painted in 1568, thirty years after the *Duke of Urbino*; Titian was certainly more than eighty. One is curious to learn why the aged artist undertook the task and produced such a masterpiece, in a field in which he had had hardly any practice for years. We possess a report from a Venetian art dealer dating from the time when this canvas was on Titian's easel. This man writes: 'The worst of it is that Titian is still asking prices which are not only as high as, but even higher than, those of former days, and this in spite of the fact well-known to everybody in Venice that he can no longer see what he is doing, and that his hand is so shaky that he cannot finish anything and has to leave it to his pupils.' The letter goes on: 'One of these pupils is living in his house—his name is Emanuel; he is a German and a nephew of the bookbinder Anthony the Fleming at Augsburg. He is quite excellent; and Titian just touches up his works, which he then sells as being of his own hand, cheating wherever he can.' You may feel certain that no pupil participated in this canvas, and that the old man used his thumb when the brush was shaking in his hand. The cartouche is the only addition; it was ordered by the sitter's family. The sitter is Jacopo Strada, adviser to the Imperial court in collecting antiquities; and the portrait itself was in lieu of commission for two business transactions which Strada had successfully carried out on Titian's behalf. One of these concerned the sale of a number of pictures to the

186. Titian. *Portrait of Francesco della Rovere*. Florence, Uffizi.

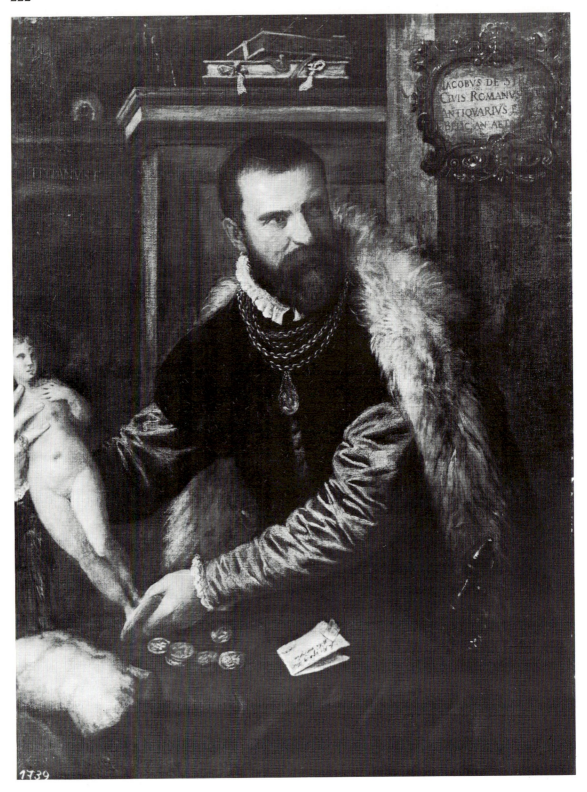

187 (*left*). Titian. *Portrait of Jacopo Strada*. Vienna, Kunsthistorisches Museum.

Emperor; these pictures still exist and are of the sort described in the gossip just quoted (the workshop replica of the *Diana and Callisto* (Plate 160) at Vienna is one of them).

We know the biography of this business partner of Titian. He began as a painter, as a pupil of Giulio Romano at Mantua. But he soon found that a better living could be made by dealing in antiquities, and he specialized in statues, inscriptions, coins, and in books in oriental languages. He was first employed as an agent by the Fuggers at Augsburg; later the Emperor Ferdinand accepted his services, and Strada managed to retain his position as 'Caesaris Antiquarius' under two succeeding Emperors. He bought in a grand style for both the Court of Vienna and the related Court of Bavaria. Contemporary records speak of him as a man of great persuasive power; in money matters he was not too reliable. Titian depicted him with all the attributes of his trade: statuettes, medals, books, and rare works of craftsmanship; his dress anticipates the knighthood which he received six years later. (There is a *pentimento*: at first there were only two gold chains, then two more were added.)

Now, how is this portrait related to Titian's activity as a portrait-painter? There exists something like a precedent for it in the picture at Hampton Court, painted by Lorenzo Lotto forty years earlier (Plate 188). Lotto's sitter, Andrea Odoni, was a passionate collector. He is shown here among his treasures, which were so minutely listed by Marcantonio Michiel in his diary, and his gesture expresses his fondness for these works and his devotion to his noble hobby. But the strong movement of both arms and the whole body in the *Strada* is quite unusual in portraiture. In order to stabilize this restless pattern Titian has made use of an architectural background consisting of horizontal and vertical forms; thus the figure in action has been fastened to a stable framework.

Titian used this expressive style in some of his late religious paintings. *The Temptation*, now in the Prado, dates from the second half of the 1560s (Plate 189). Never before was the Fall of Man represented with such an impetus—not even by Michelangelo on the Ceiling. The out-stretched left arm as well as the entire body of Eve express the desire for the forbidden fruit, while the whole attitude of Adam, from his hand to the position of his feet, reveals unwillingness and self-defence. These strong movements are echoed in the forms of the background, the trees and the foliage. These free and grand movements are not merely gestures of the limbs, they are movements of the whole of the body, encompassing the space and, as it were, floating in it.

And so Titian did not use a motive or a figure from his large compositions for his *Strada*, but, in formulating it, he adopted the essence of his new conception of how to represent fundamental events. Strada was an *homme de métier* and a colleague of Titian, and the swagger of his personality seemed to Titian best to express the man.

224

These three examples, the portrait in Copenhagen, that of Francesco della Rovere, and the Jacopo Strada, illustrate different ways in which history painting exerted a fruitful influence on portraiture: motives and methods which had been invented for monumental compositions were drawn upon to enrich and transform the portrait. This leads us to consider another aspect of Titianesque portraiture. To put it plainly, both public and artists in the Cinquecento looked for a kind of likeness different from what the previous century understood by this word. This change in the conception of likeness has a positive and a negative side: you have no longer a record of each individual feature, no longer a map of every wrinkle in the face; on the other hand, the new likeness is intended to give not only the social position of the sitter, but also

189 (*right*). Titian. *The Fall of Man*. Madrid, Prado.

188. Lotto. *Portrait of Andrea Odoni*. Hampton Court, Royal Collection (reproduced by gracious permission of H.M. The Queen).

190. Titian. *Portrait of Antoine Perrenot de Granvelle*. Kansas City Museum.

191. Anthonis Mor. *Portrait of Antoine Perrenot de Granvelle*. Vienna, Kunsthistorisches Museum.

FERDINANDVS ALVARVS A TOLETO DVX D'ALVA
PHILIPPVS II REGIS HISPANIARVM BELGICARVM GVBERNAT
obyt An.º 1582 ÆTATIS SVÆ. 74.

Titianus Pinxeit P. de Iode excudit

his character and the whole of his personality. This involves his status and rank, his profession, the power he wields and the position he holds.

Let us consider some further examples from the viewpoint of this changed conception. Plate 190 shows a portrait of *Antoine Perrenot de Granvelle*, now in the Museum at Kansas City. Titian painted it in Augsburg in 1548, at the same time as his famous picture of *Charles V at the Battle of Mühlberg*. It is the portrait of a young politician, who at that time was, on behalf of the Emperor, in charge of the negotiations

following the defeat of the Protestant League; later he succeeded his father as chancellor. The extraordinary nobility of the figure is partly due to the fact that in it one sees the axis of a rectangular section of space made tangible. This also gives the clue to the subordination in a strict order of head and hands as well as of all additional details. The head, small in comparison with the body, is longish, similar in proportions to the section of space which was chosen for the whole. The traits of the face have been generalized. Granvelle has the look of a statesman, decided but open; in his expression there is still something of the humanistic calm of Erasmus, of the High Renaissance. The small oval face, the high eyebrows, the straight, long nose all reflect the nobility of a long line of ancestors. You see the generalized traits of the ideal type of nobleman, in the form in which the age liked to see them.

There exists another portrait of Antoine Granvelle, painted only a few months later (Plate 191). The artist, Anthonis Mor, was, in contrast to Titian, a specialist in portrait-painting; and being an artist of the North, a Dutchman, his conception of likeness still coincides to some extent with the older ideal of exactness, line by line as it were, which had survived in the Netherlands. Although in the general disposition there seems to be a resemblance between the two, the conception of the whole and the style in which the later portrait is executed show considerable differences. There is here a minuteness in rendering every detail. Our attention is called to the head and the hands, whereas the relation between figure and surrounding space is less clearly defined. The face bespeaks a man who has retired within himself, is thoughtful and resolute, unwilling to accept anything at its face value and searching in his inquiry. At the same time his body has vanished behind the finely treated garment, the pose has become stiff and is not quite balanced.

That all this is not accidental but the outcome of two fundamentally different conceptions can be proved by another couple of portraits, also dating from 1548–49. They both represent the *Duke of Alba*. Unfortunately the Titian was burnt and this engraving (Plate 192) was made from a copy by Rubens, now also lost. As shown by a coarse copy at Christ Church, in Titian's original the background was a plain wall, with a landscape seen through an opening; the triumphal arch was added by the seventeenth-century engraver. This lost picture may be considered as a companion to the Granvelle portrait. Titian represented the Duke of Alba not as a soldier but as a courtier, because at the time when this portrait was begun Alba's official function was that of a minister, introducing Crown-prince Philip to the Lombard Estates. Mor's picture was made in honour of the victor of Mühlberg (it exists in two versions: that in the Hispanic Society in New York (Plate

193) and that at Brussels). No need to repeat the remarks on the two Granvelles. The apparent family resemblance of the two sitters in Titian's portraits, Granvelle and Alba, is only due to the fact that both were represented as nobles of the Spanish court. The type has long survived, down to the Don Quixote of Doré and Daumier. Anthonis Mor used psychology and physiognomy; in the Titian the content is conveyed by the form alone.

We possess an interesting group of portraits in which to study Titian's power of creating the typical. They are works in which circumstances forced him to use a prototype instead of a living model. I think we all admire Titian's *Charles V with his Dog* in the Prado (Plate 194), and this in spite of the fact that it was copied from another artist's work. It was executed in 1533.

The relation between the Emperor and Titian seems to me to be indicative of that change of significance in portraiture with which we now are concerned. Charles and Titian first met in Bologna in 1530, at the time when the Emperor made his peace with the Pope and was crowned by him. The young Duke of Mantua wanted to curry favour with the Emperor by introducing Titian to the court. But this turned out to be a complete failure. Titian then began a half-length portrait of the Emperor, in his armour and with his sword unsheathed in his right hand, the form suitable for a coronation portrait (Plate 196). Charles, as we know from a document, gave him a golden ducat for his labours—hardly more than a tip; the Duke of Mantua had to hand out 150 gold pieces to appease his protégé.

Three years later the Emperor and Titian met again at Bologna. In the interval Jacob Seisenegger, an Austrian artist, who was court-painter to Charles's brother Ferdinand, had portrayed the Emperor four times, apparently much to his liking, since this young artist was asked to quit the service of Ferdinand and join the Imperial household (Plate 195). So it happened that Titian's first job in 1533 was to copy Charles Seisenegger's latest work.

The full-length, life-sized portrait is, as far as we can see, a German invention of the early sixteenth century. We have examples of it by Cranach and Bernard Strigel from the second decade, and we meet the type again at Augsburg in the third decade; and it was in all probability here that Seisenegger received his training. We also possess a memorandum written by Seisenegger in 1535, containing a list of paintings for which the Vienna court had not yet paid him. This catalogue is detailed and precise: it states which of the pictures were done from the life, which from prototypes, and which were replicas of works from Seisenegger's own hand. This portrait of Charles bears the date 1532 and Seisenegger's signature; it is also described in the list in the minutest detail and is stated to have been taken from the life at Bologna in 1532.

194. Titian. *Portrait of Charles V with his Dog*. Madrid, Prado.

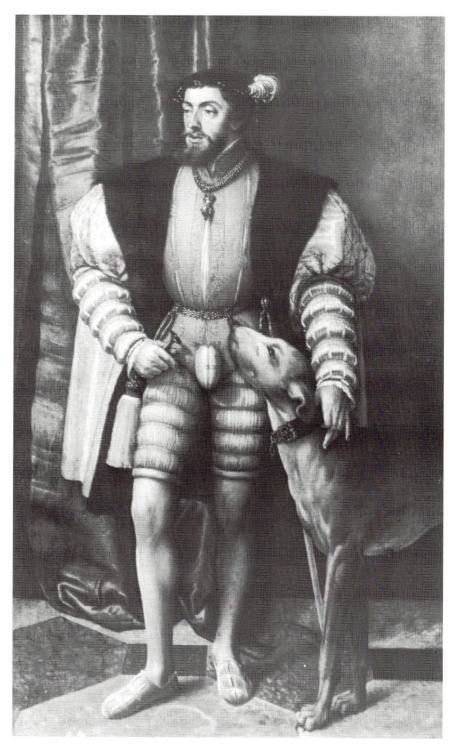

195. Seisenegger. *Portrait of Charles V.* Vienna, Kunsthistorisches Museum.

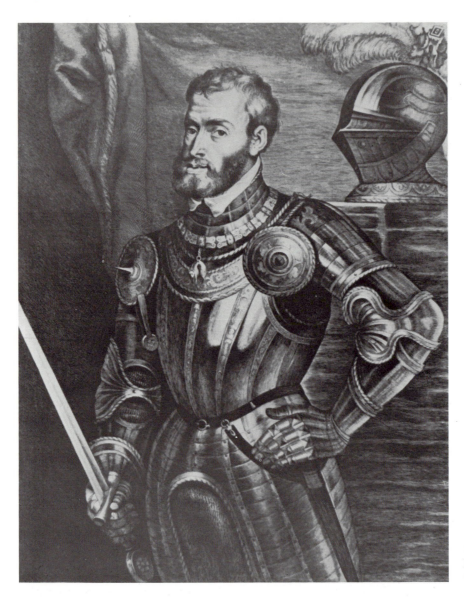

196. Engraving after Titian. Half-length *Portrait of Charles V*.

This time Titian's work, the copy, was a complete success. The Emperor appreciated his art so fully that he was made his official painter and was knighted. Though the actual alterations in the copy are few, the creative power that helped to form the state portrait of a powerful monarch from the image of a pretentious doll is manifest. Here are the two heads (Plates 197 and 198). In the one the features are rendered distinctly and precisely; they have been transformed by Titian's brush into a structure consisting of planes. The head—long, narrow, of greater firmness, and smaller in proportion—is yet entirely subservient to the organic unity of the whole.

A more difficult task awaited Titian when Charles asked him to paint the deceased Empress, Isabella of Portugal. Titian had never seen her. He was supplied with a picture on which the Emperor commented: 'molto simile al vero, benchè di trivial pennello'. The 'trivial brush' proves to be once more that of Seisenegger, whose professional skill had given the Emperor complete satisfaction ten years earlier. Charles's taste had changed in these years, and one of the two portraits of Isabella, which Titian finished in 1544, was later taken by Charles to the Monastery of San Yuste, and was his consolation in his last days (Plate 199). The success is fully explained by this contrast between stiffness and graceful nobility. In this case too we have been deprived of one of the paintings of Titian, but we possess an engraving after a copy of it by Rubens (Plate 200). In the Prado original the figure shows something of the beauty and tenderness of a High Renaissance Madonna: she also holds a prayer-book, and the arrangement is very much like that in Raphael's *Madonna with the Goldfinch*. You will again notice the relatively small head, of longish, symmetrical, oval shape; the forms of the drapery are subdued, the details do not exist in their own right, and mouth, nose, and forehead seem to have been formed on models of classical sculpture.

Now, having seen these examples of the transformation of reality and of prototypes, you may ask how Titian represented himself. In a self-portrait the artist has at least the advantage of not being hampered by any particular demand of the sitter. Two seif-portraits of Titian have come down to us. The one in Berlin dates from 1550 (Plate 201), the period between his two journeys to Augsburg which were the climax of Titian's career.[1] We are told that, like an ambassador on leave, he was asked to report to the Senate on his first return from the Imperial Court. And this portrait—this is an unfinished replica, the finished work is lost—represents him on such a high social level: he is a knight, the robes he wears are those of a nobleman, and there is nothing to show that by profession he was a painter; the skull-cap, the only intimate detail, must be classed as a personal attribute and was probably well known to all Titian's fellow-citizens. The showy grandeur of this public portrait enticed a younger colleague of Titian's to make a caricature of him. I am referring to Jacopo Bassano's large canvas of *Christ driving the Money-changers from the Temple* in the National Gallery, in which the rather conspicuous figure of an old banker embracing the table with his threatened property is a copy of the Berlin portrait, drawn in the manner of David Low (Plate 202).

Titian painted another self-portrait twelve years later; it is now in the Prado (Plate 203). It is less pretentious, more intimate; in fact, Vasari says that it was intended for Titian's family and his personal friends. Here we see a master in the realms of wisdom and poetry,

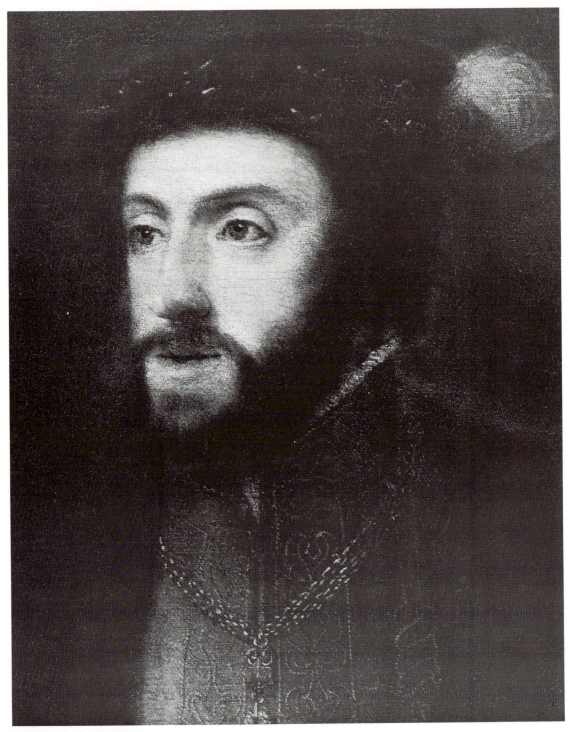

197. Detail of plate 194.
198 (*right*). Detail of plate 195.

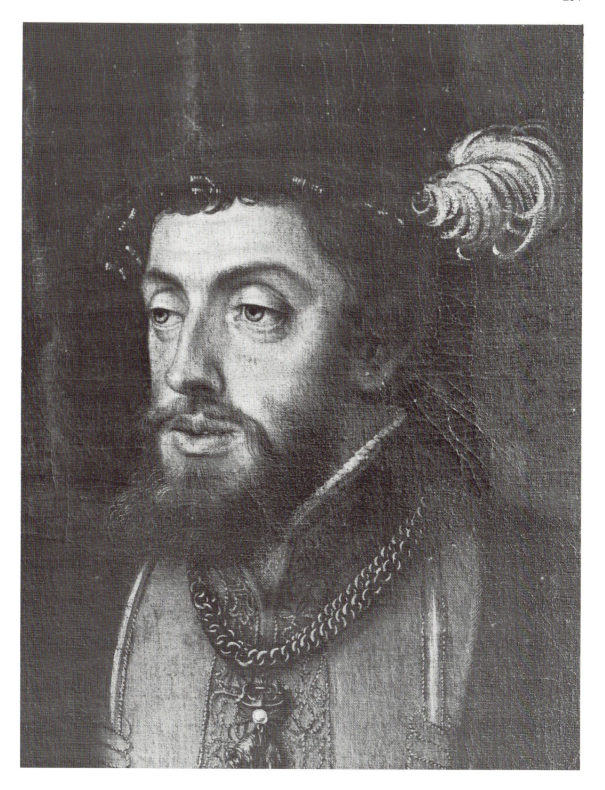

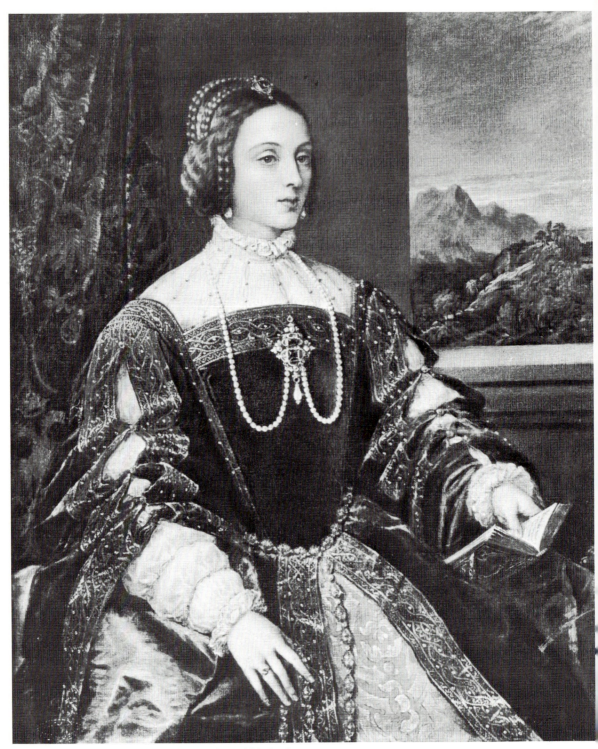

199. Titian. *Portrait of Isabella of Portugal*. Madrid, Prado.

ISABELLA LVSITANA. IMPERATRIX. REGINA. HISPANIARVM
ET INDIARVM VXOR. CAROLI. V. MATER PHILIPPI. II . obyt 4u°. 1539
Titianus pinxit P. de Iode excud.

200. Engraving after Rubens's copy of Titian's 1544 *Portrait of Isabella of Portugal*.

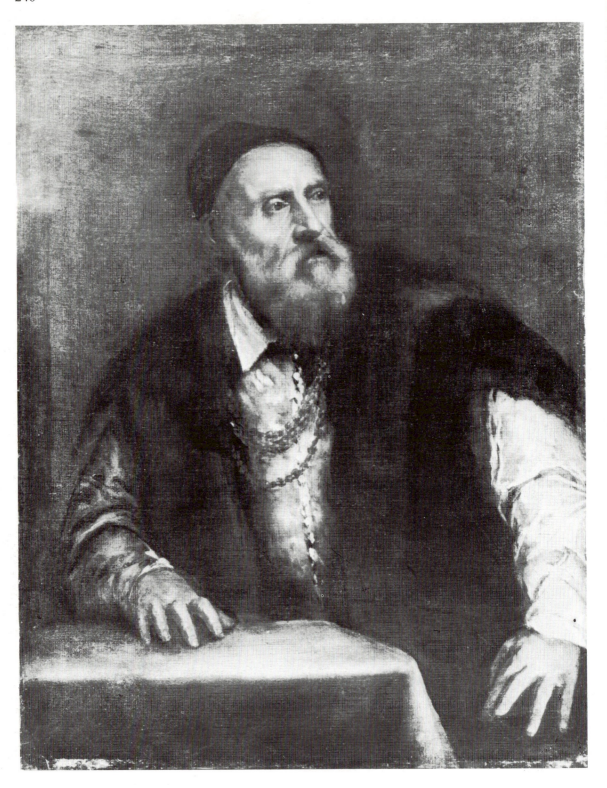

201 (*left*). Titian. *Self-portrait*. Berlin, Dahlem Museum.

202. Jacopo Bassano. *Christ Driving the Money-changers from the Temple* (detail). London, National Gallery.

and the brush only discreetly reminds one that he is used to expressing his thought in colour. It is the prototype of a long line of self-portraits which will perhaps never end.

Fortunately we also possess documented evidence of what Titian looked like to one of his contemporaries. A young Veronese artist, Orlando Flacco, or Fiacco, painted him (Plate 204); the picture is in the gallery at Stockholm. Vasari highly praised Flacco's abilities as a portrait-painter, emphasizing the perfect truthfulness of all his works. Though this is certainly not meant to be a caricature, it comes dangerously near to Jacopo Bassano's cartoon. At any rate, it seems to me that it would make a good frontispiece to an edition of Titian's correspondence with his patrons.

The new conception of likeness we have been considering leads us to a third aspect of this art, closely linked with the two others. We have seen how portraiture had become an aesthetically self-contained task,

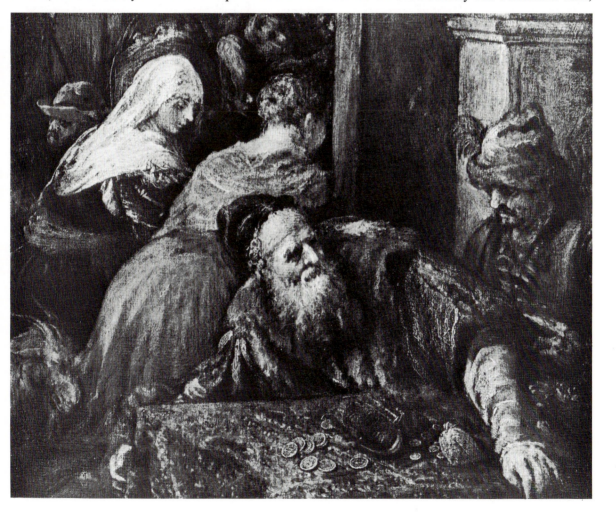

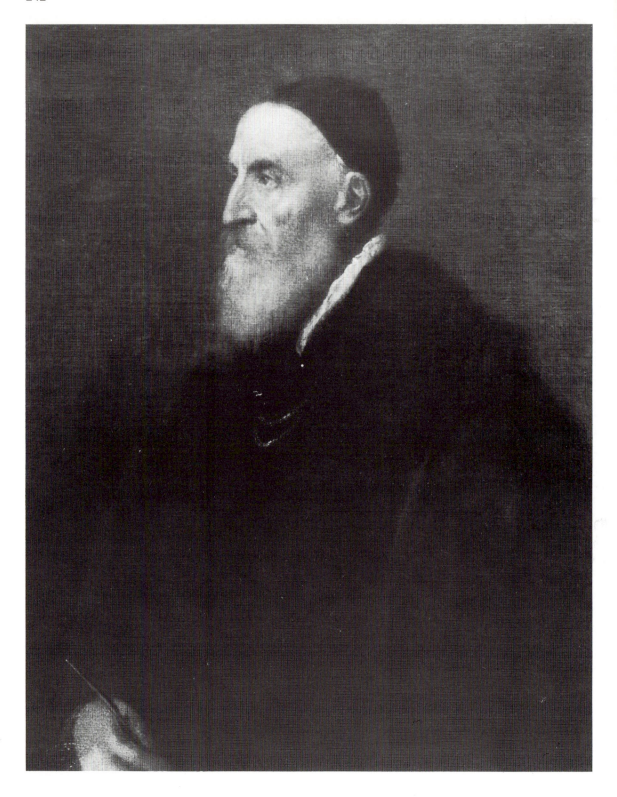

203 (*left*). Titian. *Self-portrait*. Madrid, Prado.

204. Orlando Flacco. *Portrait of Titian*. Stockholm, National Gallery.

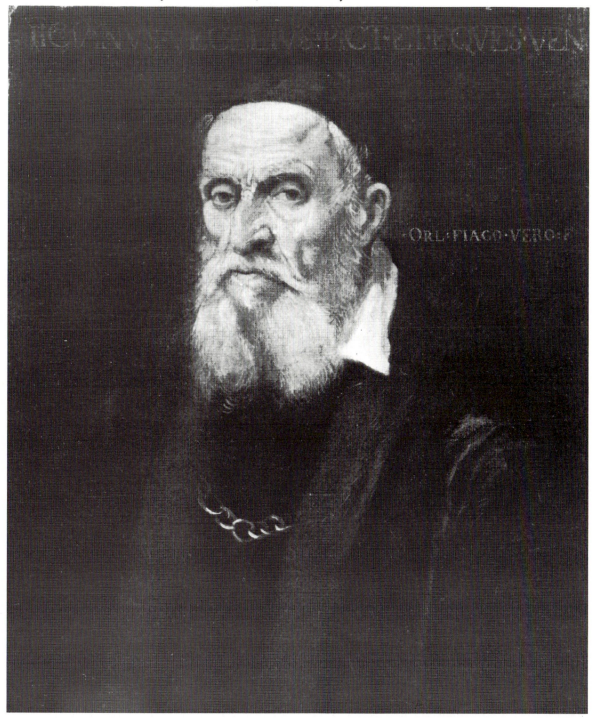

and how it had changed from describing individual features, which can only be studied at close quarters, to paintings of larger dimensions and of such decorative value as to become artistically the centre of a whole room. A man who commissions his portrait not only wants a likeness which he and his contemporaries can accept and which he can entrust to posterity, but wishes primarily to get a beautiful painting with which to decorate his home. There are many sources to throw light on this change; I should like to mention two.

This noble picture of Philip II in the Prado (Plate 205), the earliest in a long line of Spanish court-portraits which leads up to the end of the seventeenth century, belonged to Philip's aunt, Mary of Hungary, Regent of the Netherlands and owner of the largest contemporary collection of works by Titian. It was finished in 1550. When three years later Philip was to conclude his political marriage with Mary Tudor, the bride asked for a portrait of her fiancé. Mary of Hungary lent her the portrait 'until such time as the husband could replace it'. With the picture she sent some instructions: the portrait was a very good one, but it must be looked at in the proper light and from a certain distance. This, she added, was necessary for all paintings of Titian, as they are unrecognizable from close quarters. ('La voyant a son jour et de loing, comme sont toute pointures dudit Titian, que de près ne se recognoissent.')

Just as telling in this respect is the quarrel of the Emperor with the Duke of Ferrara about the possession of the latter's portrait by Titian. Relying on the artist's own statement of its exceptional quality, Charles V wished to add this picture to his own collection, although the sitter was not exactly his friend. This was in 1533, at the time of the success of Titian's copy after Seisenegger. The end of the story is that the Duke was to be comforted by the news that his portrait was decorating the Emperor's study. The picture is now in the Metropolitan Museum (Plate 206); it is a work of the first half of the 1520s, contemporary with the *Pesaro Madonna*.

In certain cases it was made quite clear that the commission itself aimed at a good painting rather than a good likeness. For instance, Isabella d'Este, the sixty-year-old sister of the Duke of Ferrara, commissioned Titian in 1534 to paint her portrait as a young lady (Plate 207). As a guide she sent him a painting by Francesco Francia, finished just over twenty years earlier, not from the life but from a still earlier likeness of Isabella. Titian understood perfectly well what was expected of him; and when the old Duchess expressed her thanks she added with some coquetry that she doubted whether she had ever been so beautiful. We know that Titian's friend Aretino had his own views about her beauty. Anyway, she was a fashion-queen in her younger days, and this hairdress was one of her creations.

205 (*right*). Titian. *Portrait of Philip II*. Madrid, Prado.

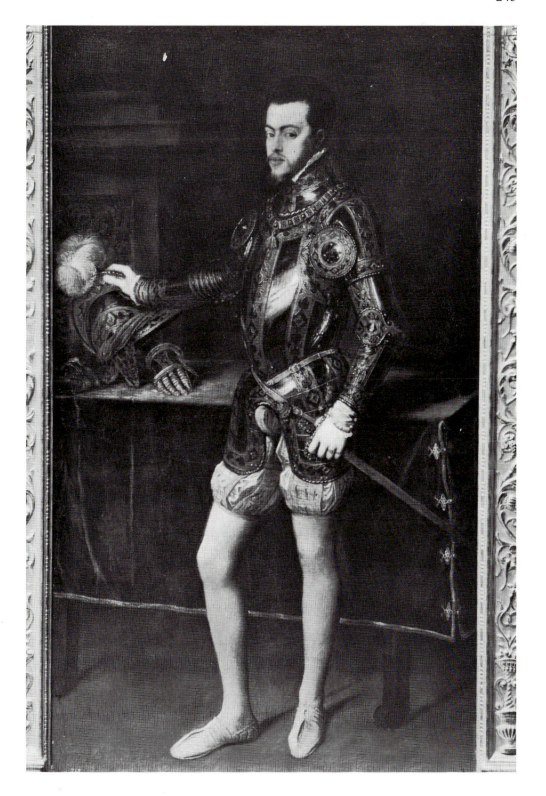

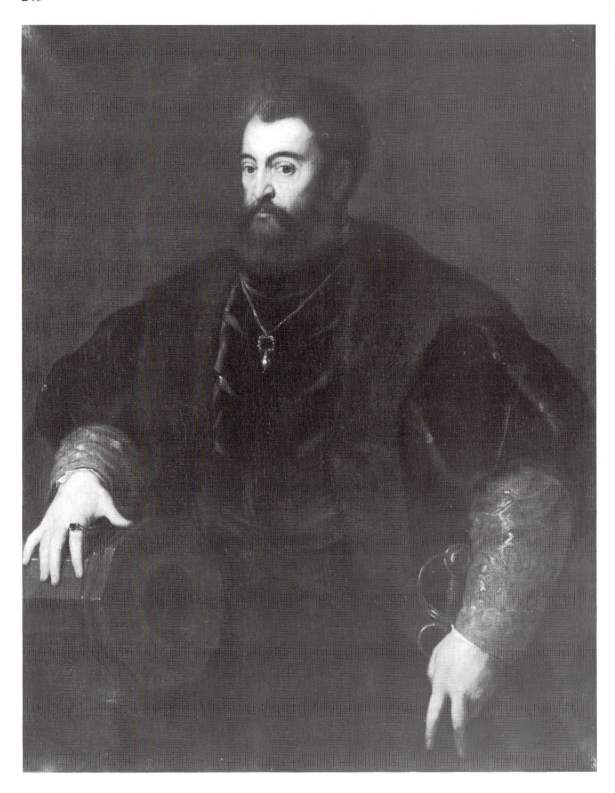

296 (*left*). Titian. *Portrait of the Duke of Ferrara*. New York, Metropolitan Museum.

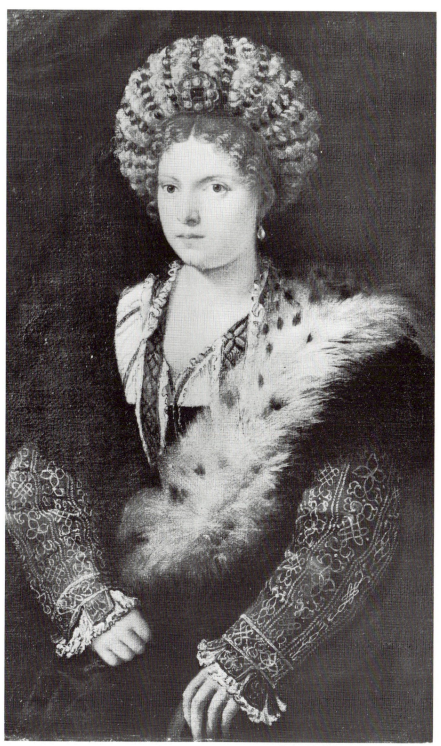

207. Titian. *Portrait of Isabella d'Este*. Vienna, Kunsthistorisches Museum.

The picture in the Palazzo Pitti, called *La Bella* (Plate 208), was painted for the Duke of Urbino at the same time as his portrait in armour. In this case one may rightly ask: is this a portrait at all? I suggest that it is, for it is like some person; but it happens that it is of no interest, and it never has been of any interest to know who the person was. In the Duke's correspondence with his agent at Venice it is referred to as 'il ritratto di quella donna che ha la veste azzurra'. Nor do we hear anything about this lady later on; her prettiness and the beauty of the picture have always been enough. This is a masterpiece of colour and composition: the lapis-lazuli, the dark plum-red, the white and gold of the dress, have grown into an ornamental pattern of a shape resembling the capital R. As you will remember, Titian liked such patterns in the 1530s.

One often hears the *Bella* and the *Girl in a Fur Cloak* (Plate 209) in Vienna named in the same breath. Usually the connection is explained by saying that Titian used the same model for both. In point of fact the connection between the two is even closer: X-ray photographs reveal underneath the *Girl in the Fur* a complete replica of the *Bella*, clearly finished by Titian's own hand. It is an exact copy: the only liberties taken concern some small details of the dress. It is known from many other cases that Titian liked to copy his own compositions before parting with them; and one is tempted to imagine that once, when chancing on his copy, Titian must have felt that he wanted to alter the figure and the dress. This is a Venetian version of the story of the draped and naked Aphrodite by Praxiteles, which may have been known to Titian from Pliny. The new artistic task was that of combining the ivory flesh-tone with the dark and warm colours of the fur coat, and that of changing the composition so as to suit this content. Titian chose a different ornamental scheme, more austere than the capital R, one with convex outlines and completely self-contained. The change in the expression is characteristic of Titian's sublime perception. The *Bella* faces the spectator with a certain conceit and complacency; her less fashionable twin-sister looks tender, almost childlike. This picture, which was copied by Rubens, has been cut on both sides. One can hardly call this a portrait. It belongs to that class of Venetian paintings the only objective of which was to render the beauty of the half-length female figure.

The aim of producing a decorative effect brings with it an increase in the size of paintings. Full-length portraits become more frequent, and additional items such as tables, curtains, and columns also often occur. Then we find pet animals, or second persons such as an African slave, a page, or a standard-bearer. I show you this portrait of *Clarice Strozzi* of 1542 (Plate 210), which also illustrates in portraiture the change of style that we observed in Titian's compositions at the turn of the fourth decade: the skirt surrounds the legs of the little girl like a

208 (*right*). Titian. *La Bella*. Florence, Pitti.

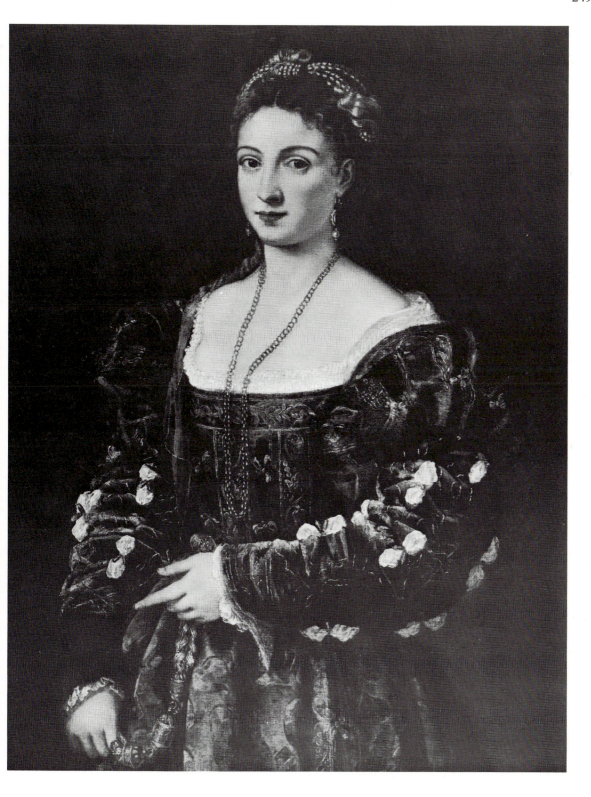

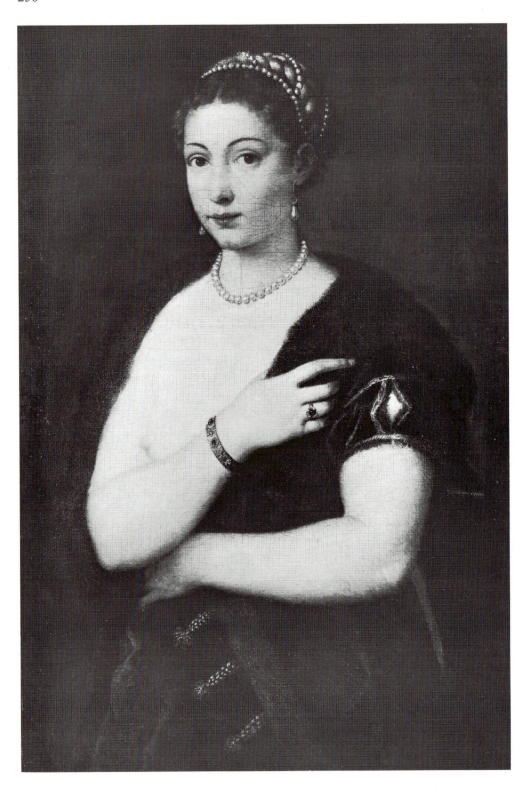

209 (*left*). Titian. *Girl in a Fur Cloak*. Vienna, Kunsthistorisches Museum.

210. Titian. *Portrait of Clarice Strozzi*. Berlin, Dahlem Museum.

cylinder (she is two years old), her head is like a ball; the cool colour-scheme of dark crimson and bluish-green against neutral grey allows the plasticity to develop fully.

The portrait group is no longer an exception, and as the portrait extends in the direction of monumental painting it also often becomes indistinguishable from it, as seen in the votive picture of *The Vendramin Family* of the late 1540s (Plate 150), or in the *Allocution of Alfonso d'Avalos* (Plate 211) in the Prado, painted ten years earlier. The latter is based on a relief from the triumphal arch of Hadrian.[2] It has suffered from heat in its lower half and is heavily overpainted.

A third picture of this type is the family portrait of the Farnese at

Naples: *Pope Paul III with two of his grandsons*, Cardinal Alessandro, his Vice-Chancellor (for whom Titian painted his first *Danaë*), and Ottaviano, the son-in-law of the Emperor (Plate 212). Titian began it in Rome in 1546; not much more than the underpainting was ever finished, for events intervened to make its completion impossible. The father of these two, Pier Luigi Farnese, was murdered in the following year, and it is known that the pope complained of his grandsons, saying that they would bring him also to an early grave. He had good reasons: Ottaviano rebelled against him, and his brother secretly approved of the rebellion. Sometimes Titian has been credited with the faculty of clairvoyance, with having foreseen the Farnese tragedy. I don't know; but it is striking to see how the whole scene is arranged as in a Verdi opera; that the figures are connected by their actions; and that they have the appearance of character actors.

In short we have been carried back to our first problem, the relation of the portrait to monumental painting, and to the determining influence of the latter on the new portraiture. The famous picture of *Charles V at Mühlberg* is a further proof of this influence (Plate 213). The complete victory which the Emperor had won through this battle was also the deeper cause of the family tragedy that I have just mentioned. Europe became Imperial for a long while—and so did Titian, although during the 1540s he had been in the closest contact with the Farnese and had even thought of taking up residence in Rome. At the end of 1547 he went to Augsburg to paint the victorious Emperor, and he sent a long-winded apology to the Farnese. Their family portrait was left unfinished, while it took him only half a year to complete this picture of Charles. One may ask again: is this still a portrait? Perhaps it would be more correct to see in it the symbolic representation of an event that altered history.

The artistic theory of the late sixteenth century recognized the new portraiture and formulated rules as an authoritative guide to the painter. These rules reflect the same phenomena that have been revealed by our examples: the importance of representing the whole personality; the search for and rendering of the typical in the character; the intimation of the position and dignity of a sitter, even if these qualities are not obvious in his daily life; the decorative effect; the embellishment of nature and the avoidance of the accidental: 'levando quanto si può coll'arte gli errori della natura' ('correcting as far as possible with your art the mistakes of nature'). The chapter on portraiture in Lomazzo's bulky treatise gives some interesting examples, and those of Titian are always quoted with the highest praise.

The theory takes full account of the fact that the new portraiture is primarily concerned with leading personalities. This is especially true in the case of Titian. In his years of greatest activity, from about 1520

211 (*right*). Titian. *The Allocation of Alfonso d'Avalos*. Madrid, Prado.

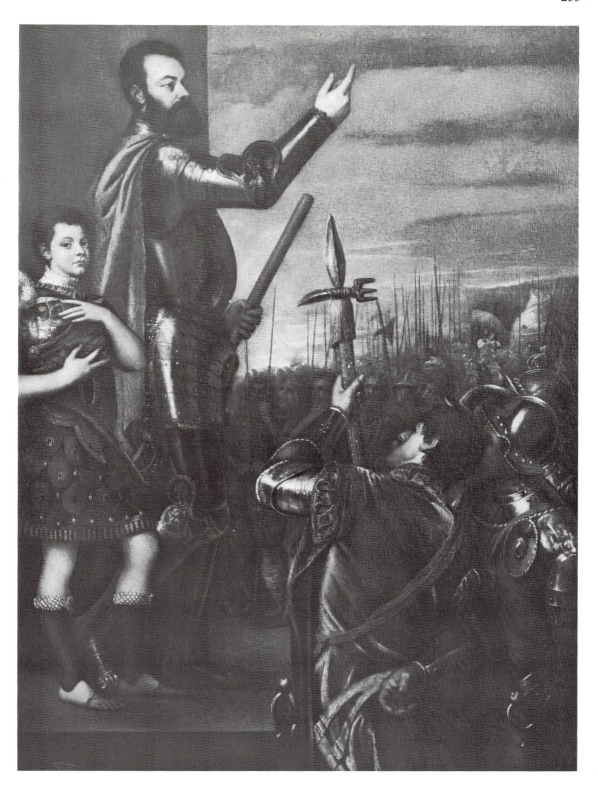

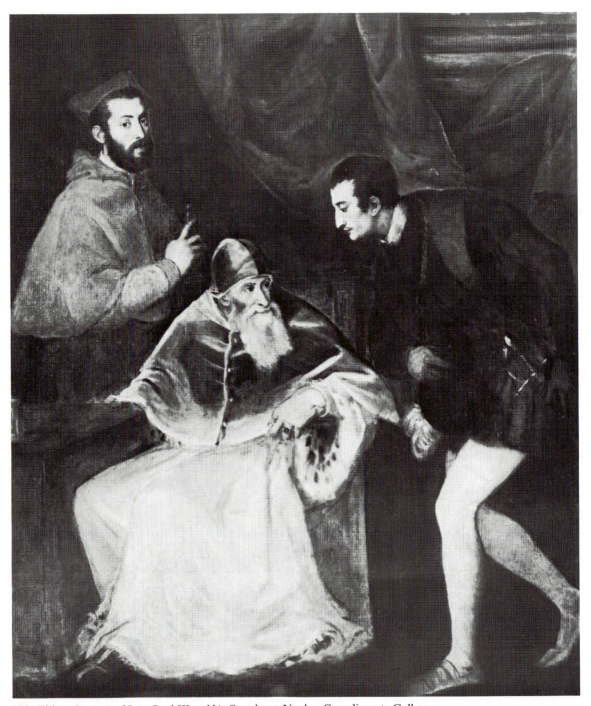

212. Titian. *Portrait of Pope Paul III and his Grandsons*. Naples, Capodimonte Gallery.

213 (*right*). Titian. *Charles V at the Battle of Mühlberg*. Madrid, Prado.

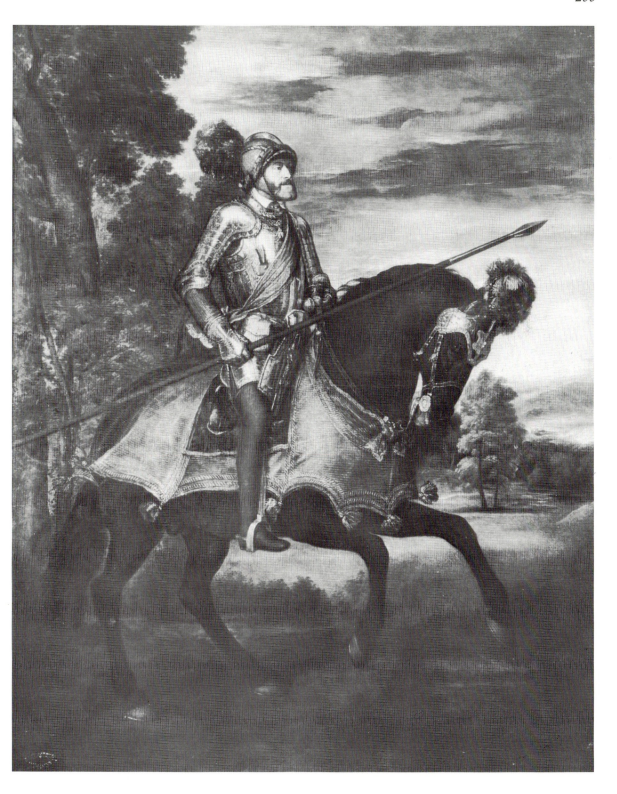

to 1550, almost all his models were members of the highest society: Emperor, Pope, Kings, generals, statesmen, prelates, and their families. The history of these decades in Europe could be fairly completely illustrated from Titian's portraits. Lomazzo goes as far as to say that only persons of the highest social and intellectual ranks have the right to have their likenesses handed down to posterity. But he knows of the wish of the bourgeois to be portrayed as a man of consequence, and he makes sarcastic remarks on traders and bankers who want to be depicted with a marshal's baton, instead of in loose gowns and with their pens tucked behind their ears.

Some changes towards this bourgeois tendency can be noticed even with Titian in his later years. Not long after the triumphal days at Augsburg in 1557, Lodovico Dolce's panegyric was published, to impress once more on the public the fact that Titian was the greatest painter of all time, just as Pietro Aretino had so often done before. Dolce praised Titian for the dignity with which he had invested his profession, above all by placing a high value on his abilities and asking prices accordingly, but also by painting the great men, and for the great men, of his age, and disregarding the demands of lesser people. However by this time Titian was no longer quite so exclusive. While he was painting his mythologies for Philip of Spain, younger men had taken over the task of decorating the churches and public buildings in Venice with large canvases. Titian now gratefully accepted commissions from all quarters, and he also painted more portraits for the middle class than he had ever done before. These works, though they are never comical in Lomazzo's sense, do sometimes touch a theatrical note. For instance, a certain Fabrizio Salvaresio, whose name occurs in no history book, was painted by him in 1558 (Plate 214). Our knowledge of the man derives only from the Latin cartouche on the picture. His whole make-up suggests that he was a merchant who had made his fortune in the East. This picture is in Vienna. The *Portrait of a Bearded Man* in Copenhagen is two or three years later (Plate 215).

From a purely artistic point of view, however, some of Titian's late portraits are among his best. They are either quite simple, on the noble lines of his Prado *Self-portrait* (Plate 203), like the *Man with a Flute* at Detroit (Plate 216), or they are monumental by virtue of their form alone. This picture (Plate 217), also in Vienna, is, I think, a masterpiece of stable composition, although it must be near in date to the *Strada*.

I conclude with yet another Vienna picture. It is usually, but erroneously, called *Benedetto Varchi*, and it dates from the early 1550s (Plate 218). As in Titian's contemporary histories, the broad brushwork is essential to the rendering of form. Colour is distributed in small particles over the whole canvas and there are no neutral areas. The X-ray photographs show the way in which the analysis of plastic form

214 (*right*). Titian. *Portrait of Fabrizio Salvaresio*. Vienna, Kunsthistorisches Museum.

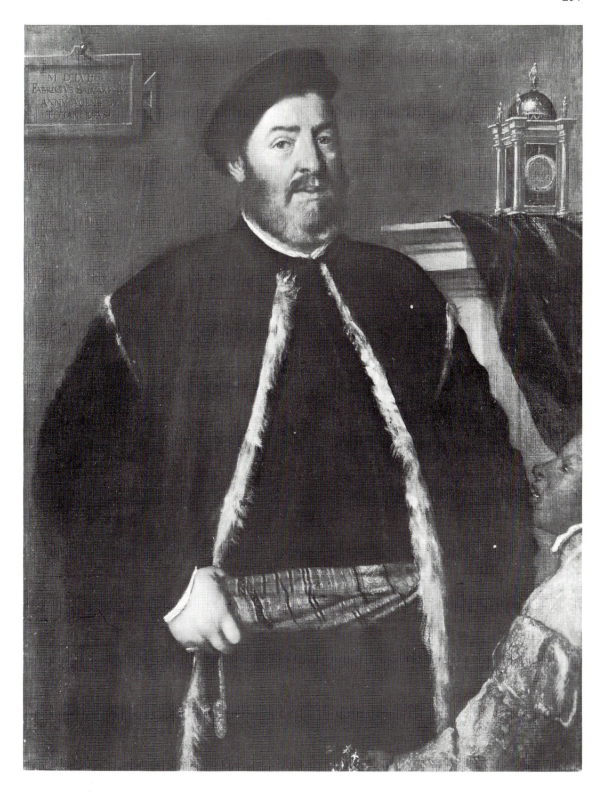

215 (*left*). Titian. *Portrait of a Bearded Man*. Copenhagen, State Museum.

216. Titian. *Man with a Flute*. Detroit, Art Institute.

was prepared in the underpainting (Plate 219): the forms are set off one against another and appear to consist only of planes. The head is a cubic structure without any roundness, resembling an unfinished sculpture by Michelangelo. The canvas, in many places not covered by paint, conveys the impression of an uninterrupted ground-texture. Bright strokes surround the head like a halo; in the finished work they are less noticeable, though, in fact, they are responsible for the smooth transition to the background. Likewise, the angles in the first layer are not without influence on the vivid appearance of the surface, as they have been covered only by thin paint or glazes. Nevertheless, I must warn you: Plate 220 is the head as Titian intended it, and not

217. Titian. *Portrait of Filippo Strozzi*. Vienna, Kunsthistorisches Museum.

218. Titian. *Portrait of a Man*. Vienna, Kunsthistorisches Museum.

219. X-ray of the head of plate 218.

220. Detail of plate 218.

221. X-ray of the hand of plate 218.

Plate 219; for this X-ray photograph, which I made when engaged on researches in the methods of old masters twenty-five years ago, has lately been used to illustrate the affinities between Post-Impressionist painting and Titian. This otherwise correct statement must be qualified as indicated. The *pentimento* is characteristic. Of the white collar only a narrow strip has been left, and so the spectator can concentrate more intensely on the bright area of the face. The same explanation applies to the change in the left hand (Plate 222), which originally held a light glove or handkerchief (Plate 221). Titian caused the hand to drop the object, and he straightened the fingers. Thus he formulated a gesture of detachment and leisure which has been a stock-in-trade of professional portrait-painters to this day.

222. Detail of plate 218.

Notes

Notes to the Preface

1. Two examples of this may be quoted. In an article on Domenico Mancini in discussing works by Giorgione and his circle Wilde noted two crucial facts about the *Concert Champêtre* which had not previously been recorded: first that it had been enlarged on all sides, particularly at the top, and secondly that the original canvas had been attached to the added strips slightly crooked, with the result that the figures are out of the vertical. This feature has incidentally been thought by some critics to be deliberate and has been used as a basis for stylistic analysis and even for attribution.

Secondly he realized that Titian's *Pietà* in the Accademia in Venice, generally taken as a work of the last years, is in fact composed of a smaller picture dating from an earlier period in the artist's career to which he made additions in his last years. Characteristically these two discoveries were recorded almost in asides, the first in a footnote to an article ('Die Probleme um Domenico Mancini', *Jahrbuch der kunsthistorischen Sammlungen in Wien*, N.S., VII, 1933, p. 107, n. 11), the second in a review of a book on Titian by T. Hetzer (*Zeitschrift für Kunstgeschichte*, VI, 1937, p. 54).

Notes to Chapter 1

1. *Officina Ferrarese* (Rome, 1934), p. 34.
2. Bembo to Isabella d'Este, January, 1506. See V. Cian 'Pietro Bembo e Isabella d'Este Gonzaga', *Giornale storico della letteratura italiana*, IX (1887), p. 106.
3. C. Ridolfi, *Le Maraviglie dell'Arte*, ed. D. von Hadeln (Berlin, 1914–24), Vol. I, pp. 64–5.
4. cf. J. Wilde, 'Die Pala, di San Cassiano' von Antonello da Messina, *Jahrbuch der Kunsthistorischen Sammlungen in Wien*, III (1929), pp. 57 ff.
5. J. Walker, *Bellini and Titian at Ferrara* (London, 1956), pp. 54 ff.

Notes to Chapter 2

1. This interpretation was first proposed by Robert Eisler, *New Titles for Old Pictures* (London, 1935).
2. F. Klauner, 'Zur Symbolik von Giorgiones *Drei Philosophen*', *Jahrbuch der Kunsthistorischen Sammlungen in Wien*, LI (1956), pp. 145–68.
3. J. C. Müller Hofstede, 'Untersuchungen über Giorgiones Selbstbildnis in Braunschweig', *Mitteilungen des Kunsthistorischen Institutes in Florenz*, VIII (1957), pp. 13–34.
4. In fact the picture was later cleaned with results which confirmed Wilde's view that it was very close to Giorgione. Curiously enough the fact is not mentioned by Pignatti in his book on Giorgione, but he publishes another version of the picture in an English private collection (*Giorgione*, English edition, London, 1969, p. 131 and plate 101).
5. Vasari, *Le Vite de' più eccellenti pittori scultori ed architetti*, ed. Milanesi (Florence, 1878–85) IV, p. 93.

Notes to Chapter 3

1. In 1902 in *The Drawings of the Florentine Painters* (London, 1903) I, p. 233. Berenson later withdrew this attribution.
2. E. Tietze-Conrat, 'The so-called *Adulteress* by Giorgione', *Gazette des Beaux-Arts* (1945), p. 189.

3. Patricia Egan, 'Poesia and the *Concert Champêtre*', *Art Bulletin*, XLI (1959), pp. 303 ff.

4. J. Wilde in 'Die Probleme um Domenico Mancini', *Jahrbuch der Kunsthistorischen Sammlungen in Wien*, N.F. VII (1933), shows that a detail of the Prado Madonna was followed by Mancini in his Madonna at Lendinara of 1511.

5. G. Robertson, 'The Giorgione Exhibition in Venice', *Burlington Magazine* (1956), pp. 272–7.

Notes to Chapter 4

1. This view is based on the proportions of the eighteenth-century engravings of S. F. Ravenet and R. Delaunay—see J. Wilde 'Die Probleme um Domenico Mancini', *Jahrbuch der Kunsthistorischen Sammlungen in Wien* N.F., 1933, p. 106 n. But against this see G. Robertson 'The X-ray examination of Titian's *Three Ages of Man*', *Burlington Magazine* CXIII (1971), pp. 725–6 and n. 12.

2. cf. the *Madonna with the Siskin*, Dahlem Museum, Berlin.

3. See E. Panofsky, *Studies in Iconology* (New York, 1962), pp. 150–60, and *Problems in Titian: mostly Iconographic* (London, 1969), pp. 110–19.

Notes to Chapter 5

1. Eugenio Battisti, 'Disegni inediti di Tiziano e lo Studio d'Alfonso d'Este', *Commentari V* (1954), p. 191 ff. See further, Charles Hope, 'The Camerini d'Alabastro of Alfonso d'Este', *Burlington Magazine*, CXIII (1971), pp. 641–50, 712–21.

2. The same point was later made by Erwin Panofsky, *Problems in Titian: Mostly Iconographic* (London, 1969), p. 126 ff.

3. Photographs have now become available, see Juergen Schulz, *Venetian Painted Ceilings of the Renaissance* (Berkeley, 1968), p. 84, cat. no. 26.

Notes to Chapter 6

1. Giorgio Vasari, *Lives of the most eminent Painters, Sculptors and Architects*, translated by G. de Vere (London, 1912–15), IX, pp. 162, 170 ff.

2. See Richard Krautheimer, *Lorenzo Ghiberti*, 2nd edition (Princeton, 1970), vol. I, p. 305, note 51.

3. See E. K. Waterhouse, *Titian's 'Diana and Actaeon'* (Charlton Lecture on Art), (Oxford, 1952).

4. See Juergen Schulz, *Venetian Painted Ceilings of the Renaissance* (Berkeley, 1968), p. 95, cat. no. 34.

Notes to Chapter 7

1. For the dating of this picture, see Harold E. Wethey, *The Paintings of Titian*, vol. II, *The Portraits* (London, 1971), cat. no. 104, p. 143.

2. See Erwin Panofsky, *Problems in Titian: mostly Iconographic* (London, 1969), pp. 74 ff.

Bibliography

For students who wish to follow up the study of the phase of Venetian painting covered in Wilde's lectures the following short list of the most important books is appended. In addition they will do well to consult the catalogues of museums and galleries in which paintings by the artists concerned are to be found, particularly those of the Accademia, Venice, the Kunsthistorisches Museum, Vienna, and the National Gallery, London.

P. MOLMENTI, *La storia di Venezia nella vita privata* (Bergamo, 1910–12), 3 vols.

D. S. CHAMBERS, *The Imperial Age of Venice 1380–1580* (London, 1970).

B. PULLAN, *Rich and Poor in Renaissance Venice* (Oxford, 1971).

F. SANSOVINO, *Venetia* (Venice, 1581); new editions Venice, 1604 with additions by Stringa, and Venice, 1663 with additions by G. Martinioni.

M. MICHIEL, *Notizie d'opere di disegno*, ed. J. Morelli and G. Frizzoni (Bologna, 1884).

C. RIDOLFI, *Le Maraviglie dell'Arte*, ed. D. F. von Hadeln (Berlin, 1914), 2 vols.

G. VASARI, *Le vite dei più eccellenti pittori, scultori ed architetti* (1568) ed. G. Milanesi (Florence, 1907).

P. ARETINO. *Lettere sull'arte di Pietro Aretino*, ed. E. Camesacca and F. Pertile (Milan, 1957–60), 4 vols.

B. BERENSON, *Italian Pictures of the Renaissance, Venetian School* (London, 1957), 2 vols.

H. TIETZE and E. TIETZE-CONRAT, *The Drawings of the Venetian Painters in the 15th and 16th centuries* (New York, 1944).

J. SCHULZ, *Venetian Painted Ceilings of the Renaissance* (Berkeley, 1968).

F. SAXL, *A Heritage of Images* (London, 1970).

P. KRISTELLER, *Andrea Mantegna*, English edition by S. Strong (London, 1901).

N. HUSE, 'Studien zu Giovanni Bellini', *Beiträge zur Kunstgeschichte no. 7* (Berlin and New York, 1972).

G. ROBERTSON, *Giovanni Bellini* (Oxford, 1968).

G. ROBERTSON, *Vincenzo Catena* (Edinburgh, 1954).

R. PALLUCHINI, *Sebastian Viniziano* (Milan, 1944).

F. VALCANOVER, *Tutta la Pittura di Tiziano* (Milan, 1960), 2 vols.

E. PANOFSKY, *Problems in Titian: mostly iconographic* (London, 1969).

H. E. WETHEY, *The Paintings of Titian, I, The Religious Paintings* (London, 1969); *II, The Portraits* (London, 1971).

T. HETZER, *Tizian, Geschichte seiner Farbe* (Frankfort, 1948).